Kelly Grovier is a poet, historian and cultural critic. He is a regular contributor on art to the *Times Literary Supplement*, and his writing has appeared in numerous publications, including the *Observer*, the *Sunday Times* and *Wired*. Educated at the University of California, Los Angeles and at the University of Oxford, he is co-founder of the international scholarly journal *European Romantic Review* and the author of *100 Works of Art that Will Define Our Age* (published by Thames & Hudson).

Thames & Hudson world of art

This famous series provides the widest available range of illustrated books on art in all its aspects.

To find out about all our publications, including other titles in the World of Art series, please visit **thamesandhudsonusa.com**.

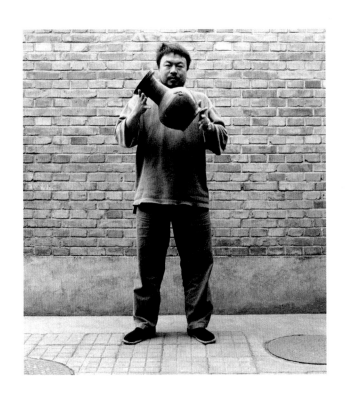

Ai Weiwei, *Dropping a Han Dynasty Urn*, 1995. Three gelatin silver prints

Among the most famous works of the age, Ai Weiwei's photographic triptych challenges observers to question the relationship between contemporary culture and traditional structures, art and authority, creation and destruction, the present and the past.

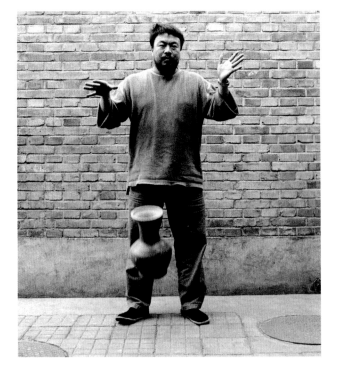

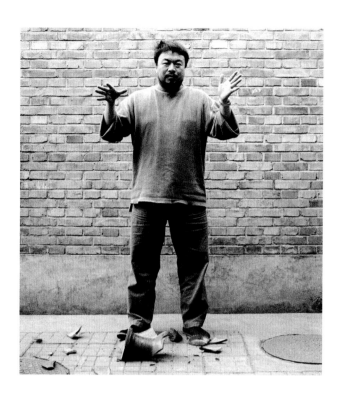

Art Since 1989

Kelly Grovier

254 illustrations

Thames & Hudson world of art

For my brothers

Acknowledgments

I am grateful to my editors, Jacky Klein and Roger Thorp, for inviting me to tell this story. Thanks too are due to the team at Thames & Hudson (especially Allie Boalch, Sarah Hull, Aman Phull and Linda Schofield), without whose expertise, advice and care this book would not have been possible. I am also grateful to Anna Vaux, Alan Jenkins and Michael Caines at the *Times Literary Supplement* for the countless opportunities they give me to exercise my eyes and broaden my knowledge. For their kindnesses, conversations, and encouragement I would also like to express my gratitude to Mark Alexander, Tiffany Atkinson, Fred Burwick, Kate Burvill, Jean Fremon, Gavin Friday, Peter Green, Guggi, Darragh Hogan, Simon Hogg, Daniel Kennedy, John Kennedy, Justus Kewenig, Christopher Le Brun, Paddy McKillen, Eleanor Mills, Anthony Mosawi, Anna Mountford-Zimdars, Cornelia Parker, Sam Phillips, Jem Poster, Mark Robinson, Anne Stewart, Rosaleen Sturgeon, Jacqueline Thalmann, Tony Waddingham, Celia White and Ben Wright. I would also like to convey my gratitude to Sean, Liliane and Oisin for their generous hospitality. Finally, I would like to thank my parents for teaching me how to look at art, and, most especially, Sinéad, who put up with me during the writing of this book and read every version of every sentence. She is entirely responsible for any errors.

First published in 2015 in paperback in the United States of America by Thames & Hudson Inc., 500 Fifth Avenue, New York, New York 10110

thamesandhudsonusa.com

Library of Congress Catalog Card Number 2015932500

ISBN 978-0-500-20426-9

Printed and bound in Malaysia by Tien Wah Press (Pte) Ltd

Contents

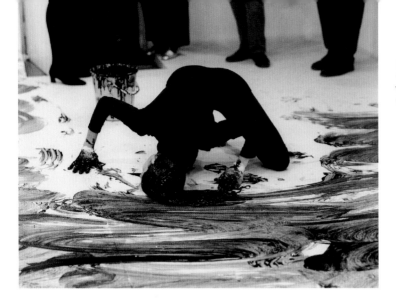

1 **Janine Antoni**, *Loving Care*, 1992. Performance with Loving Care hair dye (Natural Black)

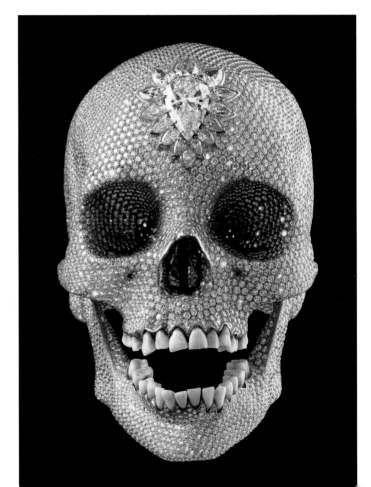

2 **Damien Hirst**, *For the Love of God*, 2007. Platinum, diamonds and human teeth

Introduction

Imagine finding yourself in a maze of connected rooms. In front of you, a man is constructing a portrait of the Virgin Mary out of clumps of elephant dung and snippets of pornography. In the next room, you see a group of men straining to push a huge concrete block from one end of the space to the other and then back again, endlessly. As you make your way to a third doorway, you are confronted by a woman on her hands and knees who whips her long wet hair (which she has dipped in cheap dye) at your feet, driving you backwards. Suddenly, she turns away and begins to gnaw at the corners of a 272-kilogram (600-pound) cube of chocolate, spitting each mouthful into a heart-shaped box. You manage to slip past her and begin running down a long corridor, catching glimpses of what occupies each of the rooms that are open on either side of you: a man pouring blood into a clear mould that resembles his own head ... a long queue of people waiting to be stared at by an expressionless woman ... a skull fashioned from diamonds ... a man with his hand on a switch, turning the lights on and off again every five seconds. You eventually find an exit and push the doors open, hoping to escape the maze. But as soon as you step outside, you are paralysed by the sight of an enormous steel spider, 10 metres (33 feet) in height, towering above you and, behind that, a West Highland Terrier, 12 metres (40 feet) tall, whose colourful fur is made out of living flowers...

Welcome to the exhilarating, bewildering and, at times, terrifying world of contemporary art. No era in the history of human creativity has ever been so diverse in its vision or so seemingly disconnected in its achievement than the one in which we currently live. Although individual paintings by Raphael, by Michelangelo and by Leonardo da Vinci may reveal the temperament and unique brushwork of the artist who created them, when seen together the works of these three masters, however distinctive, are aesthetically consistent and all belong unmistakably to the same High Renaissance moment. They sing, as it were, from the same historical hymn sheet. But what single score could hope to harmonize the discordant voices, say, of the world-weary flesh of British painter Lucian Freud's later

3 **Felix Gonzalez-Torres**, *"Untitled"*, 1992. Candies individually wrapped in variously coloured cellophane, endless supply. Installation view of 'A Day Without Art', St Louis Art Museum, St Louis, MO. 29 November–3 December 2002

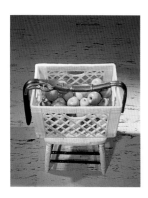

4 **Robert Gober**, *Melted Rifle*, 2006. Plaster, paint, cast plastic, beeswax, walnut and lead

portraits and the steep heap of cellophane-wrapped candies that comprises Cuban-born Felix Gonzalez-Torres's conceptual installations? What can possibly unite into a coherent narrative the motivations behind American artist Robert Gober's sculpture of a Winchester rifle melted across a plastic basket filled with Granny Smith apples and French multimedia artist Pierre Huyghe's intimate archaeologies of insects entombed in amber? How are we to square the vision of controversial Belgian artist Wim Delvoye, who tattoos the backs of living pigs with a filigree of intricate design, with that of American artist Dale Chihuly, who has transformed the field of blown glass with his sprawling *Chandeliers* of sinuous fronds?

Our story begins at a moment of extraordinary upheavals around the world. It starts in that most astonishing stretch of months that bridged the political cataclysms of 1989 and the unprecedented scientific and technological awakenings of 1990. If 1989 saw one era of human history come to an end with the collapse of the Berlin Wall, student protests in Beijing's Tiananmen Square and the wave of democratic revolutions that swept across Eastern Europe – from Czechoslovakia to Poland, Hungary to Romania – the ensuing twelve months witnessed the dawn of a new cultural epoch without obvious parallel in the story of mankind. It was in the year 1990 that our knowledge of the universe would be changed forever with the launch of the Hubble Space Telescope, that our understanding of the very fabric of our bodies would be sharpened immeasurably with the unveiling of the Human Genome Project, and that our ability to communicate with one another and to share information would be utterly transformed with the introduction of the World Wide Web. It is against this tumultuous backdrop that all of the works explored in the following pages came into existence.

Indeed this book is motivated by the premise that great art vibrates with the pulses of the age that provoked it and succeeds in chronicling its generation's consciousness more profoundly than any other human document can. However valiantly historians of the Spanish Civil War may endeavour to piece together the events of 26 April 1937, when a defenceless Basque village was ravaged from the sky by fascist forces, it will forever be Pablo Picasso's mute testimony, *Guernica* (1937), that reverberates in our imagination with the meaning of those atrocities [8]. But what of our own age? Which artists have managed to record the rhythms, triumphs and traumas of

5 **Pierre Huyghe**,
De-extinction, 2014. Film still

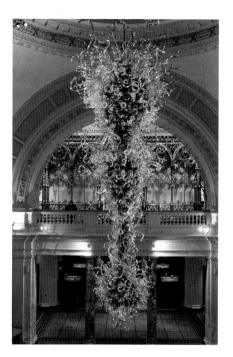

7 **Dale Chihuly**, *V&A Chandelier*,
2001. Blown glass, mould-blown
glass and steel

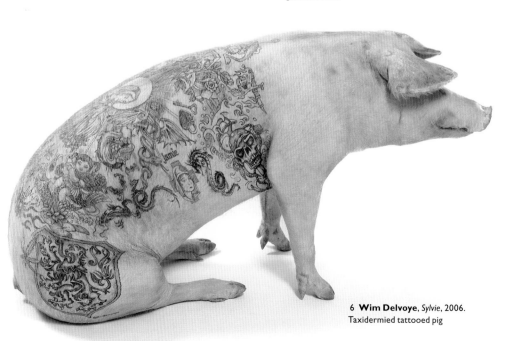

6 **Wim Delvoye**, *Sylvie*, 2006.
Taxidermied tattooed pig

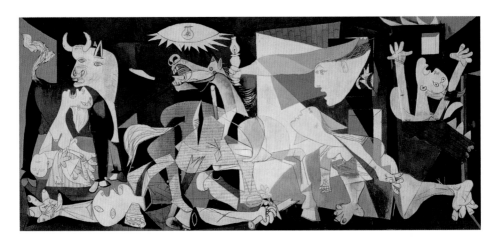

our time? *Guernica* is notable not only for its ability to capture the anguish of a given moment, but also for its genius in redefining the very nature of history painting. Picasso's devastating canvas, in other words, not only looks back to what happened, but also endeavours to drive art history forward by forging a new language with which to convey intense feeling. *Art Since 1989* goes in search of those artists who, in our own era, have likewise undertaken to shape a fresh visual vocabulary and whose works reflect upon the turbulent years since the world began delving deeper into the unknown depths of outer and inner space than any generation before has ever attempted.

The dismantling of the Berlin Wall, which began in November 1989, symbolizing the tearing down of the Iron Curtain that stretched across the Soviet-aligned nations of Eastern Europe, and the subsequent hurtling, five months later, of a pioneering scientific lens out past the furthest horizon of conceivable vision (when the Space Shuttle *Discovery* released the Hubble Space Telescope into the great beyond), provide powerful metaphors for the sudden boundlessness of imagination that characterizes the art created in the ensuing months and years. For over a century, since the closing decades of the nineteenth century, the story of modern art had seemed a relentless succession of prevailing styles. One after another, Impressionism gave way to post-Impressionism, Cubism blurred into Surrealism, Fauvism morphed into Abstract Expressionism, Pop Art into Postmodernism... Then, suddenly, the very notion of a dominant aesthetic style appeared to many as outmoded an aspiration as any tyrannical political dogma. The days of overarching philosophies and theoretical manifestos to which artists either

8 Pablo Picasso, *Guernica*, 1937. Oil on canvas

adamantly adhered or which they robustly repudiated were gone. Without an orthodoxy to resist, there can of course be no avant-garde – no overthrowing of an old order by a new one. Dramatic pronouncements that the history of art itself had reached its final act were being made by prominent critics, such as Arthur Danto, who speculated in the mid-1980s that mankind was rapidly approaching 'the end of art'. Such writers hypothesized that the future of creative expression would no longer take the form of an unfolding narrative of distinct chapters devoted to individual movements – the Medieval period followed by the Renaissance, Romanticism followed by realism – but would instead be a shapeless and unending aeon of individual visions: an anything-goes free-for-all of hit-and-miss wonders.

So far, such prognostications have been proved correct. In the current climate, there is no overriding style, technique or attitude governing artistic practice; nor is there any prevailing medium. For centuries, three predominant genres (painting, drawing and sculpture) accounted for nearly all of what society meant by the word 'art'. To restrict observation now to those three categories would be to blind ourselves to a majority of the exceptional work currently being made. What began as an audacious gesture when the French artist and thinker Marcel Duchamp introduced into artistic discourse the concept of the so-called 'readymade' – which most infamously took the form in 1917 of a urinal he entitled *Fountain* – quickly caught fire in the mischievous imaginations of Pop Artists in the 1950s and 1960s. Today, conceptual art, which often employs found or retail objects appropriated from everyday life, has been broadly embraced as a strand of creative expression that is as vibrant and viable as more conventional works fashioned by brush, pencil or chisel. Add to this the textures of new technologies introduced in the era of digitization and the full palette of possibilities now available to artists would be virtually unrecognizable to any creator of visual work in the previous 40,000 years since mankind first began making art for the eyes. An exhibition of objects by an artist operating today is as likely to consist of videos, dioramic vitrines, displays of digital photographs, found objects and live performances as it is to feature a painted canvas, a work on paper demonstrating an agility of draughtsmanship or a three-dimensional object cast in metal, marble or clay.

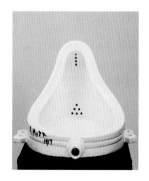

9 **Marcel Duchamp**, *The Fountain*, 1917. Replica (original lost). Porcelain urinal

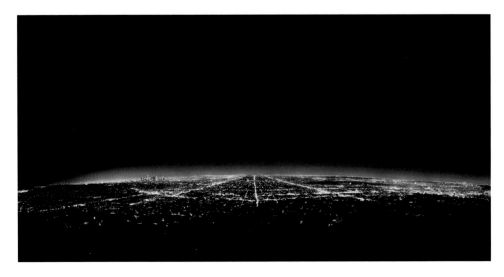

It is extraordinary to reflect that the techniques and media that we regard today as traditional in the making of art were once cutting edge and would have struck early observers of their use as bold and innovative. The appearance of stretched linen canvas, for example, as a support for oil paint would have seemed groundbreaking in the fourteenth and fifteenth centuries to viewers conditioned to expect the warp and heft of a painted wood panel. So rapid has been the recent assimilation of electronic gadgetry into our everyday lives that it is easy to forget just how new and pioneering its use is in the making of art. The combined vantage and density of detail in works such as German photographer Andreas Gursky's nightscape *Los Angeles* (1999) would not have been possible before the democratization of digitization and seems to brood over an awakening world of artistic possibility.

Freedom of form has been matched in recent decades by an overdue liberation in whom society presumes is making art and where it is that art is expected to be made. While the contribution of female artists to the ferment of creativity in previous eras has routinely been undervalued by historians, to diminish that achievement today would be significantly to misrepresent the true shape of contemporary artistic consciousness. Nor is it any longer possible to pinpoint a single geographical capital of vision. The convenient map on which critics once traced the shifting of cultural coordinates, from Paris in the late nineteenth and early twentieth centuries to New York in the post-war years, has suddenly dissolved

10 **Andreas Gursky**,
Los Angeles, 1999.
Cibachrome print

into the homogenizing pixilation of digitized Global Positioning Systems (GPS). Art is everywhere and can no longer credibly be discussed as a chiefly Euro-American phenomenon. Any effort to summarize its emphases must be prepared to accommodate examples from Latin America, Australia, Asia and Africa.

This total untethering of what art can be, who makes it and where it can be found has been matched by a reassessment too of art's appropriate place in society, not to mention what reasonable financial value should be attached to it. Before the 1990s, the Venice Biennale offered a unique international forum for the showcasing of new work by contemporary artists. In the past three decades, however, yearly and biannual events devoted to exhibiting the work of distinguished and emerging artists have been established in scores of cities around the world, most notably in Basel, Hong Kong, Istanbul, London, Los Angeles, Miami, Paris, São Paulo and Shanghai. Whether explicitly commercial in design or not, these forums are now crucial to the building of artists' reputations and, consequently, to the setting of prices that their work is capable of fetching. While an artist's market appeal has, throughout history, played a formative role in determining the trajectory of his or her profile, some commentators on the state of contemporary art, and on its resale value at auction, have concluded that money has come to have a 'disfiguring effect' on quality and on the discerning public's ability to distinguish great work from that which merely commands a high price.

Since the turn of the new millennium, nearly every year has brought with it news of the breaking of another sales record for a work by a living artist. In October 2012 an anonymous bidder made headlines at a Sotheby's auction in London when he spent 26.4 million Euros on German artist Gerhard Richter's generically entitled 1994 painting *Abstract Picture*, giving the seller, the guitarist Eric Clapton, a healthy 24 million Euro profit on his initial investment of eleven years earlier. That record, however, was remarkably short-lived. The following autumn saw the sale at a Christie's auction in New York for 46 million Euros of American sculptor Jeff Koons's stainless steel *Balloon Dog (Orange)* (1994–2000), outdistancing the record-setting price paid for Richter's work by almost eighty per cent. One year later, in November 2014, a contemporary art sale at Christie's broke the record for the highest total sales in auction history, attracting $852,887,000 in winning bids on an evening spending

spree that saw the shattering of records for a single work by eleven contemporary artists, including American abstractionist Cy Twombly ($69,605,000), German painter Georg Baselitz ($7,445,000) and Japanese artist Yayoi Kusama ($7,109,000). Such steep rises have increasingly outdistanced the budgets of public museums and galleries, effectively marginalizing their traditional role in assessing the quality of a given work or the importance of a particular artist. The promise of enormous profit has attracted a new class of private art collector who, some allege, is less interested in the enduring significance of the objects he or she buys than in their resale potential. 'The new job of art', the critic Robert Hughes remarked in 2008, 'is to sit on the wall and get more expensive.'

Hughes's concern, that the monetization of art compromises artistic integrity and confounds critical judgment, cannot be dismissed by any serious commentator seeking to survey the imaginative terrain. The task of the chapters that follow is to create a framework for appreciation that ignores the fluctuating commercial status of individual artists and sets to one side the whims of the capricious marketplace. The works included here are representative of the extraordinary age that generated them, no matter the position to which they have been jockeyed in the horserace of galloping prices. Although space does not allow for an exhaustive or encyclopaedic selection, each of the works that comprise *Art Since 1989* has been chosen for what it can tell us about the spirit of this most tempestuous of creative eras.

Face Time: Reinventing the Portrait

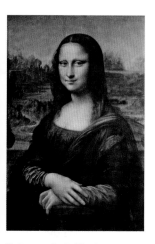

11 **Leonardo da Vinci**, *Mona Lisa*, c. 1503–6. Oil on wood (poplar)

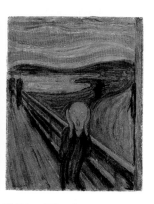

12 **Edvard Munch**, *The Scream*, 1893. Tempera and crayon on cardboard

In March 2010, a team of Spanish surgeons performed the first full transplant of a human face. A breakthrough in medical science, the procedure was nevertheless profoundly dislocating, not only for the patient who courageously underwent it following a tragic shooting accident, but also for the age in which it occurred. For the first time in human history, features that had once defined the appearance of one individual were now integral to the countenance of another. Oscar Wilde's famous assertion, 'a man's face is his autobiography', suddenly required reformulation. A visage could no longer be looked upon to record the traumas and triumphs of a single life but was a register of composite existences. From now on, the essence of identity would be as unfixed physically as it had always been philosophically.

Throughout the history of creative expression, no subject has proved more captivating to both artists and admirers of visual art than the face. Whether one thinks first of Leonardo da Vinci's *Mona Lisa* (c. 1503–6) or Edvard Munch's *The Scream* (1893), many of the most memorable works of art are portraits. Why are we drawn to the countenances of strangers and the suspended stare of painted eyes? Perhaps, unlike landscapes or abstract compositions, portraits create the illusion of looking back and have the capacity to turn our gaze onto ourselves. Portraits likewise offer our best opportunity to scrutinize the absent artist: the creator and created collapsing into a single expression.

Rationally or not, we attempt to discern from portraits not only an artist's technical skills, but also his or her grasp of human character and depth of insight. Is the artist empathetic or misanthropic? Lustful or distant? Rigidly realistic or dreamily wistful? From these fictional faces we attempt too to glean what we can of the temperament of the time in which the artist and subject lived. War-torn or peaceful? Prosperous or austere? Are these the eyes of one who looked upon an age of reason or a Romantic era? Just as the *Mona Lisa* is marvelled upon as a map that can lead us out of the Middle Ages, *The Scream*, which howls from the threshold of the twentieth century, is

seen as an anguished signpost of traumas to come: the horrors of world wars, of holocaust and of modernist dredging of the subconscious.

The years since the fall of the Berlin Wall in 1989 have seen as great an upheaval in our comprehension of the human face as any age in history. Astonishing medical and technological innovations – from facial-recognition software to full-face transplants – have forced us to focus on the connection between countenance and individual identity. The challenge for contemporary portraitists has been to keep pace with such ingenuity, to reinvent the face for a new age.

For some, such as British painter Glenn Brown, American artist George Condo, Czech miniaturist Jindřich Ulrich and German Surrealist painter Neo Rauch, the way forward has been the way back, scavenging from scrap heaps of history ambiguous ingredients from which a novel countenance can be assembled. Brown's earliest work, from the start of the 1990s, earned him a reputation as a brash bootlegger who shamelessly lifted subjects from old and new masters alike, from Rembrandt van Rijn to Jean-Honoré Fragonard, Salvador Dalí to Frank Auerbach, whose complexions he audaciously corroded into a leprous pallor. It took the art world several years to come to terms with the unsettling significance of Brown's work,

13 (above left) **Glenn Brown**, *America*, 2004. Oil on panel

14 (above right) **George Condo**, *The Laughing Cavalier*, 2013. Acrylic, charcoal and pastel on linen

which relied less on cynical recycling of forebears than on a singular vision of the whole of art history as a closed system in ceaseless decay. To look at portraits such as *Joseph Beuys* (2001) or *America* (2004) is to stare into the face of a slow aesthetic decomposition of all the portraits one has ever encountered before. The eternal warmth of Rembrandt's ambers and golds has been replaced with the slow putrefaction of gangrenous greens and rigor-mortis blues. His countenances are characterized by an intricate swirling of colour, like an alchemist's alembic percolating with corrosive chemicals that serve to heighten the impression that every portrait is a simmering concoction of every portrait that came before it.

A wryer reconditioning of conventional countenance preoccupies the portraiture of Condo, whose manipulation of precursors such as Picasso and Diego Velázquez is in accord with Brown's grotesque imagination. For Condo, though, the trajectory of intervention into the works of antecedents is one of crude caricature: a devolution of form in the direction of clumsy parody, as though the whole history of art were breaking down into a crass satire of itself.

Virtually unknown beyond Prague before the Velvet Revolution in 1989 that brought an end to communist control of his native country, the reclusive Ulrich had earned a provincial reputation as 'the last Medieval miniaturist' for his countless pocket-sized portraits that managed to merge meticulous old-master technique with innovative and often playful contemporary vision. Rarely larger than a few centimetres in height, Ulrich's paintings conjure the Bohemian past of Rudolf II's eclectic court of astronomers and alchemists, necromancers and ne'er-do-wells, by dividing a portrait's profile into a cabinet of tiny compartments into which still smaller constituent curiosities relating to Prague's occultist past were carefully tucked away. To peer into the cubbyholes of an Ulrich miniature is to witness the secret safe-keeping from political threat of a people's at once sophisticated and superstitious past, in anticipation of later retrieval and rehabilitation. For Ulrich, portraiture offers not merely the record of a single individual's semblance, but provides the possibility for historical conservation and the eventual excavation of what is public, shared and in danger of being forgotten.

15 **Jindřich Ulrich**, *The Collector*, 1996. Oil on wood

A very different kind of artistic resuscitation is evoked by Rauch. Associated with the post-reunification movement known

as the New Leipzig School, Rauch's work involves the blending of past artistic references with contemporary concerns. The figures portrayed by Rauch are often clad in antiquated dress, recalling iconic European revolutionary struggles from the end of the eighteenth century to the beginning of the twentieth. The literal dramas in which these subjects are involved are often indeterminate from the clues provided, aligning Rauch's imagination in the estimation of many commentators to Surrealism. But where pioneering works that define that earlier movement, such as Dalí's *The Persistence of Memory* (1931), were invigorated by emergent ideas concerning psychoanalysis and human consciousness, Rauch's work is illustrative of an age preoccupied by the brutal dismemberments of history and the recombination of cultural shapes.

The result is works of irresolvable narrative tension, where the past and present struggle for the upper hand. In Rauch's double portrait *Armdrücken* (*Arm Wrestling*) (2008), for example, two figures from what appear to be distant eras lock fists across a nondescript table in a curiously timeless interior, straining for control. Complicating the composition is the viewer's suspicion that the two men may be aspects of the same individual – reincarnations of each other – a split in personality occasioned less by psychological disorder than by the ravages of time. The hunch is made all the more intriguing by the near resemblance of both to the artist himself. In Rauch's work, identity is an elusive value that involves reconciling the temporally irreconcilable: the past and the present, then and now.

Awkward unions of the historical with the contemporary likewise enliven the work of the New York-based portraitist Kehinde Wiley. A restaging of Jacques-Louis David's *Napoleon Crossing the Alps at Grand-Saint-Bernard* (1801–5) is characteristic of Wiley's technique of reimagining paintings by canonical artists of the Western tradition set against a dislocating intricacy of regal and floral designs, which serves to amplify the cultural clashes the artist is choreographing. Wiley's reinvention, *Napoleon Leading the Army over the Alps* (2005), updates an iconic art historical scenario by substituting an African-American man clad glamorously in today's fashion for the white European figure at the centre of the old master's original work. The result is a vibrant recalibration of overly familiar artistic situations whose compositions have become fatigued under the weight of too much staring.

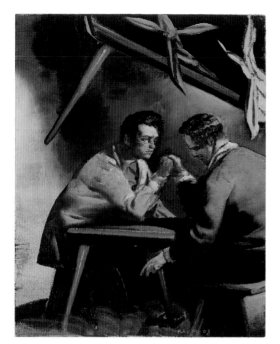

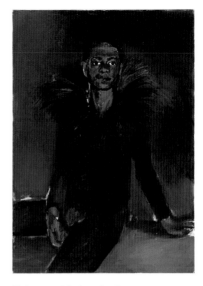

18 **Lynette Yiadom-Boakye**,
Greenfinch, 2012. Oil on canvas

16 **Neo Rauch**,
Armdrücken (Arm Wrestling),
2008. Oil on canvas

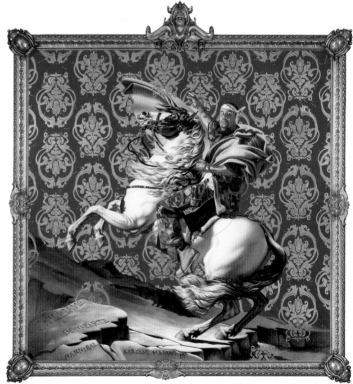

17 **Kehinde Wiley**, *Napoleon
Leading the Army over the Alps*,
2005. Oil on canvas

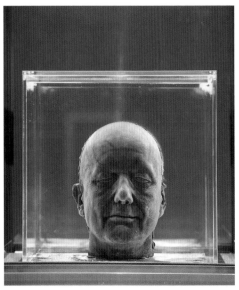

For London-born painter Lynette Yiadom-Boakye, the ambition to shine new light on an old tradition of Western portraiture has resulted ironically in the strict rationing of light not only from her depictions but from the very spaces in which they are exhibited [18]. Yiadom-Boakye's portraits, almost exclusively of black subjects rendered in dark hues often against dim backgrounds, strive to resist any conspicuous allusion to earlier works in the tradition or indeed to any actual person or place. Constructs from her imagination, rather than representations of real sitters, the artist's work is characterized by a timelessness of setting uncluttered by objects that can tether the vision to any particular era or location. The visionary otherworldliness of Yiadom-Boakye's work has, on occasion, been accentuated by the bold curatorial decision to display her portraits in galleries that enforce near darkness on the viewers, the canvases themselves made visible only by the careful positioning of spotlights.

Where some have sought to reconfigure the face from intellectual references to history, other artists have marshalled instead more elemental material components to reconstitute the human countenance, broadening our understanding of what comprises identity both physically as well as psychologically. In the case of Chuck Close, an American portraitist who, in 1988, suffered a paralysing spinal artery collapse at the age of forty-eight, leaving him unable to hold a paintbrush in

19 (above left) **Chuck Close**, *Self-Portrait*, 2004–5. Oil on canvas

20 (above right) **Marc Quinn**, *Self*, 2011. Blood (artist's), liquid silicone, stainless steel, perspex and refrigeration equipment

his hand, the aesthetic reconstitution of identity mirrored an arduous physical rehabilitation. No longer able to work in the hyperrealist style on which his reputation had been building since the 1960s, Close was forced to reinvent himself and his art. A period of convalescence and physiotherapy returned sufficient function to the artist's arms (though he remains reliant on a wheelchair) to allow him to strap brushes to his wrist and to begin experimenting with a distinctive technique that breaks a portrait down into small cells that he fills with squirts of paint. The result is a poignant pointillism of amorphous elements that cohere from a distance into a recognizable face, as though the portrait were endlessly decomposing and recomposing into constituent molecules before the viewer's eyes. Among the more affecting examples of Close's unique style – vibrating between abstraction and realism – are the many self-portraits the artist has undertaken throughout this period, in which he endeavours, over and over again, to amass a relatable self from an anonymizing blizzard of shifting particles.

For British sculptor Marc Quinn, the assemblage of self is achieved with gruesome literalness. Where Close conjures form from a matrix of measured formlessness, Quinn, in an ongoing series of sculptures entitled *Self* (begun in 1991), reconstructs from siphoned pints of his own blood perishable moulds of his head. Repeating the process every five years, the artist freezes friable jellies of platelets and cells, preserving a fragile record of a single individual's existence in the world. Quinn has compared his technique to the serial self-portraiture of Rembrandt and Vincent van Gogh. For both Close and Quinn, representing the human face is an obsessive enterprise that allows the artist an opportunity to explore the feeble equilibrium that is being in the world. Where Brown and Rauch invite the viewer to contemplate the disaggregation of self into historical signs and cultural allusions, Close and Quinn shake individuality through an imaginary sieve, granulating identity into material components.

A very different kind of material assemblage that summons a semblance of the self is achieved in the British creative duet Tim Noble and Sue Webster's *The Individual* (2012) [21]. The work is comprised of heaps of random rubbish, dumped with apparent haphazardness onto the gallery floor. Only the perfect aiming of a spotlight, which casts uncannily accurate silhouettes

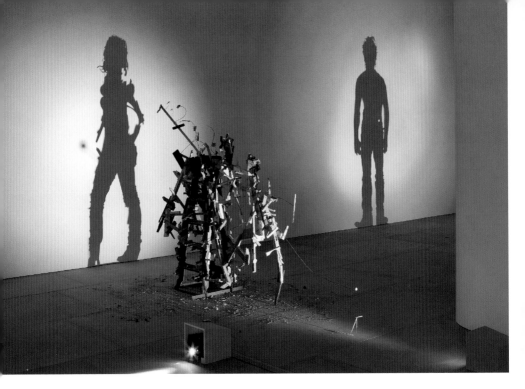

of the artists' profiles against the wall, redeems the clutter and conjures from the clunky mess an unexpected elegance of phantasmal form. The result is a work of deceptive simplicity that suggests the contours of our character are an endlessly recycling composite of even the most seemingly incidental and disposable aspects of our existence.

Chinese painter Yue Minjun and British sculptor Gavin Turk also attracted attention for their distinctive experiments with self-portraiture, and in particular for their respective ability to inflect their works with sharp social irony. Yue, who was born in the north-eastern province of Heilongjiang, is best known for his countless depictions of himself – often several in a single work – cackling grotesquely in paintings that obliquely mimic famous works from the history of art. The static hysterics in which Yue, whose artistic consciousness has been shaped by the enforced conformities of the Cultural Revolution, inserts his own face into an endless array of contexts, require viewers of his work to consider the authenticity of their own day-to-day demeanour and to what extent the face they present to the world is sincere or supplicating. Similar anxieties are prompted by Turk's waxwork sculpture, *Pop* (1993), a life-size self-portrait of the artist assuming the guise of the notorious punk-rock

21 **Tim Noble & Sue Webster**, *The Individual*, 2012. One wooden stepladder, discarded wood and light projector

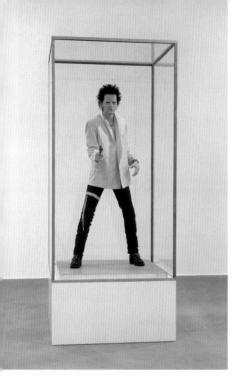

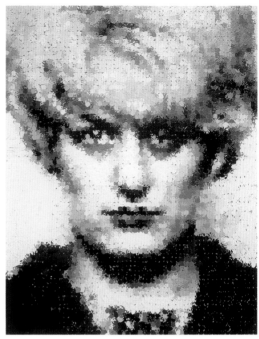

guitarist, and member of the band The Sex Pistols, Sid Vicious, who in turn is impersonating Andy Warhol's famous silkscreen depiction of Elvis Presley in the stance of an American Hollywood cowboy. *Pop* is an undisentanglable wad of contrived personality, whose manufactured egos are knotted so tightly it is impossible to tell for certain where one identity begins and another ends. By calling acerbic attention to the artificial roles we play in society, both Yue and Turk invite us to consider to what extent even our truest selves are really us at all.

The disintegration of the human countenance into Close's cellular squirts on the one hand and Quinn's frozen haemoglobin on the other was matched in the mid-1990s by one of the most controversial works of the era: British artist Marcus Harvey's portrait of a convicted child-murderer comprised of countless handprints. The tiny palms and fingers, which appear to be pressed with deceiving innocence into the monochrome white and grey acrylic paint that constitute *Myra* (1995), magnify a notorious photograph of Myra Hindley. Hindley, along with accomplice Ian Brady, was found guilty in 1966 of a spree of child killings in northern England known as the Moors Murders. The work's inclusion in an exhibition at the Royal Academy of Art, London, in 1997 of young British

22 (above left) **Gavin Turk**, *Pop*, 1993. Waxwork in vitrine

23 (above right) **Marcus Harvey**, *Myra*, 1995. Acrylic on canvas

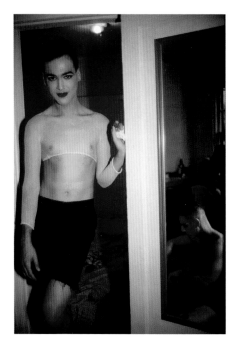

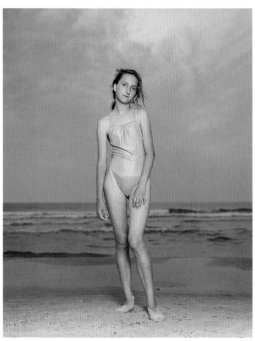

artists (or so-called YBAs), organized by the legendary art dealer Charles Saatchi, met with considerable criticism in the media from those who believed the work shamefully glamorized Hindley. Where Close and Quinn focus viewers' attention on the universal physical ingredients of shared humanity, Harvey's work constructs the face of chilling inhumanity from a ghostly snowdrift of innocence.

If the intention behind the techniques of some recent artists has been to isolate the essence of a subject by breaking the sitter's expression down to irreducible elements, it has been the intuition of notable contemporaries working in the field of photographic portraiture to fashion instead artificial masks in order, paradoxically, to expose the psychological and spiritual tensions of the individual underneath. A significant leitmotif of contemporary portraiture, which has characterized the work of artists such as American photographers Nan Goldin, Dash Snow and Cindy Sherman, as well as Cameroonian photo-portraitist Samuel Fosso, Iranian-born multimedia artist Shirin Neshat and Chinese photographer Zhang Huan, has been the resuscitation of human masking, a creative preoccupation whose ancient origins pre-date Neolithic times. Goldin is best known for her photographic chronicling of drag queens and gay

24 (above left) **Nan Goldin**, *Jimmy Paulette and Tabboo! undressing, NYC*, 1991. Cibachrome photograph

25 (above right) **Rineke Dijkstra**, *Kolobrzeg, Poland, July 26, 1992*, 1992. C-print

culture, a milieu with which her work has been preoccupied since the late 1960s, when the artist was in her teens. For Goldin, the most intense images are those that capture subjects in moments of guarded unguardedness, where an individual is permitted to preserve the careful choreography of his or her transgendered disguise in an otherwise unposed and informal situation. Characteristic of the emotional texture of Goldin's work are her 1991 dressing-room portraits of the celebrated hairstylist Jimmy Paul (drag name 'Paulette'), preparing for a Gay Pride parade. The friction between the fiction of an invented persona on the one hand and the uninhibited gestures and expressions that such contrivance ironically enables on the other is fundamental to the power of Goldin's work.

Where Goldin sanctions cosmetic masking as a means of overcoming camera-induced self-consciousness, Dutch photographer Rineke Dijkstra is keen to document social awkwardness itself. Dijkstra came to public prominence in the mid-1990s with a series of full-length portraits of young beachgoers that she had taken years earlier. An alluring ungainliness of posture and an affecting shyness discernible in her adolescent subjects' expressions force viewers to contemplate the virtue of adult poise and the real value of the masks that society demands we construct.

Goldin's and Dijkstra's eyes would prove influential on the next generation of photo-portraitists and the infectiousness of their lenses' candour can be traced in the strung-out, half-cut countenances captured by fellow New York-based artist Dash Snow. For Snow, however, the veneer of vulnerability that glosses the surface of Goldin's and Dijkstra's portraits has cracked to reveal a brasher foundation, pocked by drug-fuelled excess.

Where Goldin's photographs document the moving, unrehearsed pageantry of spaces that sprawl on the border between private and public identities – the dim anterooms and mirrored dressing tables where individuality is awkwardly forged – Sherman's work is unselfconsciously staged and disconcertingly artificial. Having attracted attention in the 1980s with a series of photographic self-portraits in which the artist adopted the guise of Hollywood starlets from the 1950s and 1960s, Sherman turned her attention to the reinvention of old master portraiture. History Portraits (1988–90) features

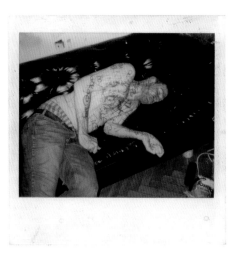

26 **Dash Snow**, *Untitled*, 2000–9.
Digital chromogenic print

28 **Samuel Fosso**, *Autoportrait*
from *African Spirits* series,
2008. Gelatin silver print
on paper

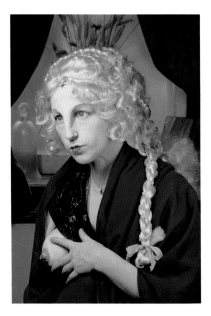

27 **Cindy Sherman**, *Untitled
#225*, 1990. Chromogenic
colour print

29 **Roni Horn**, *You are
the Weather*, 1994–96. 64
chromogenic prints and 36
gelatin silver prints, 100 parts

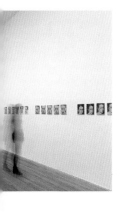

the artist re-enacting familiar vignettes from the canvases of everyone from Raphael to Fragonard, Caravaggio to Jean-Auguste-Dominique Ingres, implying that in a media-saturated society even the highest-brow culture can be furrowed into farcical charade. The results are irreverent subversions of familiar art historical scenes, whose cumulative effect is the suggestion that even the most contemporary of countenances is a carefully rehearsed masquerade of half-remembered attitudes and inherited postures. If, in Goldin's vision, the glamorous cosmetic masks of drag culture are empowering props that help dissolve inhibition – signposts that point to, but do not substitute for, identity – for Sherman the accessories actually comprise the individual. So heavily cloaked in outmoded contrivance are Sherman's subjects that any semblance of innate personality percolating below the surface is obliterated by the thoroughness of the smothering disguise.

Sherman's work has proved enormously influential on the imaginations of her younger contemporaries, and in particular on African artist Fosso, who began his creative career taking passport photographs in the embattled city of Bangui, Central African Republic, promising to make the sitters 'beautiful, elegant, delicate, and easy to recognize'. Before long, Fosso was seizing on the throwaway tail ends of unused film rolls as opportunities to dress up in flashy garb and shoot selfies that he would send back to his mother in Nigeria. By the early 1990s, Fosso had begun to glimpse in such experimentation the profundity of reinventing oneself and creating, if only in a flash, a fresh backstory and future. Now impersonating celebrities from popular culture, now wearing traditional folkloric dress in the guise of an African chief, Fosso's works allowed himself the chance, if only for a fleeting moment, to meditate on a given individual's role in determining the troubled trajectory of his beleaguered homeland. For a celebrated series of self-portraits, *African Spirits* (2008), Fosso choreographed his transient transformation into a cast of cherished cultural luminaries including American former professional boxer Muhammad Ali and former President of South Africa Nelson Mandela.

For American artist Roni Horn, the acclimatization of identity to one's environment took on strangely literal, meteorological dimensions in her 1994–96 photographic series, *You are the Weather*. Comprising one hundred portraits of the same woman posed in different Icelandic hot springs, the

series endeavoured to chart subtle fluctuations in the sitter's mood based on her physical situation. The assembling of so many close-ups of the same face, through which gallery goers were forced to navigate, created an uncanny hall of finely tuned expressions. The cumulative effect on visitors of the ceaseless scrutiny of their every move through the exhibition by the same set of eyes was a disquieting reversal of the artistic gaze, as though the sitter had become the starer and the onlooker, the looked-at.

An elegant inversion of the conventional gallery gaze also occurs in one of the most talked-about works of the era: Serbian performance artist Marina Abramović's inimitable reinvention of the tradition of self-portraiture, *The Artist is Present*, which she undertook in the Museum of Modern Art, New York, over the course of 736.5 hours in the spring of 2010. For that almost inconceivable length of time Abramović, who came to prominence in the 1980s with a series of punishing displays of personal stamina, sat motionless at a table in the museum and invited visitors to sit opposite her and to peer into her eyes for as long as they could bear. Each participant witnessed something that none before or after could: a human being at a perishable moment in her life, sharing the silence of an unrepeatable encounter. Visitors to galleries are of course accustomed to looking deep into the unflinching eyes of a drawn, painted or sculpted fiction that they convince themselves embodies a semblance of the humanity that created it. *The Artist is Present* melted such ritual into reality while poignantly preserving the façade of a portrait's quiet impassivity.

The heavy cloaking of character is likewise at the heart of one of the most arresting photographic projects of the age: Shirin Neshat's series of black-and-white portraits from 1994, entitled *Women of Allah*. After studying in New York during the formative years of her education, a period that coincided with revolution and the rise to power in Iran of the Ayatollah Khomeini, Neshat returned to her native country to find herself lost in a society whose new laws and obligatory customs she scarcely recognized. *Women of Allah* shows the artist in a variety of postures adopting the concealing fundamentalist Islamic dress that was now mandatory for women in public. But the most striking dimension of these portraits was the webbing of the artist's own face with Persian calligraphy. Although Neshat transcribed these extracts over developed

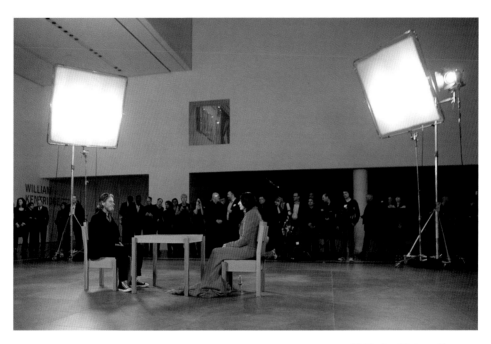

30 **Marina Abramović**,
The Artist is Present, 2010.
Performance at the Museum
of Modern Art, New York,
duration 2.5 months

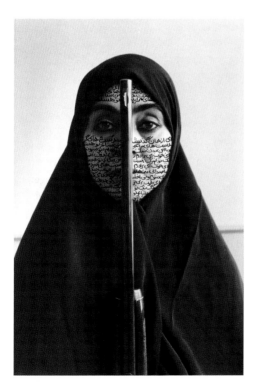

31 **Shirin Neshat**, *Rebellious
Silence*, from the series *Women
of Allah*, 1994. Black-and-white,
resin-coated print with ink

photographs, her handwriting has the appearance of a worn veil of words, a second skin of lyrical assertion whose meaning she knew would be undecryptable to most Western viewers of her work. As with many of the finest portraits of the age, Neshat's photographs emphasize the complex tissue of tensions – political, historical, sexual, religious – from which human identity is fragilely woven.

CHAPTER 2

You Are Here: Seeing Space in Contemporary Art

Since the early 1990s, a seemingly absurd theory about the very structure of the universe has gradually gained acceptance by the majority of the scientific community. According to what is known as the Holographic Principle, the three-dimensional space that we observe in everyday life and everything that it contains (not to mention the galaxies that whirl above us and every floating atom that they hold) are nothing more than elaborate illusions. A cosmic trick of the light transforms data that is inscribed on a two-dimensional screen at the outermost boundary of creation into the luminous phantoms we mistake for a three-dimensional reality. In a sense, the theory is an expensive version of Plato's famous allegory of the cave, in which the ancient philosopher suggests that existence as we comprehend it is a dark pantomime of shadows that only feebly corresponds to a higher reality. Formulation in recent years of such a disorientating hypothesis about the essence of who we are and our relationship to the space around us is bound up with theories about the multilayered nature of space and time: that the universe is in fact played out in nine or more dimensions that vibrate in cosmic harmony and are tied together by mysterious strings.

Against the backdrop of such astonishing discoveries in physics that will forever change the way human beings conceive of themselves and the universe they occupy, it is not surprising that contemporary artists have experimented with notions of both intimate and infinite space. Indeed, among the defining features of human progress over time has been the ceaseless modification in mankind's understanding of its position in the totality of creation: how it figures in the figuring of the universe. Whether one thinks first of the historical coincidence of Christopher Columbus's explorations at the close of the fifteenth century with the apprenticeship of Nicolaus Copernicus and the visionary artistic achievements of Andrea Mantegna, Leonardo da Vinci and Albrecht Dürer, or the simultaneity of Albert Einstein's bending of our concepts of space and time in the twentieth century with Salvador Dalí's mystically melting clocks, the story of art is an endless braid of

seemingly dissonant consciousnesses, of science and the soul. So it is with the era under review in this book. It is remarkable that at the same instant promoters of the Holographic Principle in the realm of theoretical physics have scrutinized our most basic assumptions about the nature of the space we occupy in our everyday lives, and whether or not it is in fact a sophisticated sleight of hand or trick of the light, artists working independently from each other across the globe have begun questioning the essence of that most familiar and precious space of all: the home. Since the early 1990s, the works of Argentina-born conceptual artist Rirkrit Tiravanija, British sculptor Rachel Whiteread, German artist Gregor Schneider and Korean artists Do Ho Suh and Haegue Yang have been exemplary of recent revaluations of domesticity and household space.

For Tiravanija, whose upbringing included years in Thailand, Ethiopia and Canada, before the aspiring artist settled in New York in the 1980s, home has always been a fluid property and one's engagement with it necessarily restless. Fittingly, for over two decades, he has challenged visitors engaging with his work to reconsider where the designation 'home' is physically to be found, by converting the gallery space that his exhibitions occupy into experimental venues that render redundant many of the features of one's own bedsit, apartment or house. In 1990, for a show entitled *pad thai*, Tiravanija transformed a New York City gallery into a makeshift canteen in which he served food to his peckish guests. A decade later, Tiravanija ambitiously amplified the concept for an ongoing series of installations, *Apartment*, for which he constructed working replicas of his own kitchen, living room, bathroom and bedroom. Inviting visitors to rest, socialize and prepare meals in a space that is traditionally reserved for cultural enrichment – distinct from the parameters of quotidian domesticity – the artist arrestingly blurred the boundaries between formal and informal institutions.

Where Tiravanija's work is devoted to the impermanence of domestic action, Whiteread is obsessed by the possibility of preserving the very space within which such ephemeral movement endlessly occurs. The British sculptor came to prominence in the early 1990s with two concrete casts of vacated architectural interiors: *Ghost* (1990) and *House* (1993). For the former, a living room in north London was fossilized in cement so that every contour of the space, from

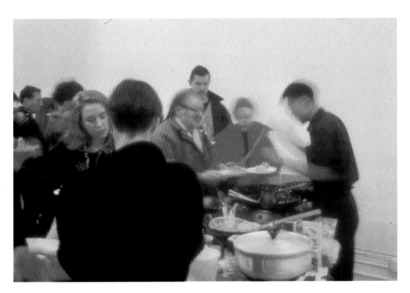

32 **Rirkrit Tiravanija**, *untitled (pad thai)*, 1990. Mixed media

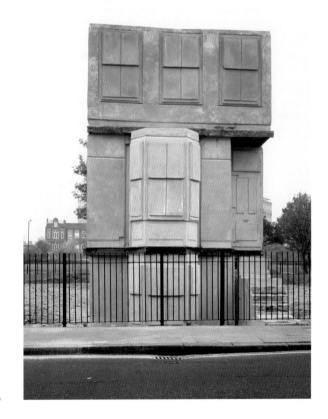

33 **Rachel Whiteread**, *House*, 1993. Mixed media

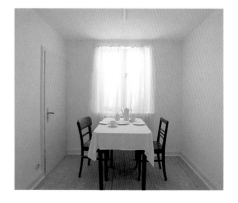

34 Gregor Schneider, *Totes Haus u r*, Rheydt 1985–Venice 2001. Constructed rooms, mixed media

the curve of its skirting boards to the faintest blemishes of its walls, registered permanent impressions in the memory of the cement with which the artist filled the open space. *House* was more ambitious still, expanding the artist's methodology to the scale of an entire urban dwelling: a condemned Victorian house in East London. Demolished in 1994 by order of the city council, Whiteread's work was at once affecting and unsettling, evoking the claustrophobic feel of petrified air, as though the space had fallen victim to a freak catastrophe, or suddenly been solidified by the cooling of an inner lava. To encounter *House* was to be placed in the anachronistic position of a contemporary archaeologist, searching for clues in the ossified air for evidence of who we once were.

The works of Schneider and Seoul-born Suh provoke a similar sense of domestic disorientation. Representing Germany at the 49th Venice Biennale in 2001, Schneider won the prestigious Golden Lion for a work that represented the culmination of experiments with household space undertaken by the artist since the mid-1980s when he was just a teenager. Unlike Whiteread's concrete *House*, whose intensity relied on the stolidity of household memory, Schneider's *Totes Haus u r* (2001) was a complex architectural puzzle of kinetic life-sized rooms, engineered to slip and slide within each other: now concealing a corridor, now exposing a previously hidden room. The result was an elastic floor plan whose unstable coordinates were easily equated to the movement of the mind.

Like Tiravanija, Suh's creative imagination and notions of home have been significantly shaped by pressures of geographic displacement and cultural transit, having moved at an impressionable stage in his development as an artist from Korea, where he first began experimenting with visual expression, to Rhode Island, where he earned a bachelor's degree in Fine Art, to Connecticut, where he undertook an MFA course at Yale, and eventually to New York, where he established a studio. Suh's 2012 public sculpture, *Falling Star* [35], is characteristic of the artist's uprooting vision. The work consists of a small, fully furnished, traditional wood-framed baby-blue cottage, which appears to grow like a curious appendage from the corner of the seventh floor of Jacobs Hall: a much larger, concrete building on the University of California, San Diego campus occupied by the faculty of engineering. The site-specific work has been described by visitors as resembling, from below, Dorothy's house in the

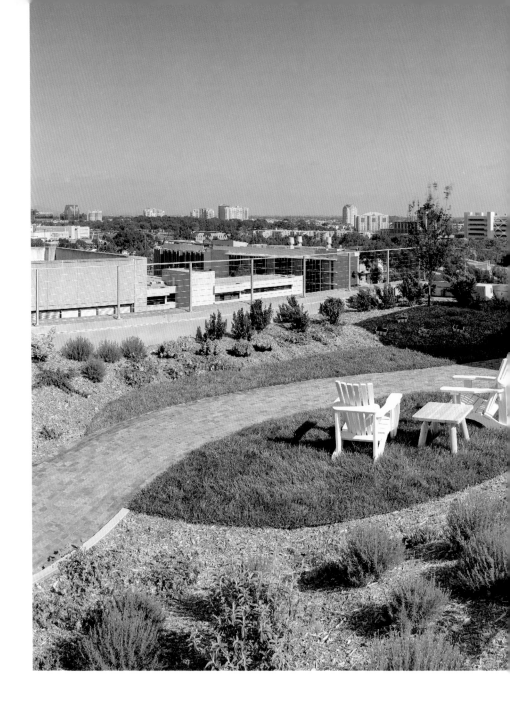

35 **Do Ho Suh**, *Fallen Star*,
2012. Mixed media

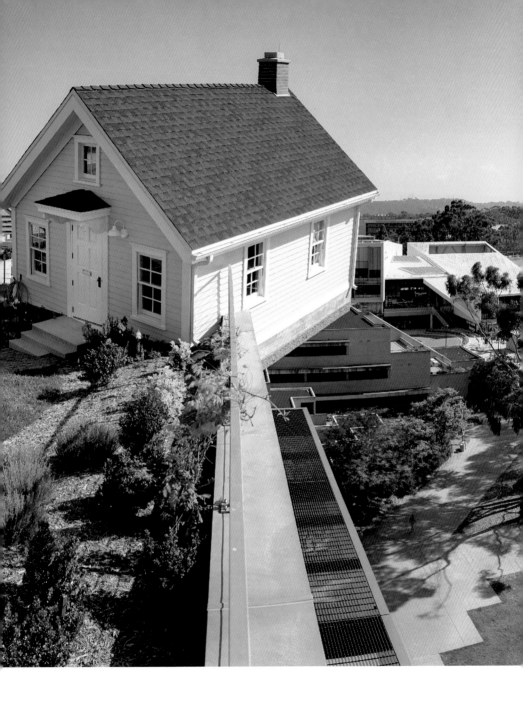

film *The Wizard of Oz* (1939), having been violently whisked into the air by unpredictable forces of nature. In a sense it has: the powerful feelings of existential displacement that sustained homelessness can provoke, especially in college-age students away for the first time from their families and the spaces in which they grew up, are compellingly expressed by Suh's sculpture, whose sloping floors and precarious perch some visitors find too disbalancing to bear. *Falling Star* revisits themes the artist explored in an earlier installation, *Home Within Home* (2009–11), for which Suh constructed replicas of every dwelling in which he had ever resided, variously interpreting those domestic spaces as ghostly blueprints, dolls' houses and small-scale edifices crashing like meteors into the side of larger models.

If home, for Suh, implies a collapsing inward, for fellow South Korean artist Haegue Yang the concept provokes instead a moving outward, a pilgrimage. For her 2006 site-specific installation *Sadong 30*, Yang invited visitors into a derelict property once inhabited by her grandparents in a modest district of Incheon City, near her native Seoul, from which the title of the work is derived. Although the house was uninhabitably run down and strewn with the dusty debris of abandonment, Yang interjected into the dilapidation an incongruous geometry of colourful origami and a scatter of lights. The affecting ornamentation made no effort to redeem the property for occupation, but served merely to honour the spirit of the place in all its slow decay.

Where Suh and Yang prove that mystery and melancholy are valid levers for adjusting our attitudes to domestic space, Austrian artist Erwin Wurm has shown how effective wit can be. A pair of humorous large-scale sculptures, *House Attack* (2006) and *Narrow House* (2010), goes so far as to poke fun at our confidence in the very habitability of a home. For the former, the artist managed to affix an upside-down house haphazardly to the roof of the Museum Moderner Kunst in Vienna, making the smaller structure appear as though it had been flung there from outer space. Looked at one way, the house is an unsightly tumorous growth, bulging malignantly from the institution's crown. Or perhaps the two are intended to be seen as symbiotic: the space of home and the space of culture asymmetrically relying on each other for survival. For the latter work, *Narrow House*, a radical compression of the width of a

home, which in other respects – height and length – appears to be of ordinary scale, has been convincingly achieved. The effect is a crushing of viewers' confidence in the traditional comforts of home: a message that would resonate powerfully across a credit-crunched Europe following the cataclysmic financial downturns of 2007–8.

The latent violence in Wurm's and Suh's senses of domesticity, where familiar structures mysteriously collide, finds more overt articulation in the work of contemporaries such as British sculptor Cornelia Parker and Doris Salcedo, who are less concerned with concepts of home per se than with exploding our understanding of physical constraints of space. In a pair of works executed in the 1990s, Parker assembled the fragments of destroyed structures, suspending in the gallery space the shattered pieces first of a garden shed (for *Cold Dark Matter: An Exploded View* (1991) [38]), which she had had blown up for her by the British military, and then the splintered remnants of a Texas chapel (for *Colder Darker Matter* (1997)), which had been destroyed by a bolt of lightning. The artist's arrangement of the ruinous material such that the structures appear to be endlessly detonated from deep inside themselves imposes upon the gallery a sense of outward propulsion that threatens to overwhelm the visitor, transforming the tranquillity of the meditative space and charging its air with unexpected energy.

A similar assault on visitors' confidence in the safety and stability of their surroundings was waged in late 2007 and early

36 (above left) **Haegue Yang**, *Sadong 30*, 2006. Light bulbs, strobes, chains of lights, mirror, origami objects, drying rack, fabric, fan, viewing terrace, cooler, bottles of mineral water, chrysanthemums, garden balsams, wooden bench, wall clock, fluorescent paint, wood piles, spray paint, IV stand

37 (above right) **Erwin Wurm**, *Narrow House*, 2010. Mixed media

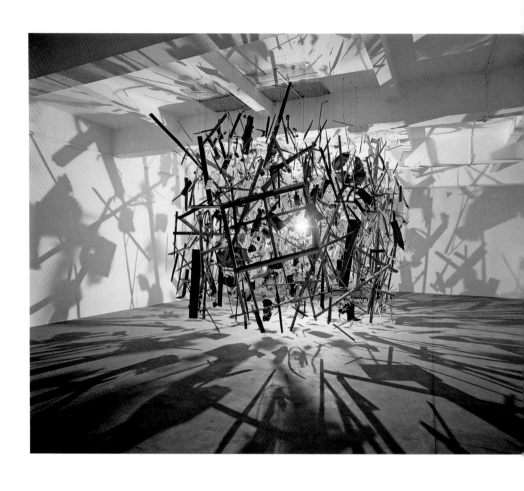

38 (above) **Cornelia Parker**,
Cold Dark Matter: An Exploded View,
1991. A garden shed and contents
blown up for the artist by the
British Army, the fragments
suspended around a light bulb

39 (opposite) **Doris Salcedo**,
Shibboleth, 9 October 2007–24
March 2008. Installation, Tate
Modern, London

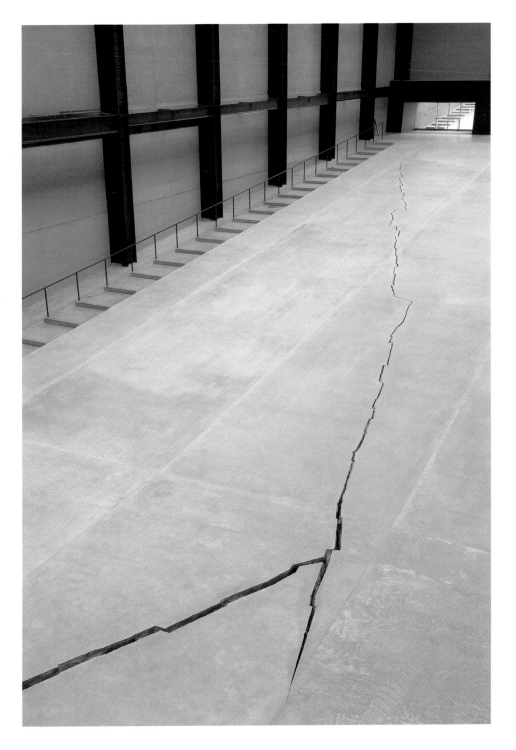

2008 by the Colombian-born sculptor Doris Salcedo, when she installed her controversial work *Shibboleth* in the Turbine Hall of Tate Modern, London, the eighth project to feature in the Unilever Series of annual large-scale installations [39]. The work consisted of a long, deep crevice in the floor of the gallery: a fissure in the institution's foundation that extended the entire length of the hall, or 167 metres (approximately 547 feet). Resembling a seismic scar in the structure's seemingly sturdy groundwork, the destabilizing fracture was ironically a feat of expert engineering, which challenged viewers not only to reconsider the physical integrity of the spaces that they otherwise unthinkingly inhabit, but also the emotional and spiritual, national and economic, gaps that divide human beings.

Where the power of Salcedo's work relies on the illusion of deep structural distress, the strength of Polish sculptor Monika Sosnowska's 2003 work *The Corridor* stems instead from the artist's success in luring viewers into a false sense of comfort in the integrity of their environment. Conceived for the 50th Venice Biennale, Sosnowska constructed what appeared to be nothing more than a lengthy hallway down which visitors were invited to meander. It required more than a few steps, however, before those engaging with the artist's work began to sense a gradual tightening of the walls' grip around them and a slow plunging of the ceiling. In Sosnowska's skilful hands, a future that looked sufficiently accommodating from a distance eventually became intolerably cramped.

Salcedo's and Sosnowska's installations, intended to expose the invisible fault lines that run beneath our most basic assumptions about who we are and the very fabric of the ground on which we stand, are aligned, conceptually, with the work of several artists of the age whose broader aim is to open an aperture into life's darker, more dangerous spaces. Two years after *Shibboleth* smashed the foundations of the Turbine Hall, Polish sculptor Mirosław Bałka took aim at another fundamental dimension of visitors' engagement with the same space with his 2009 installation *How it is*: a huge windowless steel enclosure that stood inside the cavernous gallery on 2-metre (approximately 6-foot) stilts and deprived museum-goers of their ability to see. Entering the deep darkness of the 30-metre-long (approximately 98-foot) chamber by way of the slow slope of an ominous industrial ramp, visitors experienced the horror of sightless containment, which critics variously

40 **Monika Sosnowska**,
The Corridor, 2003. Installation

42 **Monica Bonvicini**, *Stairway to Hell*, 2003. Steel stairs, steel chains, broken safety glass, aluminium plates, spray paint, 'S' hooks, clamps

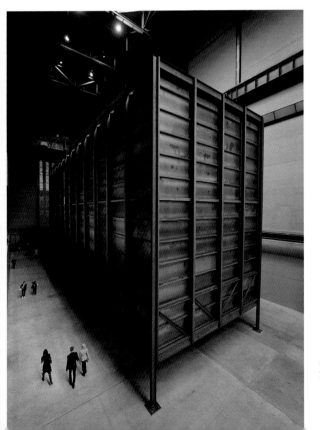

41 **Mirosław Bałka**, *How It Is*, 2009. Steel

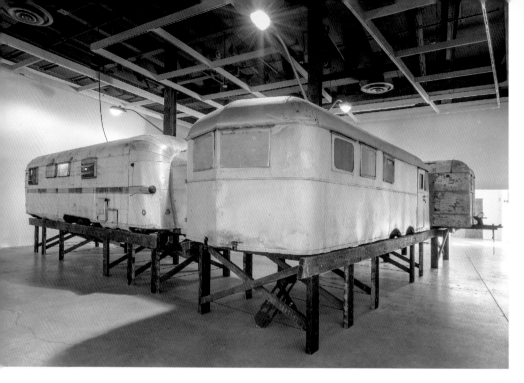

compared to the rounding up of Jews for transport to Nazi concentration camps, or, more recently, the illegal detainment of terror suspects in remote locations on the margins of social awareness for the purpose of rendition.

The unmistakable menace that gathers into the visual vacuum of Bałka's work is compatible with the spirit of Italian artist Monica Bonvicini's 2003 architectural sculpture *Stairway to Hell* [42], which the artist created for the 8th International Istanbul Biennale. At the centre of the work was a utilitarian staircase running between the floors of the pavilion in which the work had been installed. Unsettlingly, however, a dense curtain of heavy chains encompassed the steel steps, which were likewise overlooked by panels of shattered safety glass that appeared to have provided the backdrop to an exchange of gunfire, guerrilla ambush or summary execution. To enter into the work was to find oneself ascending or descending a space of implied violence, disorientatingly removed from the contemplative calm one expects, if not requires, from an art gallery. The movement seemed to many a metaphor for the transition from material space to a sphere of mental or spiritual torment (a shift accommodated by the work's unsettling title).

43 **Mike Nelson**, *Quiver of Arrows*, 2010. Mixed media

Blurring the boundaries between physical and psychological space has been central to the disquieting imagination of British installation artist Mike Nelson. For an ambitious installation in 2010 entitled *Quiver of Arrows*, the artist arranged four shabby caravan trailers into an anti-social quadrangle of shadowy dealings. The grungy interiors were riveted together as connected passageways – holes punched into the flimsy walls – that allowed visitors claustrophobically to chase themselves through the work's seedy tunnels like rats pursued by an exterminator. To move round and round through Nelson's installation was to spin deeper and deeper into the minds of the absent occupants, evidence of whose depraved existences littered the cramped cabins. The intended oscillation of the viewer's attention from the external world of the gallery that hosted an earlier installation to the interior tunnels of troubled minds allegorized by the work was made unmistakably explicit in the title of Nelson's entry for the Turner Prize in 2007: *Amnesiac Shrine, or The Misplacement (a Futurological Fable): Mirrored Cubes – Inverted – With the Reflection of an Inner Psyche as Represented by a Metaphorical Landscape* (2007). The installation constituted the latest phase in an ongoing project that the artist embarked upon a decade earlier, which he based around a fictitious group of Gulf War veterans called The Amnesiacs, whose imagined 'flashbacks' provided, according to the mythology of the work itself, the blueprints for the surreal construction of door frames and the strange alignment of mirrors that comprise the artist's bizarre 'shrine'. While, on their surface, the domestic materials Nelson employs metaphorically invite creative entry and reflective engagement, his are psychically closed systems of signs that ultimately refuse emotional access.

Where Nelson cast a torch down the corridors of psyches on the fringe of social consciousness, prominent contemporaries such as American artists Richard Serra and James Turrell, British sculptor Antony Gormley, and environmental artists Christo and Jeanne-Claude sought instead to redefine the meaning of open public spaces. Serra is renowned for his command of giant sloping walls of rusting Corten steel that incongruously inject a stark dislocating element of geological age into the pristine galleries and manicured municipal squares in which they are erected in cities around the world. The hulking curves of such works as *Torqued Torus Inversion* (2006) [44], whose sloping sides tower over visitors, have been compared to abstracted hulls of

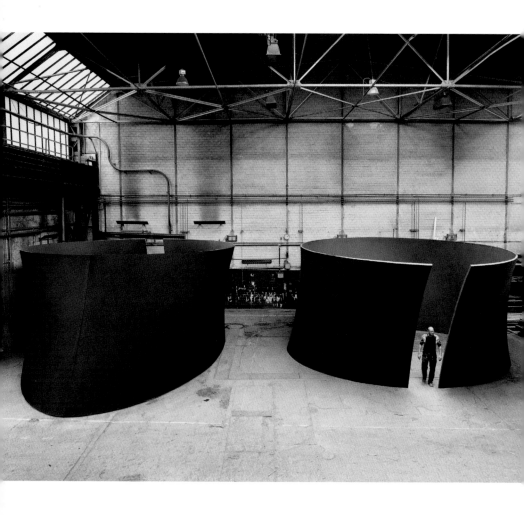

44 (above) **Richard Serra**,
Torqued Torus Inversion, 2006.
Weatherproof steel, two identical
torqued toruses inverted relative
to each other

45 (opposite) **Richard Serra**,
Open Ended, 2007–8.
Weatherproof steel, three
torus sections and three
spherical sections

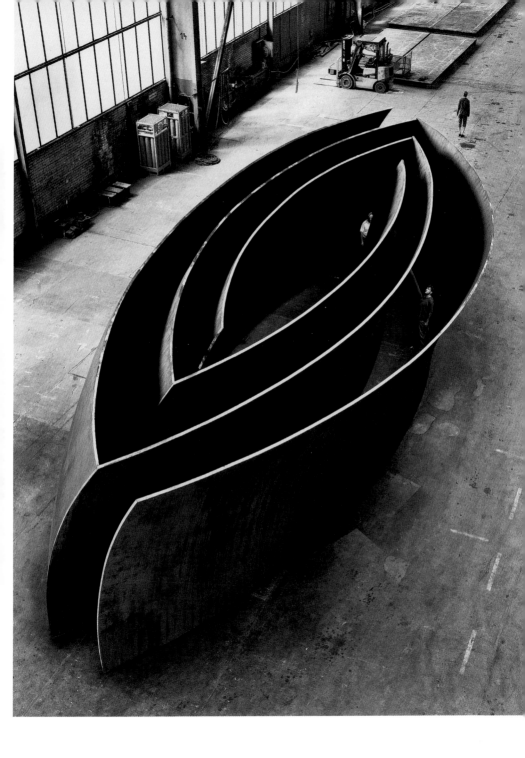

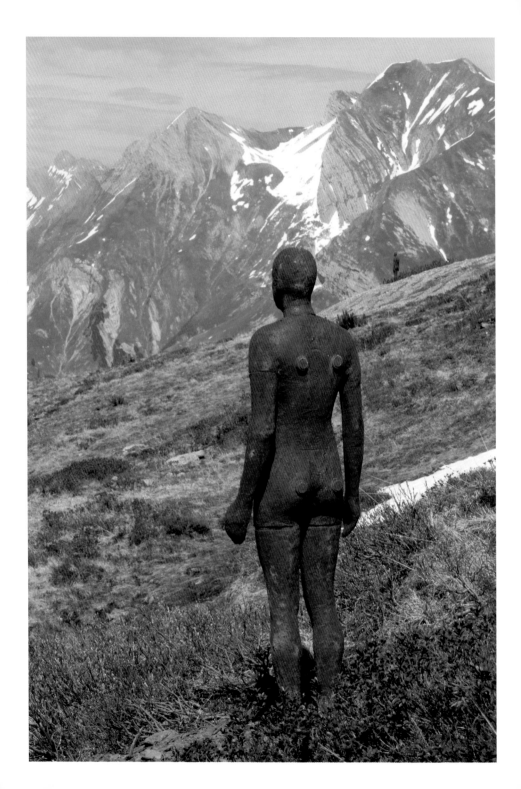

titanic vessels and the distressed scraps of industrial docks. But such analogies fail fully to capture the transcendent power of works whose ability to redefine the intimacy of shared spaces goes beyond any such circumscribed metaphors. His 2007–8 work Open Ended [45] impelled viewers into the central chapel of its elliptical eye-like design by way of a winding labyrinthine path that enforced an uncanny feeling of rotating around an existential emptiness – at once collective and personal – of a very different kind of conveyance from that experienced on a groaning, anonymous passenger liner.

In an ongoing series of installations collectively entitled Skyspace, Turrell likewise directs visitors' eyes upwards, through a wide aperture opened in the ceiling, beyond the confinements into which the audience has initially been lured. The dimensions and interior ambiance of each enclosure changes, depending on the natural contours of the hosting landscape, from a stone-shielded crater in County Cork, Ireland (Irish Sky Garden (1992)) to an LED-illuminated pyramidal tower in Texas, USA (Twilight Epiphany (2012)). The effect is exhilaratingly disorientating, evaporating one's reliance on the relative position of such elemental coordinates as the earth and sky, which feel reversed, as a sense of spiritual oneness with the environment is calmly conjured.

Finding the awkward equilibrium where the individual simultaneously dissolves into and maintains its separate identity is similarly central to Gormley's imagination. For a series of ongoing projects first conceived in the late 1990s, the British artist (best known for his 20-metre-tall (approximately 65-foot) sculpture in Gateshead, England, The Angel of the North (1998)) has crafted hundreds of life-sized, anatomically accurate, replicas of himself (some out of fibreglass, others in iron), which he situated either singularly or in small clusters in cities and along waterfronts across Europe. Another Place was first unveiled in 1997 on a beach in Cuxhaven, Germany, before relocating to littoral situations in Norway, Belgium and eventually Crosby beach in England. For the work Gormley fashioned as many as sixteen iron effigies that were scattered along coastlines, their metallic countenances staring towards the distant horizon, as rising and receding tides alternately overwhelmed and exposed their stoic forms. Ensuing versions of the project under such titles as Time Horizon, Event Horizon and Horizon Field [46] saw the artist install over one hundred

46 **Antony Gormley**, Horizon Field, August 2010–April 2012. A landscape installation in the High Alps of Vorarlberg, Austria. One hundred life-size, solid cast-iron figures of the human body, spread over an area of 150 square kilometres (detail)

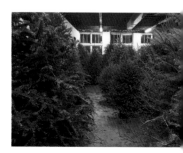

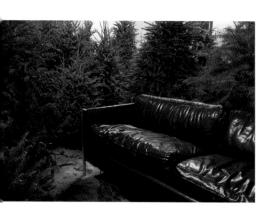

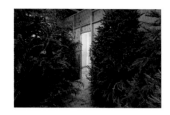

47 Klara Lidén, *Pretty Vacant*,
2012. Plywood, paint, discarded
Christmas trees, grow lights
and couch

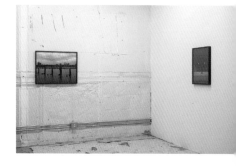

self statues in Calabria, Italy and London, England, and across a wide tundra-like expanse in the Austrian Alps. Where Serra's works reconfigure awareness of public space by establishing powerful psychic enclosures and bold partitions of collective consciousness, Gormley's stark steely self-portraiture suggests instead a material refraction of identity: a ubiquity of being.

If *Horizon Field* seeks to redefine the dimensions of the exterior world by way of a uniquely personal measurement – his own body – with her work *Pretty Vacant* (2012) Swedish installation artist Klara Lidén endeavoured to achieve something of the reverse by ambitiously importing into the finite capacity of a commercial space a significant portion of the great outdoors. Visitors who entered the display through a simple, nondescript door in a temporary wall that divided the artist's New York gallery soon found themselves in a secret Alpine sanctuary surrounded by the sharp, sweet scent of around eighty discarded Christmas trees salvaged by Lidén from the city's streets. Through the makeshift forest's convincing density, a path led the way to a contemplative clearing at the centre and a strange, out-of-context couch on which visitors were invited to recline. To do so was to find oneself evaporated into fantasy, as if transformed into the lounging nude in the preposterous jungle of Henri Rousseau's *The Dream* (1910).

The permeability of the membrane that separates the self from the wider space in which the individual plays out his or her existence (and back into which his or her material form eventually dissolves) is an important trope in the imaginations of environmental art collaborators Christo and his wife Jeanne-Claude, who died in 2009. Since the 1960s, the couple had experimented with various fabrics and cloths in the construction of large-scale interventions into vast public spaces, covering urban bridges, suburban walkways and even a cluster of islands in Miami's Biscayne Bay. Never prescriptive about how they would prefer visitors to interpret their billowing kinetic sculptures, the pair deposited their curious cocoons into the collective psyche as open invitations to spiritual transformation. In June 1995, after decades of dreaming, Christo and Jeanne-Claude undertook to enshroud in 100,000 square metres (approximately 1,076,000 square feet) of pale polypropylene fabric the Reichstag in Berlin, where the official reunification of Germany had taken place five years previously. The imposing building, which was first opened a century earlier to house the

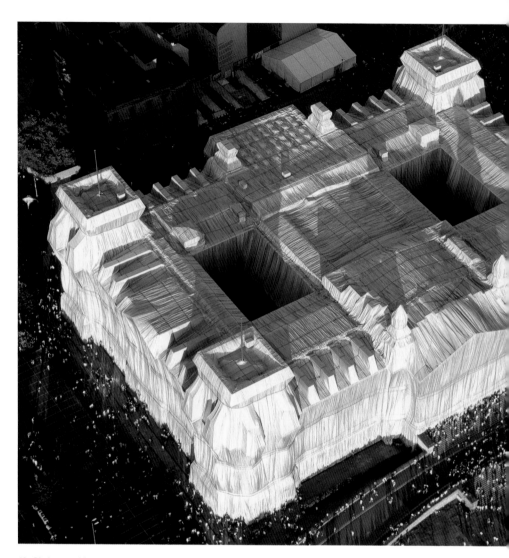

48 Christo and Jeanne-Claude, *Wrapped Reichstag*, 1971–95. 100,000 square metres (1,076,000 square feet) of polypropylene fabric and 15,600 metres (51,181 feet) of rope

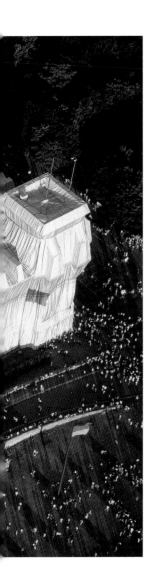

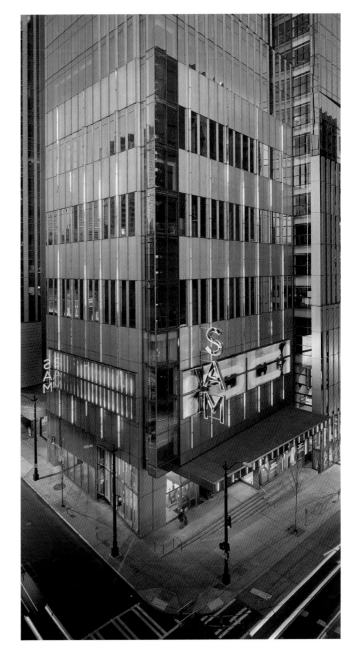

49 **Doug Aitken**, *Mirror*,
2013. Custom software editor
displaying responsive video
on site-specific architectural-
media façade, Seattle Art
Museum, Seattle

Imperial Diet, was on the verge of a major reconstruction for the purpose of accommodating the Bundestag (which eventually convened there in 1999), and many interpreted *Wrapped Reichstag* [48] as symbolizing the rebirth of a nation, articulated in the language of a delicate chrysalis: a structure of powerful yet fragile engineering.

The poetic urge to alchemize the harsh utility of urban architecture into something aesthetically fluid, forcing a reassessment by those who experience it of the solidity of the public spaces through which they move, likewise motivates American multimedia artist Doug Aitken. In 2013, Aiken permanently wrapped the north-west façade of the Seattle Art Museum in a sophisticated LED screen on which are displayed a constantly morphing array of images, whose textures and rhythms are synchronized to the changing tempo of the city itself. The kaleidoscopic work, entitled *Mirror* [49], relies for its liquidity of mood upon a complex system of sensors to gauge the ever-shifting ambiance of Seattle's municipal environment: from roadway congestion to fluctuations in temperature. The calculations are then used to identify images of compatible temperament that are projected onto the restless screen. By harmonizing itself to the collective vibe of the city, *Mirror* transforms a public space into a reflection of our interior selves, offering itself as a communal sanctuary whose coordinates are shared and not imposed. As a two-dimensional metric of our multi-dimensional souls, Aitken's *Mirror* is a kind of alluring inversion of the riddling Holographic Principle, currently wrinkling some of the greatest scientific minds of the age.

The Seen and the Unseen: Death, God and Religion

In May 1990 a distinguished mathematician living in Silicon Valley, who had been diagnosed with terminal brain cancer, initiated litigation in the state of California seeking permission to allow his head to be frozen before he died. Professor Thomas Donaldson, then forty-six years of age, was hopeful that future advances in medical science would lead to a cure for his condition and would eventually make it possible for his consciousness to be reattached to a living body. A lifelong advocate for the low-temperature preservation of tissues, Donaldson had explored in his writings what he called 'neural archaeology': an emergent subfield of science involving the recovery and decryption of dormant human memories from cryogenically stored cells. The first such legal action of its kind ever to be undertaken, Donaldson's lawsuit was motivated by an age-old desire to stall death's unconquerable creep and a conviction that the very notion of dying itself will in time become antiquated. For Donaldson, the competing temperaments of science and of religion shared convergent aspirations: to penetrate an artificial veil of mortality and to realize in real time the resurrection and reunion of material and immaterial selves, body and mind. His determination to challenge preconceptions about death coincides with a key artistic impulse of the age: to test society's assumptions about the fate of our physical and spiritual entities.

For some artists, such as Australian sculptor Ron Mueck, South African painter Marlene Dumas, German filmmaker Christoph Schlingensief and French multimedia artist Philippe Parreno, death's inescapability demands from art utter candour and from the artist a coroner's unflinching eye. A series of unsettling paintings executed by Dumas between 2003 and 2008, including *Measuring Your Own Grave* (2003) and *Skull (of a Woman)* (2005), reclaims in murky puddles of oil on linen the art historical trope *memento mori* (or 'remember that you will die') for a new age. *Dead Marilyn* (2008) [50], which Dumas created in the months after her own mother's death, relies on an autopsy photograph of the deceased film star Marilyn Monroe, who was found dead in August 1962

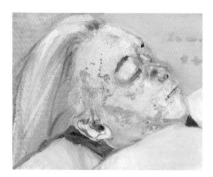

50 Marlene Dumas,
Dead Marilyn, 2008.
Oil on canvas

51 Christoph Schlingensief,
*Diana II – What Happened to Allan
Kaprow?*, 2006. Photograph by
Aino Laberenz

52 Philippe Parreno,
Marilyn, 2012. Film still

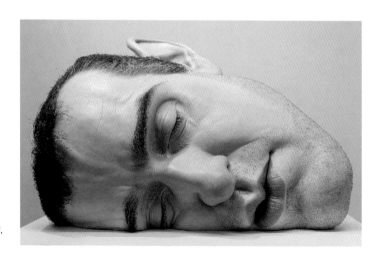

53 Ron Mueck, *Mask II*,
2002. Mixed media

and presents the former sex symbol in the most sensually unalluring of conceivable postures. Splotches of mottled blues pock the actress's bloated, bloodless complexion. *Dead Marilyn* constitutes a startling rejoinder to the eternal glamour that vibrates from Warhol's endlessly replicating silkscreens, implying a vapidity in the perky Pop Art project as a whole that seems only to celebrate the primary colours of youthful vitality.

For Parreno, it is not the starlet's moribund countenance that disturbs the imagination, but an eerie conjuring of her breathy speech and a reconstruction of the spaces in which she once respired. For his 2012 film *Marilyn*, the artist digitally coaxed a semblance of the Hollywood actress's evocative voice that leads the viewer on an intimate turn around a suite of rooms in the Waldorf Astoria hotel, where Monroe was a guest in the late 1950s. Shot from the perspective of the deceased actress's eyes, *Marilyn* allows us to possess the celebrity's body like unexorcized demons. By forcing viewers to adopt the guise of a ghost within a ghost, Parreno hints at all that is haunting and unwholesome about our obsession with figures who can only ever be strangers to us.

Dumas's and Parreno's provocative visions are sepulchrally in sync with Schlingensief's controversial 2006 exhibit *The Last Hour, Diana II*, constructed to recall the circumstances of Princess Diana's death nearly a decade earlier in August 1997 by featuring the crumpled body of a car. An assemblage of paparazzi photographs and a video re-enacting the conveyance of an automobile through a fateful tunnel demanded viewers re-evaluate society's response to the tragic death of a celebrity figure many felt represented the very embodiment of life's dynamism, and to reconcile that existential elevation with the paltry materiality of her mortality.

A similar shift from popular culture to a new sobriety that refuses to blink at the inexorability of death can be traced in the imagination and career of Mueck, who honed his model-crafting skills as puppet maker for children's television and Muppet creator Jim Henson. Whatever lightheartedness characterized the sculptor's earliest work was drained away in the piece that brought Mueck to critical prominence in 1997: *Dead Dad*, an unnervingly lifelike shrunken effigy of the artist's deceased father. Eerily truncated yet anatomically precise, the sculpture seems to teeter discomfortingly between cadaver and toy. Included in Charles Saatchi's 'Sensation' exhibition at the Royal Academy

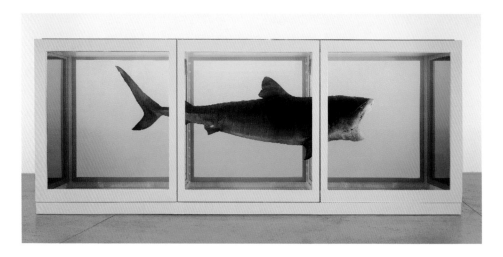

and contributing to the intense controversy surrounding that notorious event, *Dead Dad* was followed four years later by a magnified replica of the artist's own face, entitled *Mask II* (2002) [53]. Expressionless and slumped on its side, the oversized countenance seems suspended between death and sleep, while the work's carnivalesque title appears to comment upon a superficial culture of discarded persona and disposable selves.

Death-in-life and life-in-death are likewise themes stitched tightly into the fabric of works by British artists Damien Hirst and Polly Morgan, who make arresting use of the salvaged carcasses of dead animals. Among the best-known works of the era is Hirst's display of a 14.3-metre (14-foot) tiger shark suspended in a vitrine of five per cent formaldehyde solution, teasingly entitled *The Physical Impossibility of Death in the Mind of Someone Living* (1991). Commissioned by Saatchi, the sculpture, with its serrated grin frozen forever on the verge of a flesh-tearing clench, was a symbol of inconceivable menace, the unfathomability of whose terror could be equated with that of death itself. The friction between the philosophical pretensions of the work's title and the visual achievement of an exhibit that would neither have looked innovative nor out of place in a museum of natural history, sparked considerable debate among critics and casual admirers of contemporary art about the intellectual merit of conceptual art and to what extent it operated in a cultural vacuum, ignorant of the visual language of other disciplines. Hirst ignited further debate with an ensuing exhibition, three years later, of twelve severed bulls' heads displayed in separate vitrines for a series bearing

54 Damien Hirst, *The Physical Impossibility of Death in the Mind of Someone Living*, 1991. Glass, painted steel, silicone, monofilament, shark and formaldehyde solution

the inflammatory religious title, *The Twelve Disciples* (1994). Whether or not the work, which comprised, at first glance, little more than a college laboratory experiment, managed to elevate itself to a higher level of artistic profundity by virtue of its theologically provocative title vexed viewers.

So too did the artist's hands-off approach to the making of his displays, which were often constructed by assistants and contractors. While Hirst's detached process of object production made some query the tolerable ratio of concept to craft in works of contemporary art, Morgan's intimate engagement with the materials with which she explores the unsettling borders where death and life and art collide has made many marvel as much at the artist's technical skill as at her nerve and stomach. An expert taxidermist who assembles sculptures from the preserved remains of woodland creatures, Morgan coaxes from her deceased subjects a mysterious energy of static movement that paradoxically challenges viewers to reassess the physical limitations of life. By rehabilitating the feathered flesh of a robin, for instance, in her work *Morning* (2007), which positions the red-breasted bird in an instant of impossible penetration – triumphantly breaking through a pane of plate glass like a sniper's bullet – Morgan ironically invites visitors to meditate on the aspirations of the soul to pierce the fabric of one realm of existence into a world that lies beyond. The summoning of the detritus of death in order to overcome its fearsome dominion is made more explicit still in a subsequent work, *Carrion Call* (2009), for which Morgan rescues a disintegrating wood coffin, clogging the cracks and

55 **Polly Morgan**, *Carrion Call*, 2009. Taxidermy and wood

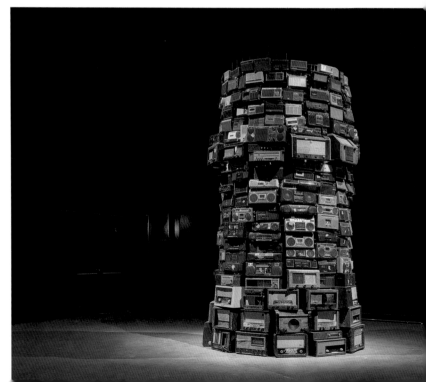

crevices of its rotting seams and sides with clutches of chicks, their boisterous beaks booming silent exultations.

One imagines no such rejoicings, alas, issuing from the dislocated hulk of Argentinian artist Adrián Villar Rojas's sprawling outdoor sculpture *My Dead Family*, which artfully suspends the fabricated decomposition of a 28-metre-long (approximately 90-foot) whale in a remote forest of beech trees. Surreally estranged from its native habitat by forces the viewer is left ineluctably to equate with environmental improvidence on the part of man, the convincing wooden sculpture augurs portentously for the future of every species. Intervening implausibly into the natural world like a revelatory sign, Rojas's carcass crosses the viewer's path like an omen hurled into our reality from a parallel universe: one in which the horrors of our unreconstructed habits have fully been realized.

If *Carrion Call*, with its frozen cries and endlessly interrupted eruptions of life from a vessel of death, and *My Dead Family*, loaded with lethal portent, present themselves as mute symbols for the conduction of energy from a spirit world, recent works by Brazilian artist Cildo Meireles and American installation artist Susan Hiller seek to amplify the conceptual volume of sculptures tuned to the frequency of religious metaphors and the supernatural. Born in Rio de Janeiro, Meireles came to prominence in the 1960s and 1970s as a pioneer of conceptual art and was only twenty-one years of age when he attended, as one of four artists from Brazil, the groundbreaking 'Information' exhibition at the Museum of Modern Art, New York, in 1970, an event widely recognized as seminal in the establishment of the conceptual art movement. An accelerating dimension of Meireles's work since the 1980s has been an oblique spirituality that took the form, in his 1987 installation *Mission/Missions*, of a glittering display comprised, according to the artist, of 'a sky of bones, a floor of money, and a column of communion wafers to unite these two elements.' The work's insinuation of a conversionary current pulsing from a *terra firma* of filthy currency, the life blood of this world, to a stark stratosphere of bones, the disposable scaffolds of departed spirits, is fitted with literal volume in a subsequent work of 2001, entitled *Babel*. Intended to recall the story of the biblical structure with which man hoped to compete with God's elevated position, Meireles's 5-metre (197-inch) tower consists of over 800 functioning radios from different eras, each tuned to a separate frequency.

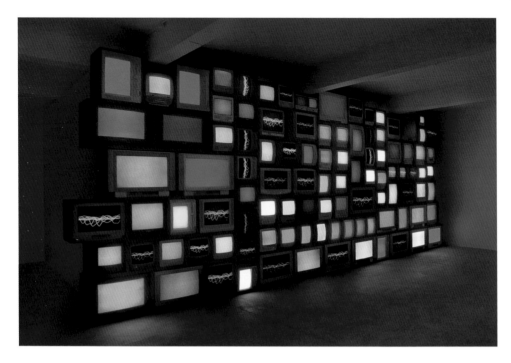

A haunting hubbub of indistinguishable syllables and sounds, *Babel*'s intriguing design, which relies on the positioning of the oldest devices at the bottom of the work and the sleekest, most technologically advanced at its summit, seems like a makeshift contraption from a Hollywood science-fiction film, a gigantic gadget construed to make contact with the great beyond.

Meireles's cacophonous apparatus is curiously in tune with recent works by Hiller, an artist likewise fascinated by the channelling of voices through visually striking circuitry. For her 2010 installation *Witness*, Hiller dangled from a gallery's ceiling hundreds of disc-shaped speakers on cords of varying lengths. To wander through her static shower of electrical strands was to detect whispering, from each disc a garble of accents and idioms, as each small loudspeaker broadcast recordings of eyewitness testimonies of first-hand encounters with alien visitors to our planet. The work was followed in 2013 by *Channels*, a monolith of over one hundred flickering television sets, media players and signal splitters stacked against the gallery's wall: a cliff of clustered technology from whose untuned consoles incorporeal voices attesting to near-death experiences mysteriously murmured. The spooky display of jumbled screens strobing static had the look of a deserted

58 Susan Hiller, *Channels*, 2013. Installation featuring 120–150 televisions, DVD players and splitters

space centre control room, or the medical monitors of an ersatz emergency tent assembled on the margins of an urban catastrophe. While the disembodied narratives were recorded by survivors, in Hiller's work they seem to conjure themselves from an unreachable elsewhere.

Where Hiller has described *Channels* as a work that addresses 'some of the gaps and contradictions in our modern belief system', notable contemporaries have been preoccupied with confronting the customs, icons and institutions associated with older more traditional systems of religious belief. British-Nigerian-born artist Chris Ofili's portrait of a Black Madonna, for example, entitled *The Holy Virgin Mary* (1997), sparked international outrage when it was shown at Saatchi's 'Sensation' exhibition in 1997. Particularly offensive to many viewers of the work were the glossy cut-outs from pornographic magazines of female genitalia that encircled the central figure and the crusty clump of elephant excrement that he fastened to the canvas in the position of Mary's exposed right breast. Some interpreted the vulgarity of the work's elements sympathetically and saw them as representative of a debased world of rampant exploitation requiring salvation. Others cried blasphemy. Not since Andres Serrano's inflammatory photograph of a plastic crucifix submerged in a phial of the artist's own urine did a contemporary religious work excite such vehement protest from the public.

It would be another four years before an artwork truly left gallery goers aghast by perceived sacrilege. In 2000, Italian sculptor Maurizio Cattelan shocked Catholic communities when he unveiled his theatrical installation *La Nona Ora* [59], which featured a life-sized model of Pope John Paul II gripping a ceremonial sceptre as he is struck by a meteorite. The cosmic clod is seen pinning the crumpled pontiff to a red carpet strewn with shattered glass. For Cattelan, the sculpture is not an expression of disdain for the Church or the papacy, but an acknowledgment of the coexistence of those structures with complex social and psychological forces that remain outside their control. 'I'm trying to connect images and tensions', Cattelan has explained, 'to bring together different impulses: I want religion and blasphemy to collide.'

Also fascinated by the unlikely merging of the holy and the horrifying is Irish-Austrian artist Gottfried Helnwein, whose series of hyperrealist paintings *Epiphany I (Adoration of the*

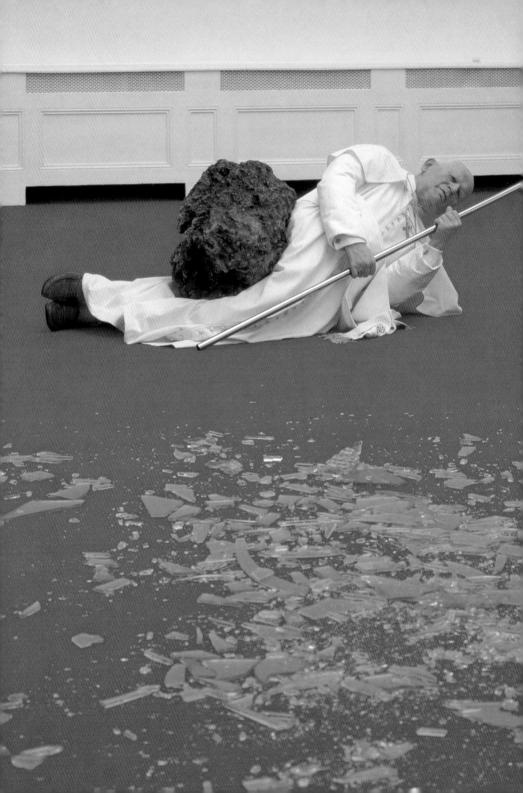

59 **Maurizio Cattelan**,
La Nona Ora (*The Ninth Hour*),
1999. Polyester resin, painted
wax, human hair, fabric, clothing,
accessories, stone and carpet

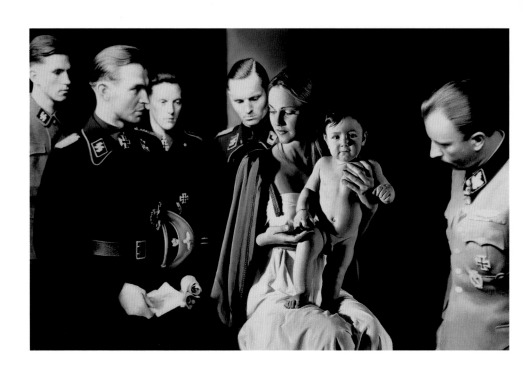

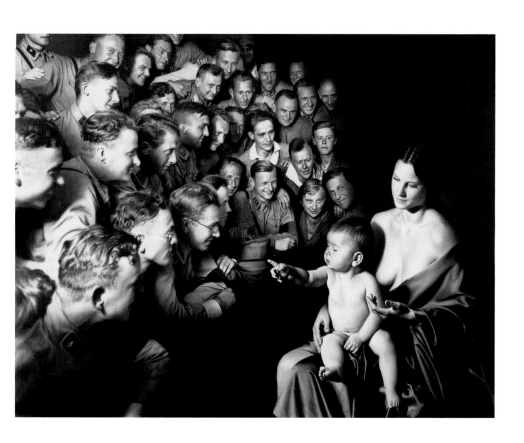

60 (opposite top)
Gottfried Helnwein,
Epiphany I (Adoration of the
Magi), 1996. Mixed media:
oil and acrylic on canvas

61 (above)
Gottfried Helnwein,
Epiphany II (Adoration of the
Shepherds), 1998. Mixed media:
oil and acrylic on canvas

62 (opposite bottom)
Gottfried Helnwein,
Epiphany III (Presentation at
the Temple), 1998. Mixed media:
oil and acrylic on canvas

Magi), Epiphany II (Adoration of the Shepherds), Epiphany III (Presentation at the Temple) [60, 61, 62], undertaken between 1996 and 1998, collapsed conventional choreography associated with the Christian narratives in traditional old master paintings with the historical set design of German Nazism. *Epiphany I* uncomfortably restages the unmistakable postures of Medieval and Renaissance depictions of the Madonna and Child in the anachronistic context of late 1930s or early 1940s Germany. In the role of the three attendant Magi, a clutch of SS officers, gazing adoringly at the Aryan miracle of mother and messiah, have been cast by Helnwein, whose monochrome palate swaddles the scene in the chilling light of a holocaust documentary. Most disturbingly of all, the countenance of the venerated child bears an unnerving resemblance to Adolf Hitler, a sinister sleight of brush that upends the viewer's sense of historical balance.

In addition to such disorientating challenges to traditional religious statements, the age has also been witness to the wide-ranging techniques of artists – from the minimalist crucifixions of Scottish painter Craigie Aitchison to the slow-motion mastery of American video artist Bill Viola – whose achievement has been to reinvigorate symbols of Christian faith. The suffering Christ in Aitchison's countless depictions recalls the whittled stick-figuration of L. S. Lowry set against a visionary luminosity reminiscent of Mark Rothko's otherworldly veils. The austere merging of primitive form with timeless abstraction strips bare a fatigued iconography upon which so much cultural patina had encrusted itself after centuries of veneration, as if returning the visual language to its irreducible accents of flesh and spirit.

A far more jarring recontextualization of the Passion story and of the symbol of the crucifix in particular troubles the hazy horizon of Cuban landscape painter Tomás Sánchez's anachronizing vision of Biblical Golgotha, or 'the place of skulls', where the torture and execution of Christ occurred. Clogging the sloped foreground of *To the South of Calvary* (1994), and consuming three-quarters of the entire canvas, is a frozen flood of consumer waste. Bin bags bulging with rubbish, crumpled cans and broken wheels, a tangle of abandoned barbed wire and a rusted bucket dissolve into a patternless mosaic of unconscionable litter, while the hobbled perspective of a discarded wooden ladder, dumped haphazardly to the viewer's

63 **Craigie Aitchison RA**,
Crucifixion August, 2008.
Oil on canvas

64 **Tomás Sánchez**, *Al Sur del
Calvario* (*To the South of Calvary*),
1994. Acrylic on canvas

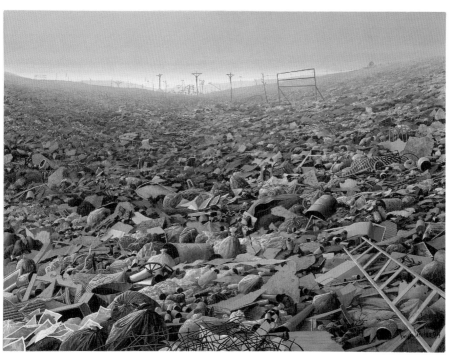

right in the foreground, ironically offers the eye its only lift by pointing in the direction of what the artist has insinuated in the smog hanging in the distance: a rehearsal of Christ's salvation in a world drowning in its own material decadence.

At the forefront of Sánchez's cluttered landscape, among the acres of unrecycled waste, lies a twisted wad of metal fencing that foreshadows a subsequent restaging of the crucifixion, seventeen years later, by Algerian-born French conceptual artist Adel Abdessemed. Wrought from twists of razor wire, Abdessemed's sculpture, *Décor* (2011–12), recalls the broken posture portrayed in Matthias Grünewald's sixteenth-century Isenheim Altarpiece, which Abdessemed encountered on a formative excursion while studying at the École Nationale des Beaux-Arts in Lyon. By supplanting the fragility of Christ's ephemeral flesh with the sturdiness of a material that enforces distance and inflicts pain, Abdessemed has created a profoundly ambiguous symbol of devotion that is at once pitiful and to be feared: a God who cuts both ways.

A comparable, though far less excruciating, ambition to reinflect artistic enunciations of the past motivates the videos of Viola. His 2002 work *Emergence* melts into movement a fifteenth-century fresco by Masolino da Panicale, which imagines the moment of Christ's Resurrection. Viola's nearly twelve-minute video, which was filmed at seven times the normal speed to enable a slow-motion playback, records the gradual appearance of a man's body from his submergence deep inside a watery cistern as well as the astonished reaction of two female bystanders who witness the miracle. At once investing movement in a static antecedent while slowing the elapse of real time down to a visual object, Viola's video manages to sculpt a fresh urgency from an artefact whose significance may have grown stagnant in the eyes of some viewers.

The measured buoyancy that lifts Viola's *Emergence* into existential exigency, as death evaporates in the spirit of the risen Christ, might be compared to the deceptively frivolous effervescence of a work created by the Mexican multimedia artist Teresa Margolles only a few months later. At first sight, *En el aire* (*In the air*) (2003) [67] seems to consist of nothing more than the jocular generation of soapy bubbles into an otherwise vacant gallery. But the water with which the artist has filled her machines is perfumed with an unexpectedly poignant backstory, having been used first to clean dead

65 (opposite top) **Adel Abdessemed**, *Décor*, 2011–12. Razor wire, four elements

66 (opposite bottom) **Bill Viola**, *Emergence*, 2002. Colour high-definition video rear projection on screen mounted on wall in dark room

bodies after autopsy. In Margolles's work, the sudsy exuberance
one associates with an infant's bath floats full circle in the playful
wafting of bubbles within the austerity of a public space associated
more with cultural refinement than light-hearted joy. The fragile
materiality of the work's display, moreover, and its delicate ballet
of weightlessness and evaporative dispersion, invites visitors to
ponder their own expectations about the eventual diffusion of
being after all the machines are switched off.

67 **Teresa Margolles**, *En el aire*
(*In the air*), 2003. Installation with
bubble machines producing
bubbles with water that has
been used to wash dead bodies
after autopsy

**Streets and Struggles:
Uprisings and Unrest**

According to popular legend, one of the most courageous artists of the age suddenly disappeared in 1990. Whether merely banned from making new works or, as is more likely the case, executed by state authorities in his native Burma, the engraver (whose name has escaped historical record) is responsible for creating a work whose simplicity belies its complex cultural significance. The artwork in question – a currency note with a face value of less than one cent – was conceived around the time that the military junta in Burma refused to relinquish power to the party that had legitimately won the country's recent general election in May 1990 [68]. Sympathetic with those agitating for democracy, and in particular with the opposition figure Aung San Suu Kyi (who was put under house arrest immediately following the election), the artist who was selected to design the new one kyat note for the ruthless regime resolved instead to do what he could subversively to advance the cause of reform. In a blank space reserved for the note's watermark, the artist concealed an otherwise invisible portrait of Aung San Suu Kyi, discernible only when held up to the light. More brazenly still, he stencilled, at the very centre of the note, a stylish allusion to the memorable countercultural date, 8/8/88, on which the democratic uprising had begun two years earlier: an elaborate floral pattern comprised of four eight-petal blossoms, each embedded within the other to create the impression of an endless rippling-out of hope. The clandestine tributes were quickly recognized by the silent majority of the nation's democrats for what they were: a rebellious rallying cry that refused to allow the aspiration of freedom to be devalued or to fall out of currency. The fearless spirit of the anonymous draughtsman, who was eventually silenced for his defiant design, is emblematic of a disposition among artists of the age to spike their works with political messages not always detectable on initial inspection: levels of meaning capable of converting the value of the work's significance from the perishable to the enduring.

The Chinese conceptual artist Ai Weiwei has been a pioneer of the new dissidence, creating objects that measure the cultural cost of his native country's rapid industrialization. A series

68 Anonymous, *One-kyat Note*,
1990. Burmese banknote with
altered watermark showing
forbidden image of Aung San
Suu Kyi. Monetary note from
Myanmar, Burmese; twenty-
first century

69 (opposite top) **Ai Weiwei**, *Dust to Dust*, 1998. Thirty glass jars with powder from ground Neolithic pottery (5000–3000 BC), wooden shelving

70 (opposite centre) **Zeng Fanzhi**, *Tian'anmen*, 2004. Oil on canvas

71 (opposite bottom) **Cai Guo-Qiang**, *Desire for Zero Gravity*, 2012. Gunpowder on canvas

of works undertaken since the mid-1990s reveals the artist's displeasure at what he sees as the gradual erasure of China's past in favour of economic competitiveness. For *Coca Cola Vase* (1997), Ai Weiwei defaced a 7,000-year-old Neolithic urn by embossing it with the soft-drink manufacturer's familiar logo. In doing so, he reinvigorated the moribund notion of the Duchampian readymade – whose potential Pop Artists such as Andy Warhol had all but drunk dry – by refilling it with a sardonic verve all its own. Where Warhol celebrated an equanimity of style and utility in the readymade, Ai Weiwei challenges viewers to contemplate the consequences of uncurbed commercialization of resources to a people's heritage, customs and identity. The artist, who was detained by Chinese officials in 2011 on allegations of 'economic crimes', amplified the volume of protest in his 1998 work *Dust to Dust*, for which thirty cheap glass kitchen jars were filled with the pulverized remains of crushed Stone Age ceramics before being placed in separate cubby holes in a large wooden bookcase. As with many of the artist's works, *Dust to Dust*'s meaning relied on a profound absurdity in its construction: the rendering useless of that which was once durable and beautiful for the purpose of showcasing that which is inherently ruinous and disposable.

The work of Ai Weiwei's compatriot, Chinese painter Zeng Fanzhi, is likewise a jarring collision of past and present consciousnesses. His large 2004 painting, *Tian'anmen*, is a palimpsest of overlaid iconic images from recent eras: the public square in Beijing where student protests in 1989 (when Zeng was still in art school) were violently suppressed by the government, and an impassive portrait of the communist revolutionary Chairman Mao, founder of the republic. On the clotted surface of Zeng's painting, the two incongruous images compete for legibility, the superimposition effectively cancelling the coherence of each. The result is a powerful work of muddled identity that fails at once to make transparent sense of its past or to provide any way out of it.

Anxieties about China's propulsion into the future also complicate the message of *Desire for Zero Gravity* (2012), a six-panel wood screen created by Cai Guo-Qiang. On its surface, the work, whose form calls to mind traditional free-standing furniture screens from eighth-century BC China, tells the enchanting story of the minor Ming Dynasty official Wan Hu, who endeavoured to become the first human being to be launched into space by exploding forty-seven rockets beneath

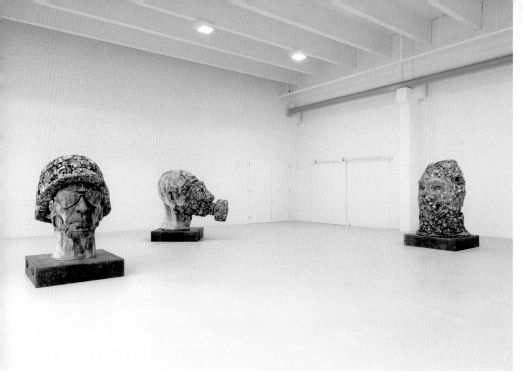

his chair before a crowd that included the emperor. By electing to inflect his depiction of the momentous scene by igniting gunpowder strewn across the six screens, thereby scarring the work with the charred shadows of actual pyrotechnic trauma, Cai Guo-Qiang highlights the likely physical fate of his forebear, who would have met a grizzly end attempting to defy gravity without having correctly calculated the risks. That the artist's allegorical work was commissioned by and unveiled in the Museum of Contemporary Art, Los Angeles, within a wider community that ceaselessly struggles to control gun violence between gangs, *Desire for Zero Gravity* absorbs into its assaulted skin social and political implications that propel the antiquated story into the here and now.

Similar tensions between the everyday utility of a work's constituent materials, such as vases and screens, and the broader political message that it conveys are discernible in the sculptures of Indian artist Subodh Gupta. The power of many of Gupta's works originates in the political friction and nuclear stalemate that have arisen between India and Pakistan. Most notable is his enormous stainless steel sculpture, *Line of Control* (2008) (so-called after the disputed hinterland between Kashmir and Pakistan), which, comprised of ordinary

72 **Subodh Gupta**, *Gandhi's Three Monkeys*, 2007–8. Bronze, old utensils and steel

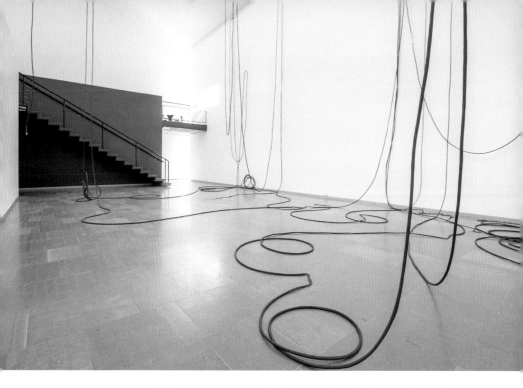

kitchen pots, pans, and cake tins, takes the alarming form of a billowing atomic mushroom cloud. Other works, such as his 2007–8 series of sculptures *Gandhi's Three Monkeys*, are more beguiling and manage to transcend the language of local conflict. As with *Line of Control*, the three works that comprise the series are assembled from a dense jumble of domestic kitchen implements – including mixing bowls and tin tumblers – wadded into large busts of three men wearing, respectively, a balaclava, a helmet and a flute-snouted gas mask. Representing the virtuous postures described by Mahatma Gandhi in his famous ideal of peaceful detachment – 'The three wise monkeys: see no evil, hear no evil, speak no evil' – Gupta's busts are a surreal tangle of domestic, philosophical and militaristic symbols.

It is difficult to avoid detecting from Gupta's use of objects traditionally associated with the expectations that society places on females in the home, a comment too on the changing role of women in India's political landscape: a theme that energizes the imagination of installation artist Sheela Gowda. For an elliptically entitled work undertaken in 2007, *And...*, Gowda dyed over 270 metres (880 feet) of thread an angry arterial crimson before dragging its livid length, over and over, through the eyes of needles. She then draped the distressed strands in dishevelled

73 **Sheela Gowda**, *And...*, 2007. Thread, needles, pigment, glue and three cords

74 **Francis Alÿs**, *Paradox of Praxis 1 (Sometimes Making Something Leads to Nothing)*, 1997. Documentation of an action, Mexico City, Mexico. Video

garlands against the walls of the galleries in which the work was exhibited, while allowing some of the sinew to wad into unnerving nests on the floor. Pulsing through the fibres was a quiet violence that spilled out into a clutch of needles dangling from its end like a makeshift masochistic cat-o'-nine-tails. The dye used to colour the thread, made from dried turmeric or saffron and known as *kumkum*, figures significantly in Indian tradition, and is customarily given to women and girls on the threshold of a domestic existence as a blessing. In *And...*, Gowda stretches the symbolism out of shape, suggesting perhaps that what was once considered a benediction might now be a curse: a soft shackle that must be ripped loose if true gender equality is ever to be achieved.

Gowda's sculpture relies for its effect on the observer's ability to equate the tedium of dragging a thread through a needle's eye with the plight of women, both domestically and politically, thereby not merely aligning its methodology with the tradition of Process Art – a movement that began in the 1960s emphasizing the making over the made – but relocating that movement in a political context. For Gowda and for several notable contemporaries such as Spanish artist Santiago Sierra, every process of creation is necessarily a political act and every motion a manifesto. In 1999, Sierra hired, for a minimal wage, a group of unemployed labourers to shove blocks of concrete around a gallery, recalling the absurd expenditure of effort that defined a work created two years earlier by Belgium-born artist Francis Alÿs's, *Paradox of Praxis I (Sometimes Making Something Leads to Nothing)*, for which Alÿs pushed a huge mass of ice around the streets of Mexico City. In Sierra's mind, the work on show was not the unsculpted objects that the men gruellingly inched across the floor, but the pointlessness of the strenuous effort itself, whose commission by the artist was intended, like Alÿs's work, to call attention to the frivolous waste of life and effort that is demanded of the poor by the rich everyday across the world. A work undertaken the following year, *Person remunerated for a period of 360 consecutive hours* (2000) [75], required the participation of an individual willing to be incarcerated behind a wall for over two weeks, connected to the outside world by only a small slot through which food could be passed.

Some viewers struggle to sympathize with Sierra's methods, arguing that his collusion in the exploitation of vulnerable and

desperate workers, albeit in the service of exposing broader abuse, constitutes, at best, a naive double standard. Mapping the difficult line that separates courageous representation of mistreatment from complicity in that behaviour, although in a very different context, has likewise defined the work of American installation artist Kara Walker. By reintroducing into contemporary aesthetic vocabulary the austere silhouette – simple shadowy cut-outs of objects and figures set against a pale background, the fashion for which evaporated at the end of the nineteenth century with the introduction of photography – Walker lit upon a profound form for discussing the complexities of black and white relations in America. In wall-sized works such as *Gone* (1994) and *They Waz Nice White Folks While They Lasted (Says One Gal to Another)* (2001), the artist's silhouettes rely for their emotive effect on the visual echoing of racial typecasts. But in the static staging of Walker's ambiguous dramas, form and meaning come together in a closed system of remarkable control: 'the silhouette', Walker has explained, 'says a lot with very little information, but that's also what the stereotype does'.

The deceptive simplicity of Walker's silhouettes, which mounts a sophisticated challenge to racial stereotypes, might be compared with the streetwise efficiency of British urban artist Banksy's reinvention of the graffitist's stencil, which likewise forces viewers to reassess cultural clichés. Wry and politically subversive in their motivation, Banksy's nocturnal defacements of public walls frequently undermine the folksy platitudes and saccharine slogans we unreflectively utter every day, but which linguistically short-circuit more profound

75 (above left) **Santiago Sierra**, *Person remunerated for a period of 360 consecutive hours*, 2000. Installation

76 (above right) **Kara Walker**, *They Waz Nice White Folks While They Lasted (Says One Gal to Another)*, 2001. Cut paper and projection on wall

meditations on the horrors of the status quo. A recurring trope in the artist's work has been the apparent intervention into what appears to be pre-existing vandalism – graffiti within graffiti. The cursively inscribed quotation from Ridley Scott's film *Gladiator* (2000), for example, 'What we do in life echoes in eternity', seems forever in the process of being scrubbed from the wall by a mirthless city official, apparently unappreciative of his role in rendering incongruous the soulful aphorism.

Ceaselessly self-ironic, such as in his self-deprecating assertion 'If graffiti changed anything – it would be illegal', Bansky's mischievously anti-authoritarian maxims (for example, 'Sorry, the lifestyle you ordered is currently out of stock'), taken together, constitute a kind of informal archive of civil cynicism. Hooded and operating only under cover of anonymizing darkness, Banksy has skilfully cultivated an alluring mystique within the established art world. For those who believe the urgency and integrity of his work is tied to its illicitness, Banksy's artistic credibility remains contingent on a self-imposed exile to the fringes of society.

The status of Banksy's legitimacy as a credible cultural spokesman, which relies paradoxically on the illegitimacy of his artistry, is in accord with the instincts of other image makers of the age, including Lebanon-born Walid Raad and Palestinian Khaled Jarrar. Raad adopts comparable strategies of evasion when discussing the inception and objectives of The Atlas Group Archive [78]: an organic on-going collective of multimedia records that claim to document the recent history of Lebanon. Compiled and curated by an imaginary scholar, Dr Fadl Fakhouri, the library is in fact a fiction: an elaborate forgery whose very

77 Banksy, '*What We Do In Life Echoes In Eternity*' , 2013. An artwork created by British graffiti artist Banksy in Queens, New York

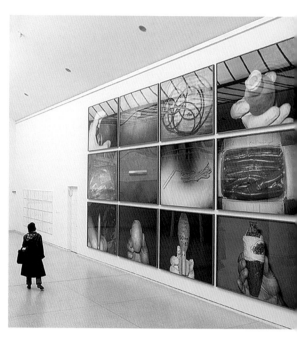

79 **Khaled Jarrar**, *State of Palestine stamps*, 2011. Postage stamps

80 **Yael Bartana**, *First International Congress of the Renaissance Movement*, 2012

contrivance brings into focus the absence of historical authority in the country. Similar motivations invigorate the imagination and initiatives of Jarrar, who designed in 2011 an unofficial state stamp for the officially stateless Palestine, which he impresses into passports of visitors to Ramallah. Although Jarrar's unauthorized stamp and the material that comprises Raad's Atlas Group initiative – including fabricated literature, photographs and videos – may be counterfeit, the essence of social trauma, tragedy and triumph they seek enduringly to document are nevertheless authentic. Indeed, the very inception of their works challenges visitors to the galleries in which Jarrar's stamps are issued or installations of Raad's archive have been displayed to redefine the role of the artist as a catalyst in generating souvenirs of cultural consciousness.

For Israeli-born Yael Bartana, the artist's responsibility goes beyond the mere manufacturing of material objects and involves the mobilization of an entire people. In 2012, Bartana convened the *First International Congress of the Renaissance Movement*, with the aim of re-establishing the eradicated community of Jews living in Poland. Convinced that enough time has passed since the genocide of the twentieth century, the artist has committed herself to helping realize the migratory resettlement of nearly three and a half million people to the European neighbourhoods from which they were violently expelled. The repopulating of a state as an aesthetic objective courageously challenges traditional notions about the nature of artistic pursuits.

An innovative recalibration of what constitutes artistic perspective is likewise fundamental to Polish filmmaker Artur Żmijewski, whose 2009 collection of twenty-three short documentaries, *Democracies* [81], sought to capture the broadest range of public temperament and behaviour at social gatherings across the globe. Displayed simultaneously on separate monitors, these films purported to provide viewers with candid apertures into local customs and congregational instincts. But the extent to which the presence of the artist and his lens unwittingly manipulate the events they seek unobtrusively to record is nevertheless a concern that remains at the forefront of Żmijewski's ambitious work.

Similar anxieties about how society consumes foreign affairs and remote conflicts are at the heart of Paris-born multimedia artist Cyprien Gaillard's 2007 film *Desniansky Raion*. Among the arresting sequences that comprise Gaillard's work

82 (right) **Cyprien Gaillard**, *Desniansky Raion*, 2007. DVD with soundtrack by Koudlam

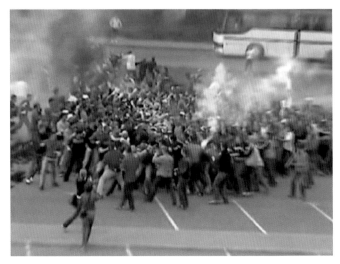

81 (below) **Artur Żmijewski**, *Democracies*, 2009. Single-channel video, projection (or to be shown on twenty flatscreens)

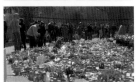

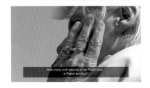

is a violent clash between two gangs of individuals outside a housing estate in St Petersburg, whose ideological, political or religious positions are left unexplained and who appear to have assembled for no other reason than the opportunity violently to vent their rage by engaging in a lawless public brawl. One of the two groups, consisting of scores of individuals, is dressed chiefly in denim and shades of working-class blue, while the other clan, of approximately equal size, is clad predominantly in red. Choice of attire is all that appears to distinguish the warring populations as an affectingly shaky handheld camera captures an unscripted opera of punches, smoke bombs and black eyes, set to the pulsing rhythms of French composer Koudlam's entrancing original score. Without knowing what is at stake or what initially provoked the conflict, viewers of Gaillard's work can form neither an intelligent opinion about the justifications for the unrest nor any preference for its outcome. As such, the video is a mesmerizing metaphor for the absurdity of a culture addicted to fleeting and superficial media coverage of fracas around the world whose complexities it rarely has the patience adequately to unravel and understand.

The cultural restiveness that troubles Gaillard's work, shuttling as it does from Serbia to Russia to France, similarly disturbs German artist Franz Ackermann's *African Diamond* (2006), created the year before. A curious compression of three-dimensional sculpture and two-dimensional painted surface, the work is the very embodiment of creative (and colonial) agitation. By constructing the work in the allotropic

83 **Franz Ackermann**,
African Diamond, 2006.
Mixed media on wood

shape of an enormous precious stone, the artist raises issues of complicity in the exploitation of Africa's natural resources and its people. Enveloping the polyhedral faces of the work is an enrapturing collage of indecipherably stylized shapes and what appear to be trails traced by a frantic adventurer on a treasure map, leading the eye anxiously from one side to the other, without ever establishing the coordinates of a coherent expedition. The ingenious aesthetic result is a visually cumbersome work around which the observer is forced awkwardly to spin, but is ultimately frustrated from ever seizing.

Implicitly compressed into the meaning of Ackermann's work are issues of art's ever-magnifying market value that seems, like his diamond, to have become obscenely bloated in its unwieldiness. As sales figures for works by living artists grow, so too do the anxieties of some cultural commentators, who fear that the gap between those potentially interested in visual art and those who possess the means of owning and privately sequestering the most important examples of it is becoming unbridgeable. Museums and civic galleries eager to acquire significant contemporary works on behalf of the public, so the fear goes, cannot compete with the resources of wealthy hedge fund managers who snap up masterpieces for corporate board rooms and the draughty hallways of rarely occupied third, fourth or seventh homes. Art has become one per cent of the one per cent. Such apprehensions about art's accelerating exclusivity trouble the imaginations of Scandinavian

concept artists Michael Elmgreen and Ingar Dragset. Inflected with characteristic humour, the pair's 2012 sculpture *"But I'm on the Guest List, Too!"*, conceived for the Liverpool Biennial and installed along a busy pedestrian thoroughfare, consisted not merely of a shiny stainless steel doorframe and door (with the letters VIP engraved on it), but also a burly bouncer who was not about to let anyone through. That the faux entrance led nowhere seemed emblematic of so much of contemporary art's inert self-involvement and hardly detracted from the element of social and economic division that its absurd intervention into social space introduced. Bemused passers-by found themselves suddenly compelled to confront the doorman, demanding to know from what part of their lives they were now being aggressively excluded.

A devastating critique of the legacy of Duchamp's readymade, Elmgreen and Dragset's work invites viewers to consider to what extent aspects of their everyday existence are cordoned off from them in the elitist space of art galleries, only to be repackaged and resold at a premium price as 'art'. Its ability to confound our comprehension of the distinctions between exclusive commodities (those things reserved only for VIPs), the material of everyday life and art is a quality that is shared by the works of German-based American artist Christine Hill. Since the mid-1990s, Hill has presented versions of a functioning shop that she calls *Volksboutique* (1996–97), in which ordinary retail objects are slightly altered and then resold. In Hill's world, the work of art is created when the visitor and proprietor of the installation (the artist herself)

84 (above left) **Elmgreen & Dragset**, *"But I'm on the Guest List, Too!"*, 2012. Performance during the Liverpool Biennial in 2012, UK

85 (above right) **Christine Hill**, *Volksboutique*, 1996–97. Organizational venture and second-hand shop in Berlin, Germany

engage in commerce, whether social (bargaining or discussing an item's utility) or financial (when the actual exchange occurs). The conflict of artistic and commercial motives has perplexed more than one curator of events in which Hill's work has been displayed, a confusion that the artist embraces as fundamental to society's attitude towards the making of any work of art.

Among the greatest catalysts of art with overtly political messages in the past quarter of a century has been the war on radicalized Islamicism, declared in the aftermath of the terrorist attacks on New York and Washington, DC on 11 September 2001, and the recurring tensions between allied forces led by the United States of America and the United Kingdom and Saddam Hussein's brutal and diplomatically recalcitrant regime. The disputed legality of the allies' decision to invade Iraq in the spring of 2003 provoked several notable works of the era, including an elaborate reconstruction of a vast protest camp in London's Parliament Square demolished by UK authorities in May 2006. British installation artist Mark Wallinger's *State Britain* (2007) painstakingly re-created every one of the 600 discordant posters, banners, flags and flyers that had been confiscated on specious charges that the site, which had operated peacefully for three years, could potentially provide cover for terrorists.

A rather more excruciatingly intimate demonstration of dissent was undertaken by the Iraqi-born American artist Wafaa Bilal on Memorial Day in June 2010. For his work *and Counting...* [87], Bilal consented to having 5,000 red dots tattooed onto his back to mark the death of every American

86 Mark Wallinger,
State Britain, 2007.
Mixed-media installation

soldier that had thus far been killed in the conflict, and 100,000 dots etched in ultraviolet ink: one for every Iraqi estimated to have perished. The inconspicuousness of the UV marks when seen in ordinary light is intended to symbolize the invisibility of Iraqi suffering. Although Bilal could only endure the searing of less than a third of the specks during the twenty-four-hour ordeal, in the eerie fluorescent hum of an ultraviolet light his assaulted skin shimmers like the Milky Way seen from the desert on a clear, angry night.

A more ambiguous though no less provocative response to the conflict between Iraq and the allies was exhibited at the Prague Biennale in May 2005 by the controversial Czech artist David Černý, who came to public attention in 1991 after he painted a Soviet tank pink [88]. Midway between the capture of Saddam Hussein by US Forces in a small agricultural town outside Tikrit, Iraq, in December 2003 and the overthrown dictator's eventual execution three years later, Černý constructed a formaldehyde-filled aquarium that in every way echoed the appearance of Damien Hirst's famous shark submersion from a decade earlier (The Physical Impossibility of Death in the Mind of Someone Living, 1991, discussed on pp. 58–59). However, rather than suspending in his murky solution an enormous fish, Černý immersed a mannequin resembling the deposed tyrant wearing only a loincloth, his hands tied with rope behind his back. Some observers of Saddam Hussein Shark found the artist's parody puzzlingly equivocal and difficult to decipher. Was Saddam's viciousness being equated with the primitive ferocity of an untameable shark or was he to be seen, instead, as the victim of inhuman treatment at the hands of his prosecutors, forced forever in effigy to endure an exaggerated version of the notorious interrogation techniques involving the dunking in water of a detainee's head, rumoured to be in use by American and British forces?

For others, reaction to Černý's provocative vitrine would become difficult to disentangle from issues raised a few months later, in September 2005, when protests were staged around the world in response to a decision by the Danish newspaper Jyllands-Posten to publish twelve editorial cartoons depicting the prophet Muhammad. The demonstrations had been organized by Muslims who regard the making of images of their prophet blasphemous and an assault on Islam. Scheduled to travel next to Middelkerke, Belgium, at the very height of

87 **Wafaa Bilal**, detail from and Counting..., 2010. Performance

the cartoon-ignited controversy, *Saddam Hussein Shark* found itself swimming in uncharted international waters. It soon became the target itself of censorship when the town's mayor announced that the work would not be displayed for fear that it might cause shock and offence, particularly among Muslims. A decade later, in January 2015, a pair of masked gunmen stormed the offices of the French satirical magazine *Charlie Hebdo*, which had earlier defended the Danish newspaper's moral entitlement to print irreverent material: a journalistic right it routinely observed. Opening fire on the publication's staff, the gunmen killed twelve people including four of the magazine's artists. The massacre is among the most chilling assaults on the freedom of artistic expression in modern times and has provoked, across the world, an unprecedented outpouring of allegiance to the ideals for which the *Charlie Hebdo* staff gave their lives.

**Fleshed Out: The Body
and Contemporary Art**

In September 2008, a team of scientists from the University
of Tübingen, Germany, made perhaps the single greatest
archaeological discovery in the history of Western art. Since
the 1870s, the Hohle Fels (or 'hollow rock') – a cave in the
Swabian Alps of southern Germany – had consistently yielded
significant remnants that have refined our understanding of the
growth of human culture, including Palaeolithic tools, fossils of
prehistoric reindeer and a zoomorphic figurine of a half man,
half lion. What remained unfossicked from the fissure for over
35,000 years, however, were the most remarkable fragments
of all: a flute carved from a vulture's wing that is thought to be
the earliest musical instrument ever recovered, and a headless,
fist-sized buxom statuette shaped from a mammoth's tusk that
is now known as the 'Venus of Hohle Fels' – the oldest example
of figurative sculpture ever crafted by human hands.

Almost immediately upon its discovery, the voluptuous
ivory object ignited debate about the nature of early depictions
of the female form. Where some scholars insisted that the
representation was demeaning, if not pornographic, others
saw the crude portrayal of ample breasts and bulky buttocks as
transcending modern-day preconceptions of physical beauty, and
was probably intended to symbolize instead bountifulness and
prosperity. Although mute, the enigmatic ornament managed
eloquently to crystallize into its ancient form modern-day
anxieties about society's representation of women's bodies: an
issue that has polarized opinion since Naomi Wolf's age-defining
polemic *The Beauty Myth* was published in 1990, ushering in
what has since become known as 'the third wave' of feminism.
The appearance of Wolf's book – which argues that increased
gender equality in society has coincided, paradoxically, with
an accelerating sexualization of women – was emblematic of
a renewed fascination among artists of the era in the depiction
of women and how to reinvent the body for a new age.

Foremost among the new generation of image makers
reimagining the female form are British-born artists Jenny
Saville, Cecily Brown, Gillian Carnegie and Rebecca Warren.
Distorted perspectives of Saville's own body in larger-than-life

canvases helped bring her to public attention in the early 1990s, just as the tenets of Wolf's study were embedding themselves into the popular consciousness. Saville's early work frequently experiments with warping the proportions of the artist's own physique in order to establish more compelling surfaces to showcase her gift for allegorizing the ephemerality of skin with the endurableness of paint. By doing so, she complicates lazy equations of life with art. What may be aesthetically appealing on the level of artistic media and the proportioning of pigments is suddenly at odds with what society demands from the public presentation of women as heroin-thin and mannequin-smooth in their complexion.

Saville's embellishments of the female build are aware of a textural tradition of indulgent flesh, stretching from Peter Paul Rubens to Lucian Freud. Meanwhile, the distortions that characterize the canvases of her contemporary, Cecily Brown, seem heir instead to twentieth-century Expressionism. Where a clichéd virility of muscular stroke defines the abstract efforts of Brown's most obvious antecedents, such as Oskar Kokoschka, her work is distinctive for its assimilation of the female form into a style of expression that seems temperamentally at odds with lyrical figuration. Her large 2013 oil on canvas work *Untitled (The Beautiful and Damned)* is a raucous jamboree of acrobatic

89 Cecily Brown, *Untitled (The Beautiful and Damned)*, 2013. Oil on linen

flesh-tones. Like the 'Venus of Hohle Fels', Brown's work is an inscrutable totem of disjointed derrières and discombobulated limbs rendered in riotously indecipherable syllables. Is the body being celebrated or censured by the artist? Does she see herself as implicated in the bestial crawling of bodies or does she stand outside this circus of skin?

Where Brown may remain enigmatically detached from her depictions, Gillian Carnegie irredeemably incriminates her own gaze in her series of 'bum paintings' begun in 1998. Featuring close-ups of the artist's buttocks (the focus framed from the small of the back to the upper thigh), the sequence breaks Carnegie's body down into abstractable units in order to attach to a hyper-sexualized aspect of her physique purely objective qualities of contour and texture. She has deliberately chosen to concentrate on an aspect of herself that she can never see without the aid of a camera or an awkward alignment of mirrors. This allows her the distance, she feels, to produce as emotionally disconnected a portrait of her own body as possible, while experimenting with a range of art historical realisms (from French to Photo-).

Warren too is fully cognizant of the past and of the extent to which her work is as much moulded from the tradition of modern sculpture itself as from the lumpy clumps of unfired

90 **Gillian Carnegie**,
rsXX-18-7, 2007. Oil on board

clay she uses to make it. An exhibition of Warren's work is typically a scrapyard of crustily stylized posteriors and breasts that have broken loose from the less-sexualized parts of the human body to roam free. Her sculptures know their way around the air that fills a room as adeptly as Umberto Boccioni's *Unique Forms of Continuity in Space* (1913), while being as rooted to the toughness of the earth as Alberto Giacometti's Venice women of the 1950s. Through Warren's eyes, the female form is an elemental force of nature: a freshly discovered compound whose properties require strenuous testing. A raw quintessence to Warren's works, whose surfaces are pocked by thumbprints, gives the impression that they have been crudely chiselled free from the primordial walls of an undisclosed recess: a site of eternal discovery.

There is, of course, another side to the eloquent primitivity of embellished bodies such as Warren conjures through her rough-hewn sculptures, which appear to place the female body beyond victimization into a realm of burly archetype. For Nairobi-born New York artist Wangechi Mutu, a formidable fragility of form emerges from her complex collages. Against an otherworldly metallic shimmer of stretched polyester film, Mutu assembles figures from a cacophony of cultural sources: fashion journals and *National Geographic* magazines, sporting publications and pornography. From a melee of Mylar and machismo, ink and spray paint, the artist contrives countenances and postures that appear at once irrepressible and vulnerable. Curious composites of photographs of flimsy flowers and hardcore porn, Mutu's figures are, in one sense, merely fusions of the way society perceives women; yet the aggregation of exploitative vision paradoxically adds up to a fearsome beauty that rescues its subject by salvaging an unexpected tenderness from the wreckage of crass objectivization.

As a counterpoise to the dignity Mutu manages to construct from scraps of misogynistic staring, the fantasized forms that titillate the surface of American artist John Currin's paintings create as jarring a contrast as is imaginable in the world of contemporary art. Vacuous amalgams of pin-ups and porn-stars, Currin's portraits serve as a kind of ironic time-capsule from what ought to be the outmoded aesthetic of another era, preserving as they do an objectivizing perspective on femininity that remains appallingly prevalent. But for the continued appeal of works such as those created by Currin (his paintings

93 John Currin, *Big Hands*, 2010.
Oil on canvas

91 Rebecca Warren,
The Mechanic, 2000. Clay
on painted MDF plinth
with turntable

92 Wangechi Mutu, *Madam
Repeateat*, 2010. Mixed media:
ink, spray paint, collage on Mylar

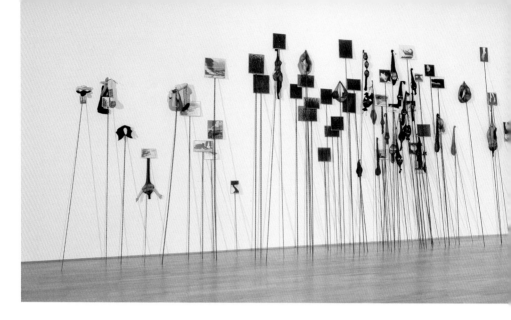

command among the highest prices at auction today), the abrasive verve of artists like Saville and Mutu would be less urgently necessary.

The drive to rip a body apart in order ironically to reveal its integrity and wholeness is an instinct that Mutu shares with French artist Annette Messager, whose 1992–93 installation *The Pikes* likewise explored the brutal fragmentation of the female body. For her work, Messager rehabilitated a Revolutionary-era weapon – the pike – upon which the privileged heads of executed members of the *ancien régime* were paraded by men (women were banned from carrying them) around the streets of Paris during the violent storms of the bloody Reign of Terror in the 1790s. However barbaric and gruesome the ritual was, by not allowing women to participate, society asserted a disingenuous prohibition against the abuse of female sensibilities. Messager's work is an anachronistic corrective that calls attention to the relentless assault on the dignity of women throughout history by attaching to scores of long steel rods depictions of torture victims and a mishmash of dismembered doll parts stuffed into stockings. The disturbingly decorated pikes are then displayed leaning against a wall in the gallery, as if abandoned by a retreating force either yesterday or centuries ago. The result is a horrific hotchpotch of history, a rag-and-bone shop of uncompromising art.

Messager's semi-cloaking of component parts of the female form behind the diaphanous gauze of nylon mesh stockings –

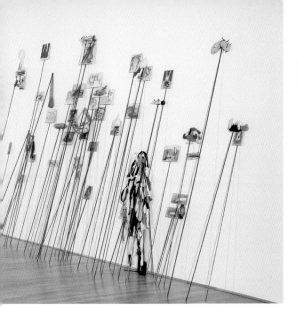

94 **Annette Messager,**
The Pikes, 1992–93. Steel,
fabric, coloured pencils, paper,
cardboard, glass and dolls

as though a sexualized accessory of feminine apparel had finally dragged the entire person inside it – anticipates an intriguing strand of representation in the past two decades that ambivalently desires to reveal and to conceal the female form. Bahamian-born New York performance artist Janine Antoni's rawhide sculpture, *Saddle* (2000) [95], is characteristic of this urge. Constructed from the same material as that used for products such as shoes, belts, briefcases, purses and, of course, saddles for horses, Antoni's work presents itself as a floating leather blanket, frozen in mid-crawl across the gallery floor. The shape of the artist's body, which has adopted the bovine posture of the beast from which the medium of the piece derives, is insinuated beneath the rumpled rawhide sheet, thus forming a distressed ghost of a work that has transformed the artist's presence into a commodified absence: a luxurious emptiness that is as hollow, physically and emotionally, as a worn-out handbag.

For Northern Irish sculptor Kevin Francis Gray, disclosure and disguise of the female body are likewise competing but never exclusive moods of a single work. Carved from Statuario marble, quarried in Tuscany, the translucent folds of Gray's silk-veiled *Ballerina* (2011) [96] conjure the skills of a Renaissance master while managing to capture an indeterminacy of attitude towards the body that is unmistakably contemporary. The stone medium that the artist has chosen is heavy and opaque yet the impression he creates is one of delicate lucency,

95 **Janine Antoni**, *Saddle*, 2000.
Full rawhide

96 **Kevin Francis Gray**,
Ballerina, 2011. White
Statuario marble

highlighting the body's own ambiguous status as simultaneously physical and spiritual, and as prone to immaterial aspirations as material expiration. The human form at the centre of Gray's work is sinuously trapped between insinuated silk and raw stone and seems as likely to evaporate through the former as sink back, unsculpted, into the latter.

Gray's deceptively diaphanous drapery draws us into its dazzling folds while at the same time enforcing a distance between the body of the observer and the body of the observed by carving a curtain between the two. A contrary impulse among artists of the age has been one of complete penetration of imagined vision: a merging of eye and I. Swiss multimedia artist Pipilotti Rist is at the forefront of these intimate incursions. Her video installation *Pour Your Body Out* [97], which occupied the 7,354-cubic-metre (approximately 259,000-cubic-foot) atrium of New York's Museum of Modern Art in 2008–9, invited visitors to relax in what felt to many like an oversized womb. From their vantage on an enormous circular sofa at the centre of the installation, like a dilating pupil, viewers were enveloped by seven 7.62-metre-high (25-foot) video screens that projected bold images of natural ingression: from a snail's view of grass blades parting as it slides, to the slipping of a worm's length through grubby fingertips. That the artist intended visitors aerobically to become one with the exhibition was unmistakable from the instructions printed on the gallery walls: 'Watch the videos and listen to the sound in any position or movement. Practice stretching: pour your body out of your hips or watch through your legs. Rolling around and singing is also allowed.' For Rist, a woman's body is not an object to be gazed upon from a distance but an interior realm that must be explored, with its own visual language and aesthetic laws: one that requires the total immersion of a viewer's senses and being.

A comparable instinct to assimilate observers' senses into the very fabric of a work motivates an ophthalmologically intense installation constructed in 2013 by a team of scientific collaborators led by British artist Gina Czarnecki. Employing cutting-edge medical technology, Czarnecki's *I* projects detailed scans of participants' irises at enormous size onto the sides of buildings and screens [98]. Frequently cited as the physical feature to which lovers are first drawn and long regarded, romantically, as the apertures through which our innermost selves can be glimpsed, eyes have in recent years also come to

97 **Pipilotti Rist**, *Pour Your
Body Out (7354 Cubic Meters)*,
2008. Multichannel audio
video installation

be valued as biometric validation of our individuality as well as a reliable gauge of one's physical health. By turning that which enables audiences to perceive visual art into the very art they perceive, Czarnecki has helped engineer an elegantly intimate and ingenious volte-face of the enterprise of looking: a work whose stare, because it is your own, literally follows you wherever you go.

The penetrative aspects of engaging with art are likewise at play in the work of British video artist Heather Phillipson. Her 2013 installation, *immediately and for a short time balloons weapons too-tight clothing worries of all kinds* [99], like Rist's earlier display, ushered visitors into a plush uterine interior that they were at pains not to compare with the anatomical canals and recesses of reproduction (indeed one exits the display crouching between what are surely a spread of stylized legs). But for Phillipson, the interiorization of the infiltratory gaze is only partially achieved through the movement of the viewer's body allegorically into the corpus of the work. Her often witty structural designs merely provide stages for the more profound voiceovers that tease the mind long after one has experienced the installation in real time. An acclaimed poet, the artist has a knack for the philosophically playful turn of phrase and a flair for refurbishing clichés in ways that are capable of triggering deeper introspection. 'You must have made your way through some tight passages', an omniscient voice hazards to guess, as if welcoming your soul for the first time to its corporeal incarnation in this world. In a Phillipson installation, one may enter or leave through a bodily orifice, but the journey is pure mind.

Nor are female artists alone in their inclination to transform the interior landscape of the body (in particular, the byways of the reproductive system) into an intimate elsewhere in which we lose and find ourselves, are created and estranged. Like those of Rist and Phillipson, the works of Californian-born artist Matthew Barney and of Brazilian sculptor Ernesto Neto seek to survey the undiscovered infrastructures of fertility. The muscle responsible for lifting and lowering the testicle provides the conceptual hook for Barney's celebrated cycle *Cremaster* [100], a sequence of five films that explores modalities of conception, both physical and cognitive, from biology to mythology. In *Cremaster 4*, the artist, disguised as a suave satyr, is seen oozing his underworld way through a slippery duct that viewers may

98 Gina Czarnecki, *I*, 2013. An interactive journey into the body through the eye, projected at spectacular scale. It combines images sourced from various fields of biomedical research, footage filmed by the artist, and, through an on-site iris scanning booth, unique biometric portraits of viewers themselves.

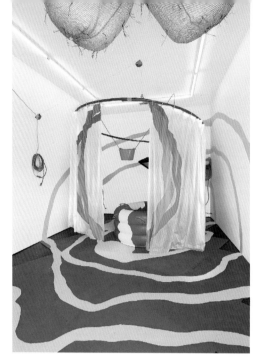

99 **Heather Phillipson**,
*immediately and for a short
time balloons weapons too-tight
clothing worries of all kinds*,
2013. Installation

100 **Matthew Barney**,
Cremaster 4, 1994.
Production still

101 **Ernesto Neto**, *anthropodino*,
2009. Mixed-media installation

102 **Sarah Lucas**, *Pauline Bunny*,
1997. Tan tights, black stockings,
chair, clamp, kapok, wire

variously equate with the inner architecture of ejaculation or the odyssey of birth.

Neto's sprawling installations allow for a more hands-on experience and the opportunity to adapt the aesthetic environment into a womb of one's own. Typically displayed in yawning cathedral-sized spaces, Neto's interactive installations are comprised of acres of Lycra mesh fashioned into biomorphic jungles of stretchy fallopian tunnels and plunging scrotal stalactites, plumbed taut by bulges of foam packed with aromatic spices: clove and cumin, ginger and pepper. The result is a disorientating adventure, sensuous and surreal, that invites visitors to escape the rigidity of quotidian interiors by providing prenatal playgrounds measured along the axes of equilibrium and grace, gravity and awe.

Neto's sinuous sculptures may seem to some as oversized allusions to British artist Sarah Lucas's *Pauline Bunny* (1997), an abstracted mannequin positioned on a wooden chair. Concocted from two pairs of overstretched hose packed tight with kapok fibres – a pair of stockings constituting the legs, and a pair of tights a set of flaccid rabbit ears that dangle obscenely like a brace of limp penises presiding over the sculpture – the anthropomorphic form is at once an amusing and disturbing caricature of hyper-sexualization, as though the female body were trapped in a suffocating mesh of society's making. There is something mythic in Lucas's transmutation of the female form: in her isolation of an egregious essence, distilled in the chauvinistic alembic of a patriarchal mind, that elevates the achievement of the work beyond the sum of its ostensibly perverted parts.

Myths of metamorphosis and the transformation of the body are likewise at the centre of German-born multimedia artist Janaina Tschäpe's video installations *After the Rain* (2003) and *The Sea and The Mountain* (2004) [103]. Through the strange lens of Tschäpe's imagination the male and female form are mutated into beings whose distorted physiques one feels awkward classifying as still essentially human. The bodies depicted in the photographs and videos that comprise the work bulge with bizarre Lycra-stretching appendages and semi-translucent sacks filled with what appear to be eggs or embryos while the surrounding landscape and streams are inexplicably strewn with colourful unhatched ovoids. To make sense of the surreality of it all, the viewer's mind auditions outlandish explanations. Are these the offspring of a future species: evolutionarily related but distinct from mankind? Or perhaps we are witnessing the ungainly descendants of

103 **Janaina Tschäpe**, *Juju I*, from *The Sea and The Mountain*, 2004. Cibachrome

104 **Bharti Kher**, *The Messenger*, 2011. Fibreglass, wooden rake, saree, resin

gene-shattered survivors of a nuclear holocaust? The strength in Tschäpe's eccentric approach to storytelling lies in its endless elasticity, inviting viewers to concoct odysseys of their own that can accommodate the vibrant variables of her vision.

An impulse to transform the body into an enduring symbol that transcends mortality similarly characterizes the imagination of Indian artist Bharti Kher. Assimilating a rich array of mythologies and folklore into her work, Kher has built a reputation envisioning hybridic orders of animals and plants in her sculptures and collages, confounding conventional notions of genetic identity. The sense of endlessly amalgamating form is achieved not only through the union of contrasting species, but also through the awkward merging of seemingly contradictory media. Her 2011 sculpture, *The Messenger*, is a larger-than-life incarnation of the part-anthropomorphic, part-monkey Hindu goddess Dakini – meaning 'she who moves in space' – crafted eclectically from austere fibreglass and the soft fibres of a colourful sari. At once agile and erotic, graceful and strong, Kher's inspiring interpretation of the female form inhabits a borderland between real and unimagined realms and looms before us like a harbinger of an exhilarating world to come.

The Long Now: Time and History in Contemporary Art

105 **The Long Now Foundation**, *Prototype 1 of the 10,000 Year Clock*, 1999. The full-scale version of the clock, conceived by Danny Hillis, is still under construction in West Texas.

On New Year's Eve 1999, a 2.44-metre-tall (8-foot) model for one of the most extraordinary chronometers ever devised was set into experimental motion. Synchronized to mark the end of one millennium and to signal the start of the next, the first prototype of a timepiece constructed to tick for one hundred centuries was activated in San Francisco. In the years since, geologically sturdy sites in several locations around the globe, including inside a mountain in western Texas and amid a ridge-top copse of bristlecone pines in eastern Nevada, were being readied for the installation of enormous full-scale versions of the curious contraption, each rigged with a sophisticated mechanism of bells designed to chime at unpredictable intervals and never to repeat the same melody. Like art itself, the aim of the '10,000 Year Clock', which the American inventor and engineer Danny Hillis began designing in the early 1990s, is to slow life's second hand down to a contemplative crawl and to force us to recalibrate our comprehension of the elapse of life. Built to tick merely once a day, to gong once a year and to thrust forward its impossibly patient cuckoo once every millennium, the ginormous gadget is an antidote to our frantic time-is-money mindset and is also a metaphor for the ingenuity of many contemporary artists who have concurrently devoted themselves to radical realignments of our society's conception of time.

Although every work of art is a timepiece – a carefully engineered gizmo that helps us measure the distance of life traversed since its initial winding in our imaginations – there is a clutch of notable artworks created since the early 1990s (when the philosopher Francis Fukuyama contentiously declared civilization had reached 'the end of history') that have challenged observers to reflect in granular detail on the slippage of sand through the hourglasses of existence. Reclusive Japanese-born artist On Kawara, who died in June 2014 at the age of eighty-one, is perhaps the most enigmatic of these contemporary chronologists. The 1990s and first two decades of the new millennium witnessed no diminishment in the artist's resolve to create, before midnight each and every day of his

28 SEP. 68

life, a painting that depicts, against a monochrome background, nothing more or less than that day's date. The diurnal ritual of making these chrono-maniacal works became for Kawara as necessary to existence as sleep or breath, as though the resetting to midnight of every clock in the world depended on his dutiful commemoration of the day just ending, installing it safely into the museum of life lived. So legendary had Kawara's incremental accumulation of painted days become, so indelibly inscribed in contemporary consciousness, it is difficult to imagine the inception of other exceptional artistic timepieces of the period outside the ambit of its overwhelming influence.

Swiss-American artist Christian Marclay's virtuoso work, *The Clock* (2010) [107], one of the most celebrated artworks of the era, is also the product of compulsive tinkering. An unprecedented feat of digital splicing, *The Clock* is a 24-hour video collage comprised of thousands of Hollywood and indie film clips in which some reference to the time of day or night is made. Fastidiously synchronized so that the time displayed in the film corresponds to the precise hour, minute and second that it actually is in the world outside the work, Marclay's chronometer – which took years of wrist-wrenching editing to construct – is a cyclical quilt of cinematic villainy and heroism, romance and desperation, drama and mirth. Only the unrelenting logic of time's unwavering order makes sense of the otherwise haphazard kaleidoscope of disconnecting plotlines and lives that spool, clip after clip, round and round through *The Clock's* parallel eternity.

The immersive spin of Marclay's film emerged in stark contrast to British artist Darren Almond's monolithic wall of time, *Tide* (2008) [108]. For Almond's work 600 digital clocks were stacked into a ticking barricade of ceaselessly blinking minutes and hours. The insomniac stupor of staring at one's bedside alarm unable to stem the tide of seconds was suddenly amplified into a kind of waking nightmare as the exaggerated sight of seeing one's life click away swelled insurmountably before visitors. Magnifying the sense of jetlagged disorientation that fixation on time can trigger, Almond's subsequent work, *Perfect Time* (2012), features yet another temporally taunting façade, only here the flip-panels that display the time have been jumbled so that the top half of each number – hour or minute – is mismatched with the lower halves of different numbers, creating an utterly inept and inarticulate tool whose only reliable function is the winding up of eschatological angst.

106 **On Kawara**, *28 SEP. 68*, 1968, from 'Today' series, 1966–2013. Acrylic paint on canvas

107 **Christian Marclay**, still from *The Clock*, 2010. Single-channel video with stereo sound, 24 hours, looped

108 **Darren Almond**, *Tide*, 2008. Digital wall clocks, perspex, electro-mechanics, steel, vinyl, computerized electronic control system and components

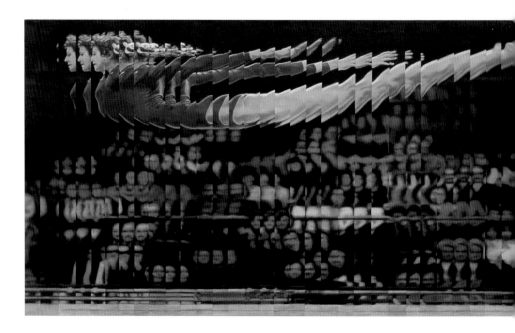

The possibility of breaking time down to the flicker of constituent units has fascinated artists since Marcel Duchamp's 1912 Futurist masterpiece *Nude Descending a Staircase, No. 2* caused a sensation when exhibited over a century ago. Duchamp's slivering of motion across a canvas-wide space is revisited in a soaring homage to his influential work by Glasgow-born Scottish painter Lucy McKenzie in her 1998 tribute to Belarusian gymnast Olga Korbut, nicknamed the 'Sparrow from Minsk'. McKenzie distends into a shuttered blur of syncopated milliseconds a mid-air plunge by the diminutive athlete, whose performance at the 1972 Summer Olympics captivated spectators on both sides of the Cold War. Korbut's alluring grace, chopped by McKenzie into frozen fragments arranged into disjointed strips, poignantly collapses key allusions to modern cultural history, suggesting an endless looping of life and representations of it.

The recycling of familiar symbols and established icons from the history of visual expression, or what became known in the 1980s as appropriationism (an approach initially explored by disciples of Duchamp and the Pop Artists of the 1950s and 1960s), has steadily gained momentum in recent decades. For several artists, including British painters Ged Quinn and Mark Alexander, appropriation's potential as a cerebral grammar for commenting on originality and the supposed linearity of

109 **Lucy McKenzie**, *Olga Korbut*, 1998. Oil on canvas

art history's unfolding, as a time-tethered narrative that progresses schematically in a straightforward chronology from one age and movement to the next – Impressionism into post-Impressionism, Cubism into Vorticism, Surrealism into abstraction – has been intriguingly explored. Quinn's 2006 reinvention of seventeenth-century ideal landscape painting, *The Fall*, is indicative of the post-appropriationist's style. Starting with an astonishingly credible replica of Claude Lorrain's twilit *Landscape with Abraham Expelling Hagar* (1668), whose heavenly, dusk-tinged horizon beckons the eye upwards from a darkened foreground, Quinn has littered the appropriated idyll with anachronistic allusions to other eras and disciplines. Hurtling perilously downwards from the sky above, as if the painting were a prequel of the famous sixteenth-century *Landscape with the Fall of Icarus* (c. 1560) (long attributed to Pieter Bruegel), is a doomed figure who we are told is in fact the twentieth-century Parisian playwright and poet Antonin Artaud, promoter of the avant-garde Theatre of Cruelty, who died by his own hand in 1948 after being diagnosed with cancer. Inexplicably, Artaud seems headed for the shattered husk of what has been identified as the American inventor Thomas Edison's film studio Black Maria, the first such structure ever built. That the studio is already in ruins – strewn with the shards of a smashed skylight – suggests that Artaud is not the

110 **Ged Quinn**,
The Fall, 2006. Oil on linen

first unfortunate soul to be flung at it from the skies, reinforcing the growing implication that every work of art is a dangerous site of relentless collisions of hapless consciousnesses, past and present. The painterly precision with which Quinn has executed the hallucinatory scene is as staggering as it is outmoded, offering observers a glimpse into an ideal realm where the divisions of time and cordons of history have utterly eroded: an eternity of shared aesthetic space and endlessly resuscitated symbolism.

In the alembic of Alexander's imagination, time and art are likewise seen as complementarily fermenting forces capable of alchemizing an otherwise familiar subject into something startling and strange. In his ongoing series of bog paintings, for instance, canonical icons from Western art and from Americana have been dramatically reimagined, as though fossicked from an undiscovered peat mire where they have been incubating for centuries. Recast in crumpled hues of russet and clotted umbers, their oily surfaces wrinkled like the dredged skin of eerily preserved Iron Age bog bodies, Alexander's paintings excavate an appalling beauty from the fatigued contours of the overused images that they echo, forcing viewers to look again at the achievement of old masters. In his work *American Bog (The Freakes)* (2013), for example, a late seventeenth-century double portrait of a mother and child (executed by an unknown hand and of extraordinary significance to the visual heritage of New England) has undergone Alexander's signature transformation into a petrified relic of seemingly prehistoric vintage. That the original painting was itself the product of successive stages of altering by the anonymous artist who conceived it three and a half centuries ago – the baby herself being a late afterthought – is in harmony with Alexander's intervention, whose philosophy implies that every artistic enunciation is a ceaseless composite of forgotten hands.

The notion that all art is in some sense the product of nameless and uncoordinated collaboration over time (after all, the context in which we observe and comprehend any given work – its position in a gallery or book – is invariably uncontrolled and unauthorized by the artist) is taken to absurd extremes by British installation artists Jake and Dinos Chapman with a sequence of thirteen watercolours that the brothers exhibited in 2008, *If Hitler Had Been a Hippy How Happy Would We Be*. As with Alexander's bog and Quinn's Arcadian idyll, the Chapmans' series began with a borrowed backdrop, only here

111 **Mark Alexander**,
American Bog (The Freakes),
2013. Oil on canvas

112 **Jake and Dinos
Chapman**, *If Hitler Had
Been a Hippy How Happy
Would We Be*, 2008. One
of thirteen reclaimed Adolf
Hitler watercolours on paper

SPIRAL JETTY

Detailed directions:

1. Go to the Golden Spike National Historic Site (GSNHS), 30 miles west of Brigham City, Utah. The Spiral Jetty is 15.5 dirt-road miles southwest of the GSNHS.

To get there (from Salt Lake City) take I-80 north approximately 65 miles to the Corinne exit, just west of Brigham City, Utah. Exit and proceed 2.5 miles west, on State Highway 83, to Corinne. Proceed through Corinne, and drive another 17.7 miles west, still on highway 83, to Lampo Junction. Turn west off highway 83 at Lampo, and drive 7.7 miles up the east side of Promontory Pass to the GSNHS.

2. From the Visitor Center at the GSNHS, drive 5.6 miles west on the main dirt road running west from the Center. Remember to take the county dirt road...not the railroad grade.

3. Five point six miles will bring you to an intersection. From this vantage you can see the lake. And looking southwest, you can see the low foot hills that make up Rozel Point, 9.9 miles distant.

4. At this intersection the road forks: One road continues west and the other goes south. Take the south fork. Both forks are Box Elder County Class D (maintained) roads.

5. Immediately you cross a cattle guard. Call this cattle guard #1. Including this one, you will cross four cattle guards before you reach Rozel Point and the Spiral Jetty.

6. Drive 1.3 miles south. Here you will see a corral on the west side of the road. Here too, the road again forks. One fork continues south along the Promontory Mountains. This road leads to a locked gate. The other fork goes southwest toward the bottom of the valley and Rozel Point. Turn onto the southwest fork, just north of the corral. This is also a Box Elder County Class D road.

7. After you turn southwest, you will go 1.7 miles to cattle guard #2. Here, beside the cattle guard, you will find a fence but no gate.

8. Continue southeast 1.2 miles to cattle guard #3, a fence, a gate, and a sign on the gate that reads, "Promontory Ranch."

9. Another .50 miles will bring you to a fence but no cattle guard and no gate.

10. Continue 2.3 miles south/southwest to a combination

fence, cattle guard #4, iron-pipe gate...and a sign declaring the property behind the fence to be that of the Rafter S Ranch. Here too, is a "No Trespassing" sign.

11. If you choose to continue south for another 2.3 miles, and around the east side of Rozel Point, you will see the Lake and a jetty (not the Spiral Jetty) left by oil drilling exploration in the 1950's. As you approach the Lake, you will see an abandoned, pink and white trailer (mostly white), an old army amphibious landing craft, an old Dodge truck...and other assorted trash.

The trailer is the key to finding the road to the Spiral Jetty. As you drive slowly past the trailer, turn immediately to the west, passing on the south side of the Dodge, and onto a two-track trail that contours above the oil-drilling debris below. This is not much of a road! In fact, at first glance it might not look to be a road at all. Go slow! The road is narrow; brush might scratch your vehicle, and the rocks, if not properly negotiated, could high center your vehicle.

12. Drive .6 miles west/northwest around Rozel Point and look toward the Lake. The Spiral Jetty should be in sight.

Maps of the area:

BLM 1:100,000 Surface Management maps - Available at the BLM's State Office Public Room, 324 South State Street, Salt Lake City, Utah 84111 phone: (801) 539-4001
 (1) Tremonton
 (2) Promontory

U.S. Geological Survey, 7.5 minute series - Available at the U.S.G.S., Federal Building, 125 South State Street, Salt Lake City, Utah 84111 phone: (801) 524-5652
 (1) Golden Spike Monument Quadrangle
 (2) Rozel Quadrangle
 (3) Rozel Point Quadrangle

For Additional Information:

Bureau Of Land Management
Salt Lake District
2370 South 2300 West
Salt Lake City, Utah 84119
phone: (801) 977-4300

Golden Spike National Historic Site
P. O. Box 897
Brigham City, Utah 84302
phone: (801) 471-2209

the historic scenes are not carefully constructed imitations, but original watercolour paintings by Adolf Hitler that the pair acquired as a set for £115,000. Onto the shared surface of these weak, workmanlike paintings, the Chapmans introduced splashes of incongruous flower-power colour: trippy rainbows and inept psychedelic butterflies. So crudely handled were the contemporary interventions, the brothers appeared to be daring observers to acknowledge that, relatively speaking, Hitler's contributions were defter. Underlying the Chapmans' work, however, was not merely the defacement of works by a despicable human being, but a challenge to society's complacency about the status of an historic symbol – Hitler as icon of evil – which, like any cultural signifier, is in danger of losing its meaning if never dusted off and held up to the light.

Themes of recovery and loss that invigorate the works of Quinn, Alexander and the Chapmans likewise invest Berlin-based British filmmaker Tacita Dean's recurring fascination with the geological fate of American land artist Robert Smithson's famous 457.2-metre-long (1500-foot) earthwork *Spiral Jetty*, constructed over six days in April 1970 out of mud, salt crystals and basalt rocks on the north-eastern shore of the Great Salt Lake in Utah. A pair of works created by Dean in 1997 and 2013 are, respectively, preoccupied with the inception and eventual erasure of Smithson's seminal sculpture. Dean's initial engagement resulted in an audio piece that records her ultimately unsuccessful attempt to locate the site where *Spiral Jetty* once stretched its twirling 4.6-metre-wide (15-foot) tail into the blood-red water near Rozel Point. Her follow-up work, entitled *JG*, is a looping twenty-six-minute film that explores the intertwining connection between Smithson's sinuous jetty and the imagination of the English novelist J. G. Ballard, who shared with Dean a fascination with the American artist (who, in turn, had been a reader of Ballard's fiction). Throughout Dean's film, which was shot in Utah and in the companionable landscapes of California's Mono Lake and Death Valley, images of ancient corrosive elements of saline, sand and water slowly seep into the viewer's consciousness as rich tropes for the uncontrollable forces of inspiration and time that shape the destiny of aesthetic creations more palpably than the perishable hands of the artists who made them.

In Dean's art, as in that of Alexander, creation and destruction are synergetic modes that cannot be disentangled:

113 (opposite top)
Robert Smithson, *Spiral Jetty*, 1970. Mud, precipitated salt crystals, rocks, water coil 457.2 m long and 4.6 m wide (1500 x 15 ft) at Rozel Point, Great Salt Lake, Utah

114 (opposite bottom)
Tacita Dean, *Directions to Robert Smithson's Spiral Jetty*, 1997. Directions faxed to the artist by the Utah Arts Council

each equally responsible for the condition and texture of artworks time hands down to us. Similar anxieties energize the art of German artist Anselm Kiefer and British ceramicist Grayson Perry. In Kiefer's hands, the very survival of time-present and time-future is likewise forever symbolically at stake. Taken together, his artistic output constitutes a courageous investigation of esoteric comprehensions of the universe's incessant making and undoing, inception and destruction. Fascinated by cyclical cosmologies and occult configurations of history, Kiefer's art is a clotted compression of medieval and modern poetry and theology, philosophy and fiction that refuses to be confined to the parameters of a single conventional medium. In his 2009 combination of painting, sculpture and installation, *Shevirath Ha Kelim*, the artist has offered what appears to be an embodiment of the Kabbalistic notion of 'the breaking of the vessels' (an approximate translation of Kiefer's title), a simultaneously traumatic and glorious event in the sixteenth-century Galilean mystic Isaac Luria's conception of the genesis of the universe, the invention of time and the creation of man. In *Shevirath Ha Kelim*, a ruinous pyramidal structure that could as easily be the fragmented steps of Babel

115 **Anselm Kiefer**, *Shevirath Ha Kelim*, 2009. Terracotta, acrylic, oil and shellac on canvas

or a bomb-shattered amphitheatre on the outskirts of Baghdad rises before the viewer on the soaring surface of the canvas while remnants of ceramic bowls lie strewn across the gallery floor, the detritus of a cataclysmic event that either occurred before time itself in the realm of the divine, and is therefore responsible for the unfolding of human history, or last week in a hammered hinterland between ancient foes.

As its title suggests, Perry's *The Rosetta Vase* (2011) is a twenty-first-century time capsule inscribed with the idioms and ironies of an age that future generations may find unintelligible without a visual key. Where the sturdiness of the Rosetta Stone, the original second-century BC granodiorite tablet discovered in 1799, proved decisive in deciphering the meaning of Egyptian hieroglyphs, Perry's ceramic chronicle of contemporary attitudes towards taste and its addiction to commercial cliché, recorded on the cylindrical surface of his anachronistic vase, seems self-consciously fleeting. By electing to emboss his often wry observations of social prejudices on a hollow vessel typically equated with the custodianship of one's cremated remains, Perry emphasizes the ultimate ephemerality not merely of all material expression and works of art but of cultures themselves.

116 **Grayson Perry**, *The Rosetta Vase*, 2011. Glazed ceramic

117 **Bill Woodrow**,
Regardless of History,
2000. Bronze

A hint of the macabre that lies just below the surface of Perry's work swells egregiously into a kind of grotesque grandeur in British artist Bill Woodrow's bronze sculpture, *Regardless of History* (2000), which occupied the Fourth Plinth in London's Trafalgar Square from 2000 to 2001. The work is comprised of a stack of oversized symbolism plonked before its audience with the subtlety of a sledgehammer. The head of an anonymous toppled statue is crushed under the groaning weight of an enormous antiquarian tome, which in turn is squeezed into the work's base by the menacing roots of a tree that rises above everything. Whether Woodrow wants viewers to contemplate the inevitable eradication of civilization by Nature or to see Nature instead as a dependent force, leeching nourishment from products of human consciousness (and indeed consciousness itself), is impossible to resolve: an ambiguity on which the work's interest relies.

An indeterminacy of interpretation and irresolvability of historical perspective lies similarly at the heart of the attitudes towards time held by German artist Luc Tuymans and Scottish painter Peter Doig. Tuymans's disconcerting 2008 interior, *Big Brother* [118], is typical of the artist's affecting approach. Cast in vague greys and washed-out blacks, as though glimpsed through a covertly-positioned surveillance camera, the work captures the shared sleeping facility of a reality television show where sequestered participants are ceaselessly monitored by the remote viewing audience. But an imprecision in the painting's focus that results in indistinct hummocks of bedclothes that could either be cadavers or the huddled bodies of victims of political persecution transforms a scene of popular entertainment into something less salubrious. Seen through the lens of Tuyman's complicating imagination, the television show's title is reinvested with the horror of its initial coinage, recalling the vantage of the omniscient dictator in George Orwell's totalitarian nightmare *Nineteen Eighty-Four*. Created by Tuymans at a moment when electorates across Europe and North America were debating the legitimate scope of governmental surveillance programmes, *Big Brother* manages to blur into an eternal instant both fictional and historical fears, suspended in the unblinking eye that deepens like an abyss at the centre of his quietly disquieting work.

Doig's large oil-on-canvas waterscape, *100 Years Ago* (2001) [119], invites viewers on an even more ambiguous voyage into art's representation of what is past, or passing, or to come.

118 **Luc Tuymans**, *Big Brother*,
2008. Oil on canvas

The work's title implies a kind of commemorative centenary of some event, milestone or age, but what exactly is being marked is never made clear. The bedraggled figure at the painting's centre (fashioned in part, the artist has said, on a legendary American guitarist) appears suspended in his journey midway between a distant island and whatever allegorical shore we, the viewers of Doig's painting, occupy. Does the mysterious canoeist represent our past or future self, or is he a living relic from another time, headed our way to bring news from an undiscovered realm that he fled a century ago? The long lithe vessel from which his eyes beckon – a recurring symbol in Doig's work – seems whittled from a dream, pointing equivocally both forward and back, towards waking and sleep, the future and the past.

Whosoever precisely the protagonist of Doig's visionary scene may be, he would appear to sit in isolated opposition to the frantic and technology-obsessed world that most of us inhabit: a distant relative who either pre-dates the wirelessness of our society or presages its post-apocalyptic extinction. Perhaps the 'one hundred years ago' of the artist's irresolvable title is a reference to the here-and-now and the cosmos-wearied canoeist is our destiny. Doig would not be alone among contemporary artists in contemplating the ephemerality of all

119 **Peter Doig**, *100 Years Ago (Carrera)*, 2001. Oil on linen

that seems unshakeably solid around us. Indeed London-born artist Richard Wright has committed himself, paradoxically, to making meditation on transience an enduring component of his practice [120]. Working directly onto the walls of galleries and institutions where he has been invited to exhibit, with full knowledge that the resulting paintings and gold-leaf rubbings he intricately creates will be destroyed and whitewashed in preparation for the next artist to display in the space, Wright embraces the imminent impermanence of his work as a crucial aspect of its power. Often insinuated into awkward crevices – a gallery's corners and cornices – the fragile filigree of Wright's delicate designs recall the ornateness of Medieval manuscript illumination, as though each room and every visitor in it were the letters of a page waiting to be turned. The artist relies on a shared awareness with his viewer that his brush's finesse, like the eyes that perceive it, ultimately will not survive. The result is a poignancy of perspective and a more candid acceptance of time's indiscriminate cruelty than is typically encountered in museums and galleries where artists, curators and visitors alike convince themselves of the invincibility of art.

Berlin-based performance artist Tino Sehgal and French filmmaker Philippe Parreno take the contention of art's essential fleetingness to extraordinary extremes. In 2013, ticketholders to Parreno's sensually absorbing survey show, *Anywhere Out of the World* at the Palais de Tokyo in Paris, which featured an array of the artist's films as well as enchanting light displays choreographed to unexpected sounds, were handed a DVD copy of *Marilyn* (2012), a work discussed on pp. 55–57. Parreno's film re-creates, as if shot through the lens of the actress's eyes herself, a hotel suite where Monroe lived in the 1950s. But what makes the claustrophobic melancholy of *Marilyn* particularly poignant is the unique formatting of the DVD itself, which, like a recording of secret instructions for a clandestine mission, destroys itself as it plays, making it impossible to watch the film twice. By doing so, Parreno deliberately engenders into the fabric of his art the very quality of impermanence that artists throughout history have aspired to overcome, challenging visitors to elevate the memory of art to the status of art itself. For Parreno, one is encouraged to look, but not stare.

Sehgal, who studied dance and political economy at university, has coined a term for his unique take on the relationship

120 **Richard Wright**,
Untitled (06.01.08), 2008.
Gold leaf on paper

between a viewer's experience of what he creates and the endurance through time of that creation. Sehgal's so-called 'constructed situations' are distinctive for their absolute eschewal of material props and the artist's resolute prohibition against the manufacturing of any documentation of a work's occurrence. No recording devices, whether visual or audio, are permitted in the galleries where the artist's elastically choreographed 'situations' play out between trained assistants to the artist, or what he calls 'interpreters', and the visiting audience that chooses to participate. Only a memory of the lived experience is allowed to leave the room. What unfolds in a work by Sehgal is an extemporaneous and therefore unpredictable and unrepeatable encounter involving dialogue, song, dance and impromptu gesture whose tempo depends on the relationship that is formed between visitor and interpreter. For Sehgal, art is not about the creation of artefacts for the consumption of future eyes but a passing moment in the long now of our shared existence.

CHAPTER 7

Event Horizons: Science and Contemporary Art

When it comes to the two pursuits – art and science – that have preoccupied human experimentation since the outset of civilization (quests whose mutual aim is a sharper understanding of who we are and how we fit into the mystery of the universe around us), there has been a marked reversal of fortunes in public opinion. Where scientific investigation (or what used to be called 'natural philosophy') in Western culture was for centuries judged from a perspective distorted by the raised eyebrow of religion, art over the past twelve decades has come under the more sustained scrutiny and become the discipline requiring the most strenuous self-defence. So dubious are many sectors of society of the integrity of the very enterprise of making contemporary art that the achievement of artists is either condescendingly diminished ('my five-year-old could have done that') or dismissed altogether as an embarrassingly failed attempt even to operate within the unruly rules of the genre: 'yes, but is it art?' In light of the suspicion that artistic endeavour is increasingly placed under, it is perhaps unsurprising that so many artists working in the past twenty-five years have resolved to magnify the connections between scientific and aesthetic inquiry. Not since da Vinci's chair swivelled restlessly between drawing boards of anatomical dissection and pioneering portraiture, cutting-edge nautical engineering and biblical illustration, has an era witnessed as frenetic an impulse among its artists to update their creative lexicons with the vocabulary of contemporary scientific enquiry.

Beirut-born artist Mona Hatoum's pair of biologically intrusive installations, *Corps étranger* (1994) [121] and *Deep Throat* (1996), might be seen as having set the tone for the age's unique synergizing of art and science. Visitors to *Corps étranger*, whose title translates as 'foreign body', enter a large cylindrical chamber that calls to mind a sophisticated medical imaging device while anticipating airport surveillance scanners introduced a few years later, as though observers are on the threshold of being transported to an unknown land. In a sense they are. Once inside, visitors find themselves

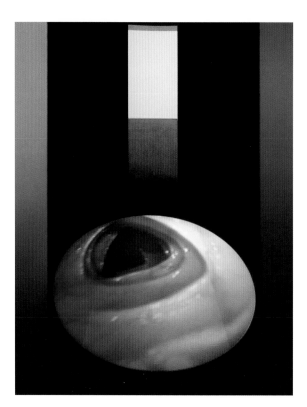

121 **Mona Hatoum**, *Corps étranger*, 1994. Video installation with cylindrical wooden structure, video projector, video player, amplifier and four speakers

122 **Justine Cooper**, *RAPT II*, 1998. MRI scans, architectural film

standing perilously above a circular projection on the floor of images recorded by the artist after inserting an endoscopic surgical camera into every orifice of her body. The looped film, which opens like a trap door into a strange subterranean realm, takes the visitor deeper and deeper into the artist's body, while an eerie audio of internal organs squidging and squelching pulsates all around. Immersive and utterly disorientating, Hatoum's contraption constitutes one of the most unsettling self-portraits ever constructed and manages to transform the most intimate aspects of one's inner material self into a mesmerizing universe of extraordinary expeditions by strangers.

Disquieting self-portraiture expressed in the language of medical diagnosis likewise characterizes the work of Australian multimedia artist Justine Cooper. For her 1998 installations, *RAPT I* and *RAPT II*, seventy-six separate radiological slices, or scans, of the artist's body made with a magnetic resonance imaging (MRI) machine – each capturing a segment of Cooper's material self – were affixed to transparent thermoplastic slides before being assembled into a distended stack and hung close together to create a ghostly suspended dissection of herself. A strung-out shuffle of smudgy silhouettes, the work both provides conclusive scientific proof of the artist's existence and is unnervingly suggestive of her fragile evaporability. By inviting visitors to walk around the display of her uncannily resonated being, Cooper has turned herself into a diaphanous film for untrained medical analysis – a public transparency – challenging conventional notions about the nature of the observer's relationship with a work of art.

For Cooper, the ethics involved in the divulging of one's own undiagnosed malformities and malignancies in the context of presenting a work of art is purely theoretical. But what dilemmas arise when real medical scans of potentially imperilled selves are involved? Such is the question British-Nigerian artist Yinka Shonibare asks in his poignant 2000 video projection, *effective, defective, creative*, which features footage from ultrasound scans taken of foetuses thought to be at risk of eventually being born 'defective'. Pulsating clips of healthy and endangered hearts are spooled and tagged with the decidedly unscientific captions 'effective', 'defective' and 'creative', generating a gentle tension between medical labels

and spiritual designations that may more accurately capture human conditions.

Japanese artist Mariko Mori expands the concept of the exteriorization of self in her futuristic installation *Wave UFO* (1999–2003), which relies on the conversion of brainwaves into mesmeric amorphous images. Mori's work is encased in a 11.3-metre-long (37-foot) and 5.3-metre-wide (17 ½-foot) smooth silver module constructed from fibreglass in the oversized shape of a sidelong tear or droplet of rain. Designed to accommodate three participants, who are helped by the artist's assistants through the translucent jelly-like door of the elevated space-age pod into squishy Technogel recliners, Mori's galactic gadget is in fact a cosy screening chamber in which a ballet of neural oscillations, transmitted through electrodes from the visitors' foreheads onto screens above them, is projected. The static transportation that the *Wave UFO* facilitates for its participants is a seemingly external journey through the entangled cosmos of one's own consciousness. A further dimension of the experience involves witnessing the transformed digitized data of one's consciousness into nebulous shapes intermingle with animation generated from paintings created by Mori herself, thereby establishing a tighter entanglement of seer and seen than audiences are in the habit of contemplating.

The apparent endlessness of the journey through inner space on which Mori's work takes its visitors involves themes explored by several of her contemporaries, including the British multimedia artist and musician Brian Eno and American inventor and software engineer Scott Draves. A pioneer of such sonic genres as ambient and generative music, Eno (who coined the phrase 'the long now', discussed in Chapter 6) is fascinated by the relationships between technology, rhythm, image and time. His innovative 2006 work, *77 Million Paintings*, involves a complex synchronicity of computer science, painting and the random generation of recorded sounds. Designed to be experienced intimately on the screens of personal computing devices, the work is a never-ending mutation of some 296 original works of visual art that entangle themselves randomly and virtually without repetition to a constantly changing soundtrack.

The perpetual morphing of image and music in Eno's work, whose ceaseless replication summons Darwinian notions

123 (opposite top) **Mariko Mori**, *Wave UFO*, 1999–2003. Brainwave interface, vision dome, projector, computer system, fibreglass, Technogel®, acrylic, carbon fibre, aluminium, magnesium

124 (opposite bottom) **Brian Eno**, *77 Million Paintings*, 2006. Painting, digital coding and architectural mapping projection

125　**Scott Draves and the Electric Sheep**, *Generation 244*, 2012. Projection

of evolutionary mutation, is nevertheless confined to a finite spectrum of possible combinations: to a gene pool of sounds and visions created by the artist and embedded in his software. By contrast, Draves's *Electric Sheep* (1999), which also relies for its exhibition on home computers and the display screens of portable electronic devices, invites a worldwide network of observers to contribute abstracted digital animations to a genetic soup of ever-evolving fractal frames that are then projected randomly across the system [125]. When one of the hundreds of thousands of computers around the globe that are connected to Draves's system slips into sleep, offspring of the algorithmically reproducing and mutating animations (or 'sheep') that have been incorporated in the system suddenly spring into dynamic life in the form of an unrehearsed and ever-changing screensaver.

In scientific terms, the computer system that Draves has created is what biologists call 'transgenic' in its openness to new material being introduced into an existing pool of shape-shifting sheep. For Brazilian-American artist and professor Eduardo Kac, however, experimentation with transgenesis as the basis for new forms of art is a pursuit more effectively undertaken in a biological laboratory with real, as opposed to digitally-contrived, life forms. For one of the most outrageous and controversial artworks of the age, Kac collaborated with a French biologist to modify the genetic profile of a rabbit by engineering into its structure an utterly foreign component, GFP, or the Green Fluorescent Protein found in the bioluminescent jellyfish *Aequorea victoria*, responsible for giving the otherwise transparent and colourless hydromedusa an otherworldly sheen when seen under blue light. The result in 2000 was Alba, a genetically modified rabbit that glowed green when exposed to the correct laboratory illumination. Artificially manipulating the very fabric of a creature purely for aesthetic purposes appalled many observers. As a metaphor for how the introduction of a sensational element can alter the evolution of art, however, Kac's work is as powerful as it is unpalatable.

The vision of a distant twilight shimmering disconcertingly with the manipulated cells of radiant rabbits is very much in accord with the imagination of American painter and self-described 'paleogeek' Alexis Rockman. Transfixed by the limitless possibilities of bioengineering to manufacture

127 **Alexis Rockman**, *Study for Romantic Attachments (Bust of Homo Georgicus)*, 2007. Ink and gouache on paper

126 **Eduardo Kac**, *GFP Bunny*, 2000. Transgenic artwork, Alba, the fluorescent rabbit

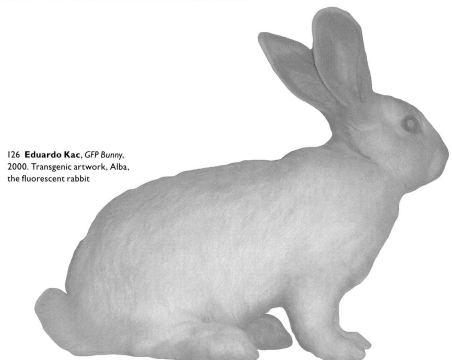

128 **Darrell Viner**, *Is Tall Better Than Small*, 2000. Electrics, electronics, computers, pneumatics, steel, LEDs, aluminium and laser ranger

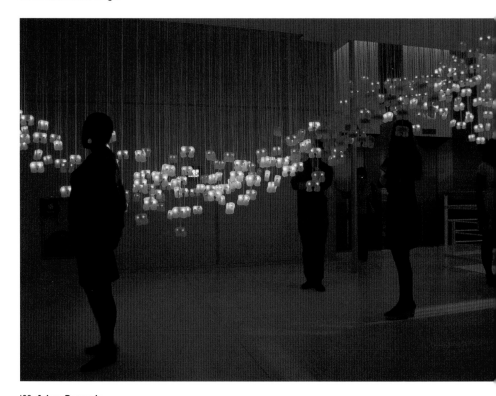

129 **Adam Brown in collaboration with Andrew Fagg**, *Bion*, 2006. 1,000+ injection-moulded plastic synthetic life-forms

improbable species, while at the same time cognizant of mankind's potential for destroying the world around it, Rockman's paintings are tense with competing emotions of awe and anxiety, fascination and fear. For his contributions to a 2007 exhibition at the Contemporary Art Center in Cincinnati, Rockman took to alarming extremes themes of crossbreeding between species that he had been exploring for over a decade [127]. In *Baroque Biology*, he depicted passionate scenes between a female human being and a male *Homo erectus georgicus*, a distant ancestor of *homo sapiens*, fossilized evidence for which was first discovered in 1991. In the light of recent advances in biotechnology making possible the revival and reintroduction of extinct species, Rockman's fearsome fiction is in fact all too feasible, scientifically, and raises the possibility of a strange cyclicity to human speciation where the future is a paradoxically degenerating regeneration of the past.

Behind the evolutionary concepts that inform the works of Draves and Rockman is Charles Darwin's impassive theory of natural selection, whereby advantageous genetic traits are privileged over weaknesses in a species: a merciless notion that rubs uncomfortably against a liberal society's aspiration to protect its most vulnerable members. An awareness of that friction invigorates British-born sculptor Darrell Viner's installation from 2000, *Is Tall Better Than Small?* Consisting of nothing more than square steel plates, individually connected to pneumatic rods that move upwards and downwards over the heads of people on an escalator, the contrivance appears to be measuring each participant's height, as though the resulting calculation might qualify or disqualify participants for some undisclosed activity at the top of the moving stairs. Ultimately, there was nothing for which the apparent selection or deselection process was in service. Rather, the apparatus served as an elaborate allegory for every species' uncertain conveyance into the future.

One strand of that unpredictable future has, for many scientists and artists alike, involved imagining the relationship between mankind and synthetic forms of life with which the coming millennia may well be populated. For their 2006 installation *Bion*, American conceptual artists Adam Brown and Andrew Fagg assembled 1,000 small consoles that dangle from different lengths of electrical wire from the gallery

ceiling, each one an artificial consciousness comprised of sensors, a speaker, a processor and blue-light emitting components. The suspended snowfall of glimmering diodes chime ethereally as observers approach. Once in close proximity to the congregation of bungeed brains, the visitor's presence is detected, triggering a sudden shushing of the devices: a silence that ripples across the room in waves. In time, the artificial minds acclimatize to the persistence of the stranger and soon incorporate him or her into the rhythm of resumed music and pulsations of light.

What Brown and Fagg created, in effect, was a synthetic ecosystem capable of accommodating human intrusion, re-establishing a beautiful balance of shimmer and sound that suffers no lasting damage from man's encroachment. For many artists experimenting in the past quarter of a century, an increasing awareness of the fragility of a world ecosystem less resilient and infinitely more complex than that of *Bion* has provoked a reassessment of the relationship between environmentalism and art. For these artists, immersion in and collaboration with natural processes produces more powerful work than observing passively from outside and requires a deeper and more scientific understanding of the environment around us. Foremost among them is Danish-Icelandic installation artist Olafur Eliasson, whose vast and all-enveloping work *The Weather Project* attracted over two million visitors to Tate Modern's Turbine Hall when exhibited for six months in 2003–4. Through a complex choreography of hundreds of monofrequency yellow lamps compressed into a huge suspended disc, massive humidifiers generating a mizzle of sugar and water, and an enormous expanse of mirroring foil mounted to the hall's ceiling, Eliasson managed to magic dusk indoors. Observers, swaddled in apocalyptic mist, seemed compelled to lie down, funereally, and watch themselves silhouetted into nothingness in the anonymizing reflection above them. Against a backdrop of increasing concern about the potentially catastrophic effects of climate change and global warming, the artist's dazzling alchemy of simple elements into awesome spectacle was tinged with portentousness, as though he had built a mausoleum for the setting sun.

Where Eliasson manufactured an illusive facsimile of a singularly unreplicable resource, Australian bio-artist

130 **Olafur Eliasson**, *The Weather Project*, 2003–4. Monofrequency lights, projection foil, haze machines, mirror foil, aluminium and scaffolding

131 (opposite top) **Daro Montag**, from left to right: *This Earth 1* (detail), *This Earth 6* (detail) and *This Earth 9* (detail), all 2006. Digital print made from film decomposed by soil microorganisms

132 (opposite bottom) **Ken Goldberg, Sanjay Krishnan, Fernanda Viegas and Martin Wattenberg**, *Bloom*, 2013. In this internet-based earthwork, ground motion along the Hayward Fault in California is detected by a seismograph and transmitted continuously via the internet to generate an evolving colour field

Natalie Jeremijenko engaged in the actual cloning of natural organisms for her ongoing organic work *One Tree(s)*. The first phase of Jeremijenko's project began in 1999 with the replication of 1,000 fruitless walnut trees from the genetic material of a single *Paradox Vlatch* found in Modesto, California. Her aim is to reveal how otherwise biologically identical beings experience very different futures when brought up in unequal conditions. In the artist's mind, these 1,000 trees, which were subsequently planted across the Bay Area in widely divergent communities and microclimates, are ever-changing aesthetic surfaces on which observers can mark the subtle changes in their respective and collective environments. Although Jeremijenko relied on scientific methodologies for the inception of *One Tree(s)*, her ultimate goal is to demonstrate that the clinical fact of genetic sameness is not enough fully to determine the shape and texture of any given life and that there is no inevitability to the opportunities enjoyed by individuals or communities.

British microbial artist and Professor of Art and Environment at Falmouth University, Cornwall, Daro Montag shares Jeremijenko's belief in the artistic aptitude of the natural world and in its ability to create works that are at once alluring and enlightening. What distinguishes much of Montag's work is its emphasis on vestigial traces of organisms in situ and its fascination with art as evidence of organic interactions. For his 2006 project, *This Earth*, the artist planted ribbons of film in moist ground for several weeks. The collagen-coated surfaces of the buried acetate became a kind of dance floor for grooving microbes, whose every mysterious two-step and pirouette was recorded. Once excavated, the films revealed in splotches of dazzling discotheque colour a buzzing nightlife of microscopic shimmying that scientists knew occurred but had rarely seen so vibrantly. Montag's absorbing cultures are intended to draw society's attention to hidden levels of endangered beauty that may be lost altogether if the environment is not protected from the toxicity of waste that threatens the survival of the minuscule craftsmen responsible for the making of his work.

The works of Jeremijenko and Montag rely for their forcefulness on a shared opinion that the earth and the ecosystems that comprise it are fragile and that disturbing

the delicate equilibrium in which they are precariously held poses risks not only to the future survival of the planet as a whole but to the beauty contained therein. Seen from another angle, however, such as that adopted by a team of collaborative artists and academics that includes Ken Goldberg, Sanjay Krishnan, Fernanda Viegas and Martin Wattenberg, the earth is not most profoundly understood as a meek victim, but rather as a formidable entity capable of astonishingly destructive power that can be harnessed and converted into compelling art. For their 2013 work, *Bloom* [132], the team devised a way of translating through the internet seismic vibrations detected along the Hayward Fault in California (which a consensus of geologists has concluded is overdue for a major event) into an ever-changing ripple of concentric multicoloured blossoms. Every computer screen that is linked to the real-time visualization of converted data plays menacing host to a constant shudder of kaleidoscopic circles, the haphazard design and frequency of whose rhythms depend entirely on the tectonic movement of the geological plates that extend beneath the Berkeley campus of the University of California. The more active and potentially dangerous the subsurface activity, the more elaborate and enticing the artwork appears. The result is a work that places into terrifying opposition its own aesthetic dynamism on the one hand and the physical well-being of those who live in one of the most populous and desirable regions of the world on the other.

Bloom dislocates the seismograph from its utilitarian and scientifically calibrated purpose into a discretionary device capable of generating beauty as well as fear.

For another group of innovators, James Auger, Jimmy Loizeau and Stefan Agamanolis, society's accelerating reliance in recent years on mobile communication is responsible for widespread complacency in its attitude towards the telephone: a truly wondrous gadget that culture has come to take for granted. As a rejoinder, the artists collaborated on the creation of the *Iso-phone* (2004): a telecommunication appliance devised for use between two people whose bodies are concurrently submerged in water in separate locations. Comprised of fibreglass astronautical helmets with three radiating spokes, which are, in turn, attached to spherical floats (so that the head of each wearer is at the centre of

133 **James Auger, Jimmy Loizeau, Stefan Agamanolis**, *Iso-phone*, 2004. Fibreglass, aluminium and electronic media

134 **Carsten Höller**,
Umkehrbrille (Upside Down Goggles), 1994 / 2009. Acrylic glass prisms, aluminium, polyethylene, polypropylene, foam, leather and nylon

135 **Christian Moeller**,
Do Not Touch, 2004. Stainless steel, PVC, electric fence system, loud speaker

the respective solar system of bulbous buoys), the *Iso-phone* enables users to drift weightlessly through water while conducting their conversation. Once fitted, the futuristic helmet cancels all external sensory distraction. Before long, the consciousnesses of the speakers, suspended in body-temperature water, become one with each other's disembodied voice. Where technology increasingly attempts to hide the science behind inventions by integrating them seamlessly into our lives as though they had always existed, the *Iso-phone*'s inherent cumbersomeness of design is intended to keep at the forefront of our minds the material weightiness of scientific research that makes our life-changing gadgets possible.

If one senses something mischievously subversive in the inception of the *Iso-phone*, whose awkwardness of operation yet purity of experience is curiously at odds with the balance of convenience and quality we expect from technological gizmos, consider the truly disorientating invention with which Belgian artist Carsten Höller has been tinkering since 1994: *Umkehrbrille* (*Upside Down Goggles*). Resembling a cross between the bulky equipment that ophthalmologists use to assess a patient's vision and futuristic eyewear, Höller's contraption confounds the expectations of its wearers by dramatically hampering one's ability to perceive the world around him or her rather than improving it. Hidden mirrors within the goggles, tilted just so, turn the world on its head and make walking from one place to the next a nauseatingly dangerous experience. The enduring effect of wearing Höller's preposterous spectacles is a profounder appreciation of those ordinary devices of which we make use unreflectively every day and of the science that informs them.

The *Iso-phone* and *Umkehrbrille* remind us that science and art are both experiment-based pursuits whose results are unpredictable. Not every work works or yields the desired result. Risk is an essential component of the unfolding narratives of both disciplines and is something that observers of created work, as much as the innovators of it, must be prepared to take. Or so German artist Christian Moeller's installation, *Do Not Touch* (2004), wittily suggests. The work consists simply of a metal pole situated in a gallery, encircled by a large sign on the floor that emphatically warns visitors not to touch the rod. Nothing, however, apart from the

verbal instruction not to do so, has been erected to prevent anyone who wishes to defy the sign. Installed in London's Science Museum in 2004, the work proved an irresistible dare that seemed to tease visitors into taking risks, without which few scientific discoveries would have ever been made. As a destabilizing double-bluff, those who resolved to disobey the warning were zapped with a mild electric current as an alarm sounded, thereby reminding observers that works of art and works of science, while motivated by similar impulses, are nevertheless distinct cultural shapes capable of shocking our senses in different ways.

Colours True and False:
The New Abstract Art

When NASA began releasing images of our galaxy captured by the Hubble Space Telescope, following the device's launch into orbit from the John F. Kennedy Space Center in Florida in April 1990, initial public reaction was sheer dazzlement at the otherworldly beauty that they revealed. Then came the questions. Among the more persistent concerns raised was whether the spellbinding pictures corresponded faithfully to what the human eye would actually see from such a cosmic vantage or whether the breathtaking hues had been artificially manipulated. Experts in astrophysics soon found themselves attempting to explain the philosophical difference between so-called 'true' and 'false colours': the difference between what the unaided eye perceives and what is depicted by the craft's sophisticated imaging equipment not as reliable colour as we know it, but as heat, mass and moisture. For NASA, no less than such pioneering forebears in the fledgling field of Abstract art a lifetime earlier as Kazimir Malevich, Wassily Kandinsky and Piet Mondrian, colour was understood as a relative dimension of a thing's existence, a property that can at once be embellished and prised free from an object's essence and appearance: a vehicle released into the unknown. Indeed, the debate over the authenticity and variableness of colour at the beginning of the 1990s might be seen as a metaphor for the recommitment at that same moment by some of the world's most gifted contemporary artists to the transcendent role of colour in art as an utterly abstracted property, disconnected from material form.

Several artists whose names were already key to the unfolding narrative of abstraction before the end of the 1980s embarked upon significant new phases of their work even amid premature predictions by some commentators that painting in general and abstract painting in particular had exhausted their ability to surprise. Crucial to that forward propulsion of abstract art's power have been veteran American abstractionist Ellsworth Kelly, English Op Art exponent Bridget Riley, German painter Gerhard Richter and Irish-American artist Sean Scully. In the case of Kelly, who had resolutely turned from figurative

136 **Ellsworth Kelly**, *Curves on White (Four Panels)*, 2011. Oil on canvas, four panels

137 **Gerhard Richter**, *16. Nov. 06.*, 2006. Oil on paper

painting to abstraction since the end of the 1940s (when the artist was in his mid-twenties), the last decade of the millennium saw a reassertion of hard-edged and gestureless works preoccupied with single colours fitted to simple non-geometric shapes. Although the forms that Kelly's paintings and sculptures take are doubtless intended to remind observers of the natural world – sea and sky, earth and light – the perfection with which they are rendered feels deduced, as from a scientific equation, as though his works are the calculated proof of a forgotten theorem.

No such semblance of mathematical exactitude is conjured by the abstract paintings that Richter has continued to create over the past quarter of a century. Since the late 1960s, the Dresden-born artist has plotted his achievement along two diverging axes of vision – realism and abstraction – refusing to allow one to be the enemy of the other, or for either to contradict the other's appeal. Indeed, it was during the process of discovering how best to capture blurriness on black-and-white photographs that Richter, renowned for his photorealism, hit upon the technique for which his subsequent abstract work has become distinctive. By tugging a handcrafted squeegee across random layers of paint in varying states of tackiness – now pulling it from left-to-right, now top-to-bottom – Richter creates an abrasive plane of controlled accidents, where paint and pressure interact with arresting unpredictability. The resulting works delight in their utter detachment from the observable world and fizz with a haphazard beauty all their own.

For British-born Riley, who established her reputation in the 1960s with line paintings whose illusory and optically complex patterns triggered strong cognitive responses in viewers, the 1990s witnessed a reawakening of the possibilities of colour for colour's sake, facilitated not by the representation of realistic form mimicked from nature but the simplicities of repeating rhythms. Riley's so-called 'lozenge' paintings from this period – a term usually associated with Piet Mondrian and the cockeyed orientation of some of his square works, whereby they hang like diamonds from one of the corners – seem at last to fulfil her youthful assertion about the possibilities of abstract painting [138], formulated decades earlier: 'For me nature is not landscape but the dynamism of visual forces – an event rather than an appearance. These forces can only be tackled by treating colour and form as ultimate identities.'

Bridget Riley

138 **Bridget Riley**,
June, 1992–2002.
Colour screenprint

Colour, as the only ground from which true identity can be excavated, has likewise been the fascination of Dublin-born Scully's work. The trajectory of the Irish abstractionist's visual language, since the tight weave of his masking-taped 'Supergrids' in the 1970s to the loose and unmeasured matrices of broad blocks of layered colour that characterize his mature series 'Wall of Light', is consistently away from the kind of fastidious retinal precision on which Op Art relied. The power of Scully's work, discernible in a surge of concurrent later sequences of large-scale oil paintings, including *Cut Ground* and *Landline*, lies in part in the artist's ability to create the sense of a geological compression of colour in his work, whose layers can seem illuminated from a source trapped deep inside them. The result of his archaeology of light are works that seem at once ancient and new. The ambition to breathe new life into archetypal form invigorates, too, the artist's ongoing series *Doric*, whose solemn masonry of monochrome slabs invokes the meditative spirit of the oldest and purest of the classical architectural orders. So elevating is the lucency that vibrates from the stonework of Scully's paintings, the songwriter Bono has called him 'bricklayer of the soul'. In Scully's 2013–14 painting *Lear*, comprised of six huge oil-on-aluminium panels, a sense of the disintegration of the Shakespearean protagonist's psyche and crumbling material empire is conveyed in the static shuddering of the work's constituent blocks. The tension between the collapse of Lear's physical self and the departure of his spirit is movingly and forcefully captured in the ambiguity of drips that weep from the edges of Scully's grids, at once tethering them to the shared earth and forever propelling them heavenward.

Scully, like Rothko and Jackson Pollock before him, confounds our expectation of a painting's vanishing points by foregrounding the philosophy of colour over the illusion of perspective. For a number of younger artists, including Los Angeles-based Mark Grotjahn and German-born Tomma Abts, the illusion of spatial depth in a two-dimensional work of art, disconnected from any material objects occupying it, becomes the vehicle for investigating the complexities of pure colour. Since the mid-1990s, Grotjahn has explored, through an ongoing series of works known as the butterfly paintings [140], the segmentation of the canvas's surface, and our perception of it, by constructing converging webs of splinter-shaped

139 **Sean Scully**, *Lear*, 2013–14. Oil on aluminium

140 **Mark Grotjahn**,
Untitled (White Butterfly),
2002. Oil on linen

141 **Tomma Abts**,
Fewe, 2005. Oil and
acrylic on canvas

planes, like a window shattered by a stone. Often collapsing into contradictory points, these sharp shards of contrasting colour crack our confidence in the stability of the work's coordinates and seem simultaneously to implode inward and to flash out.

As with Grotjahn's works, the colour palette adopted by Abts tends to be subdued, if not world-weary in its earthiness, although the compositional strategies that her paintings employ make use of a broader array of geometric patterns, intersecting lines and disrupted rectilinear rhythms. As with Scully's paintings, the richness of Abts's surfaces stems from the tireless over-painting of a work's constituent shapes. As a result, the organic spidering of straight lines and colliding contours in her work establish an inimitable grammar, punctuated by uneven shadow and erratic texture. All of the artist's works are the size and orientation of a small portrait (48 by 38 centimetres; approximately 19 by 15 inches) and bear titles borrowed from a German glossary of recognized names, qualities that invest Abts's ever-evolving project with the profundity of unreplicatable personality, as though each work were encoded with a unique genetic signature: the abstraction of an individual self.

Given the liquidity of the line between what is representational and what is abstract, it is perhaps not surprising that several artists of the period have quenched their imagination exploring the very possibilities of the line itself as a dominant component of their art. By the close of the 1980s, an expertise in Eastern calligraphy that New York-based draughtsman and painter Brice Marden had begun cultivating, triggered a radical transformation in the artist's expression. An austere minimalism that had previously characterized his work (until then preoccupied with broad blocks of monochrome colour) gave way to a tangle of thin sinuous curves echoing the cursivity of non-Western writing [142]. The result has been a sustained experiment in the unravelling of visual meaning from an ever-loosening slipknot of linguistically indecipherable scrawl.

An instinct provoked by Marden's work – that, if stared at long enough, his dishevelled lines might suddenly tighten into the legibility of language or recognizable form – is likewise manipulated by the playful imaginations of Venezuelan-born Arturo Herrera and Los Angeles-based sculptor Liz Larner. Wrapping thin steel rods with mulberry paper tinted with watercolour, Larner constructs ostensibly simple geometric models of what appear to be empty oversized chemical

142 **Brice Marden**,
Weaver Letter, 2010–11.
Oil on linen

molecules, whose shapes are weirdly warped, as though dragged through a wormhole from another dimension. The distortion of regular volume, as in Larner's *2 As 3 And Some Too* (1997–98), forces the observer's attention to the bent edges that determine the framework's integrity. In her awkward armature, colour is thinned to mere insinuation at the very margin of a thing's existence.

A significant strand of Herrera's work has been the seamless merging of areas of abstract lines on the surface of a work into iconic cartoon forms, suspended in vignettes of unfinished animation. The mingling of the abstract with the minimally representational succeeds in freezing each work ambiguously, leaving observers to question whether the image before them is slowly slipping loose or gradually grouping itself into readability. So memorable are Herrera's deft entanglements of form that even his purely abstract works, such as *Say Seven* (2000), comprised of strings of dangling felt, seem forever on the verge of weaving themselves into conventional shapes.

An ironic ambidexterity that draws the imagination simultaneously to the world of the apparent frivolousness of fleeting cartoon animation and the potential poignancies of pure paint also distinguishes the work of German abstract painter André Butzer [145]. The artist swivels restlessly between large-scale works of cramped carnivalesque expressionism, where a riot of caricatured forms and contorted faces rendered in trippy colour compete for space, and more muted works of controlled childlike scribble set against a timelessness of cold cerebral greys. When working in the latter tendency, Butzer's irregular and enigmatic lines appear at once to float to the surface of the work and to be devoured by it, as though all human attempts to scratch and scrape at eloquence are doomed to inarticulacy. The impression he creates of images drowning in the medium in which they were nearly enunciated is in accord with the technique of such fellow German contemporaries as Albert Oehlen and Charline von Heyl.

For an exhibition of new work in 2014 entitled 'Finger Paintings', Oehlen seized on advertising logos as the ground upon which to choreograph his idiosyncratic skirmishes of spills, streaks and splotches [146]. The images that emerge have the feel of luxurious vandalism: an elite graffiti that is too aesthetically self-conscious to be pushing any serious antisocial agenda. For von Heyl, the inarticulacy of language goes

145 **André Butzer**, *Untitled*,
2008. Oil on canvas

147 **Charline von Heyl**,
Momentito, 2009. Acrylic,
pastels and charcoal on linen

146 **Albert Oehlen**, *Untitled*,
2012. Oil and paper on canvas

hand-in-hand with an intriguing indeterminacy in the meaning of her work. At the centre of her 2009 painting *Momentito* [147], a square white clearing, resembling a window, has opened itself amid a murky chaos of scuffs and dingy scribbles. Through the pristine aperture a crumpled blare of cursive lines is either being blown into the conscious surface of the work or reeled from it forever: the music of a fledgling enunciation frozen on the verge of decipherability.

Straddling the fault line where the plates of ephemeral and enduring utterance clash, Butzer, Oehlen and von Heyl find themselves in aesthetic territory that Vienna-born Austrian artist Franz West has endeavoured to survey for more than thirty years. In 2008, West unveiled in New York City's Central Park what many saw as the epitome of the artist's career-long effort to challenge the pretentiousness of conventional art forms while at the same time investing the seemingly absurd with layers of unexpected seriousness. *The Ego and the Id*, a large aluminium sculpture consisting of looping swirls of vibrantly coloured beams, dared passers-by to overcome their intimidation to engage unselfconsciously with a work of art and to use the piece as a joyful urban perch, as if, in West's imagination, his work were the very thread that could mend the paralysingly alienated selves of Freud's theory of our divided being.

By winnowing the viewer's focus down to the slimmest component of visual expression – the line – such artists as Marden and West endeavour to disentangle from centuries of conventional representation of form the most basic element of artistic creation from which all else stems: the coordination of eye and mind, hand and soul. A similar instinct motivating the work of contemporaries has been to strip away even the seemingly irreducible line itself and to draw attention to the very surface upon which artistic expression is made: to make textile itself the underlying texture of their concern. For Scottish artist Karla Black, emphasizing the fragile materiality of a work's fabric has meant fabricating surfaces from unexpected and unpredictable ingredients such as chalk and plaster powder, investing her otherwise monumental works with a friable ephemerality that feels philosophically akin to human perishability. The wadded tenuousness of Black's cellophane sculpture, *Pleaser* (2009) [149], which droops like a crumpled chrysalis and transforms the space it occupies into

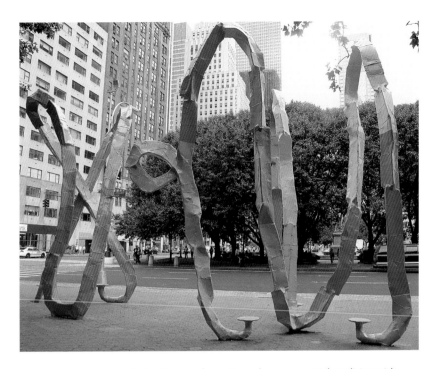

a realm of ghostly transformation, shares essential qualities with Californian artist Tauba Auerbach's recent 'fold paintings' [150] and German abstractionist Anselm Reyle's 'foil paintings' [151]. The three-dimensionality of sharp creases and pleats registered deep into the integrity of a linen canvas, which Auerbach subjects to intense twisting and pinching, is augmented when the surface is subsequently spray-painted. The resulting works create the illusion of low-relief sculpture, the beauty of whose false topographies of shadow and ridge betray the trauma they have suffered in their innovative creation, recalling the severe 'spatialism' of pioneering Italian artist Lucio Fontana's controversial slashes into monochrome canvases over half a century earlier.

For Swiss-born painter Liliane Tomasko, the tight linen weave of a conventionally painted surface is also a riddle to be unravelled. Typically working from Polaroid photographs of dishevelled heaps of contrasting fabrics – towels and rugs, curtains and sheets – Tomasko magnifies her subject and blurs the observer's focus out of all proportion, exploding any discernible connection between the deep rich colours of the materials she is depicting and the everyday functions they serve. What emerges is a mysterious intertwining of inspiration and

148 **Franz West**, *The Ego and the Id*, 2008. Lacquered aluminium, in three parts

149 **Karla Black**, *Pleaser*,
2009. Cellophane, paint,
Sellotape and thread

150 **Tauba Auerbach**, *Untitled
(Fold)*, 2012. Acrylic paint on
canvas on wooden stretcher

151 **Anselm Reyle**, *Untitled*,
2005. Mixed media on canvas,
acrylic glass

152 **Liliane Tomasko**, *Vestige*, 2012. Oil on linen

process – the material painted and the painted material – that forces us to reflect on the very essence of seeing and making. As the title of her painting *Vestige* (2012) implies, Tomasko's vision is concerned less with what *is* than what *was*, more with the presence of absence than with what is physically palpable in the here and now. For her, colour rarely denotes the thing itself but rather constitutes a vibrant echo of a reverberating memory: the invisible threads that connect the past to the future, the self to the soul.

Synchronizing the rhythms of one's own psyche with traditional patterns of the culture and history in which one is immersed became the motivating energy behind the work of several abstract artists whose reputations were forged during the period. For Brazilian painter Beatriz Milhazes, Ethiopian-born American artist Julie Mehretu, Ghanan-born Nigerian sculptor El Anatsui, and Romanian-born German multimedia artists and twin brothers Gert and Uwe Tobias, abstraction has provided a means of merging a still emergent Western visual vocabulary with fresh accents, inflecting work with cultural traditions often overlooked in the story of modern art. Influenced equally by the hard-edged lines and optical complexities of Bridget Riley as well as the rainforest atmosphere of her native region – its humid blend of glitter and darkness, dazzle and danger – Milhazes has succeeded in keeping fresh an abstract tradition in Latin American that stretches back to the early 1950s [153], when Swiss artist and early proponent of Concrete Art Max Bill staged a retrospective in the São Paulo Museum of Modern Art, igniting interest.

For Mehretu, whose family fled a junta-controlled Ethiopia in 1977 when she was seven years old, the plane on which art unfolds is itself a contested site of conflicting media, where layer after layer of pen-and-ink and dynamic slashes of acrylic paint, the half-hints of architectural blueprints and corporate ledgers, vie for control. The result is a suspended explosion of disjointed marks, an unsettling and unsettleable flurry of signifiers, severed from any sense of sensible context [154].

That a brutal beauty is capable of being sculpted out of detritus and destruction is likewise an instinct that drives Anatsui's art. Known for his enthralling large-scale wall hangings that, from a distance, resemble huge curtains of crumpled kente cloth (a sacred weave of silk strips native to western Africa), Anatsui constructs his sculptures from the discarded remains of crass consumerism: plastic soda caps and the cheap aluminium

153 **Beatriz Milhazes,**
As Irmas (The Sisters), 2003.
Print on paper

155 **El Anatsui**, *Dusasa II*,
2007. Found aluminium and
copper wire

154 **Julie Mehretu**,
Stadia I, 2004. Ink and
acrylic on canvas

seals of liquor containers. These salvaged materials are crushed, pierced and sewn together by wire into recycled mosaics of rehabilitated materialism [155]. Anatsui's art attempts to stem the avalanche of colonizing waste that threatens to crush the resources and future of Africa.

Transylvanian sculptors Gert and Uwe Tobias are similarly committed to the rehabilitation of forgotten folk symbolism and to the antique techniques once used to convey them. To inspect one of the twins' sprawling woodcut combines, constructed with the use of traditional tools, is to find oneself lost in a jigsaw of surreal shapes and fragments of Romanian visual lore: a riddle of repeated patterns that recall Joan Miró's early fascination with harlequins. But in the hands of the Tobias brothers, an abandoned biomorphism that had invigorated European art almost a century earlier has been resuscitated and laced with allusions to indigenous decoration and customary dress. Like Anatsui, the brothers Tobias look forward by reaching back to configurations of colour, textures and form that, by being old, once again feel new.

Circles are a recurrent and endlessly redefined shape in Gert and Uwe Tobias's work: now suggesting an abstracted abdomen or head, now a stylized flower, or sun or star. The obsession with such an elastic signifier is one shared by Mexican conceptual artist Gabriel Orozco, who has variously experimented in his work with a comically elongated soccer ball, an elliptical snooker table, and a cycle that lacks both handlebars and a seat, but features instead superfluous wheels sprouting upwards and outwards from its frame at every angle. Orozco is keen to challenge our confidence in the laws of physics that govern our surroundings. For a series of so-called *Samurai Tree* paintings, begun in 2004, Orozco devised a complex schema of computer-segmented circles comprised of carefully calibrated quadrants and half-moons, the position, size and orientation of each being calculated from those created before it. Once the elaborate grid has been drawn, each quarter- and semi-sphere is then painted either individually or to bleed into a background field to create a branching system of static spinning that at once echoes the exponential divisions of life on earth while mirroring the endless rotation of planets and galaxies above.

A preoccupation with capturing the essence of universal forces and how they reflect the urges of the human body and the human mind is likewise at the heart of the work by

156 **Gert & Uwe Tobias**,
Ohne Titel / Untitled, 2007.
Coloured woodcut on paper

157 **Gabriel Orozco**,
Prototype, 2004. Synthetic
polymer paint on canvas

Mumbai-born, London-based sculptor Anish Kapoor and Irish artist Guggi. Where Kapoor's sculptures throughout the 1980s conscientiously absorbed accents of Indian culture, often echoing its unique architecture, since the beginning of the 1990s he has adopted a more abstract visual language that strives instead to transcend the particularities of any one heritage or region. The result is works, like the colossal *Cloud Gate* (2004) sculpture that oozes mercurially in Chicago's Millennium Park, that seem at once primordial and futuristic, retro and refined. His 2006 red resin sculpture, *Inwendig Volle Figure*, a slender didgeridoo-like horn that flares into a whistle of pursed lips, seems designed to drown out the distinction between inner and outer senses. Is this the smooth shoot through which souls are shot into the world or the oversized eardrum of God? Also profoundly disbalancing in its exaggerated scale is Guggi's 2009 sculpture *Calix Meus Inebrians* (or 'cup runneth over'): an enormous steel chalice whose bowl rises in open-mouthed awe to the Provençal sky. At once intoxicating and ascetic, indulgent yet austere, the deep concavity of Guggi's work serves as a soulful symbol of the abstracting instinct of artists who manage to distill enduring beauty from a disposable world.

158 **Guggi**, *Calix Meus Inebrians*, 2009. Painted bronze

CHAPTER 9

The Language Generation: Using Words in Art

In 1990, a new term entered global discourse: 'emoticon', a hybrid of the English words 'emotion' and 'icon'. While the use of a keyboard's punctuation marks to approximate facial expressions – such as a colon followed by a parenthesis to create a smiling face when read sideways – had already been gaining currency among computer programmers throughout the 1980s, the sudden demand for a dedicated term for such sign language signalled an unexpected broadening of its appeal. The rise of electronic correspondence over the internet and short message texting on mobile telephones in ensuing years would provide convenient digital platforms for ordinary individuals to adopt such visual shorthand as part of their everyday dialogues. Before long, the interjection of crude images depicting animated faces (now winking, now frowning, now sticking a hyphenated tongue out) into emails and mobile phone text messages – modes of communication designed chiefly for the conveyance of words – had become second nature to millions of people. Not since the heyday of hieroglyphics had the boundary between language and figuration been so smudged, as the two weaved themselves into the grammar of the other.

Art chronicles the preoccupations of a culture and the use of written language within the visual field has countless antecedents in earlier eras – from the famous writing on the wall in Rembrandt's *Belshazzar's Feast* (1636–38) to Pop Art's fascination with advertising slogans. But the years that followed the minting of the word 'emoticon' in 1990 have witnessed an intensification and proliferation in the blurring of borders between what is read linguistically and what is comprehended pictorially.

The work of several artists best known for their experiments with the intertwining of word and image throughout the 1970s and 1980s was crucial to the transition from what the Metropolitan Museum of Art labelled in an exhibition in 2009 'The Pictures Generation' (which applied to artists devoted to the appropriation of consumer images) to what might be called 'The Language Generation'. American artists Barbara Kruger, Jenny Holzer, Ed Ruscha, and Richard

Prince are four such pivotal figures. Famous in the late 1980s
for her stark blending of arresting monochrome photographs
with socially sharp slogans (such as 'Your body is a battleground'
and 'I shop therefore I am'), Kruger proceeded, throughout
the next two decades, to amplify the incorporation of words
and phrases in her work by constructing elaborate installations
that made use of the full interior of rooms and institutions
as reading surfaces. Viewers of her work would no longer
be able to turn away from the confrontational language of a
single poster but would find themselves entirely enveloped,
architecturally, by often aggressive verbiage that variously
posed questions ('Who Speaks?' 'Who is Silent?') and proposed
riddling linguistic equations ('Belief + Doubt = Sanity'). Kruger's
syllabically suffocating interiors covered not only the whole
wall space, but also the floors and ceiling of the galleries they
occupied. Language no longer served as a means for ironically
tagging social tensions, but consumed the spaces in which
society conducted itself, dictating its very dimensions.

Like Kruger, Ohio-born Holzer rose to prominence in the
late 1970s and throughout the 1980s by making unexpected use
of pithy expressions, or of what she referred to as 'truisms':
self-fashioned aphorisms that the artist would emblazon onto
T-shirts, public property and LED sign boards. By the mid-1990s,

159 **Barbara Kruger**,
Belief + Doubt, 2012–14.
Vinyl installation

In the projection image, the following text is visible:

CE QUI RESTE ... REGARDER
SUR LA COUVERTURE J'AI PLUS DE COULEURS
EST CLAIR ET QUE ... L'AUR...
A LA COULEUR DE L'ENFER ... E TROU

Holzer began projecting at enormous scale extracts from poets and novelists, typically articulating politically activist sentiments, onto the exteriors of prominent structures across the world. For Holzer, words could no longer be content to occupy fields designed exclusively for linguistic expression but scroll across all that we behold.

For Prince, the shift from the attention he attracted in 1980s with his now notorious 'joke paintings' (acrylic silkscreened canvases that feature nothing but the text of often witless witticisms, such as 'I never had a penny to my name, so I changed my name.') to the age of the emoticon would require him to reassess the requirement of imagery within a visual work. Among the results was a series of lusty 'Nurse paintings' begun in 2002, based on the covers of lurid dime-store novels from the 1950s and early 1960s, the era of the artist's adolescence. Executed in a heatedly sketchy manner that was seemingly in accord with the crass throwaway fiction that inspired it, works such as *Mission Nurse* (2002) [161] and *Naughty Nurse* (2006) depict white-uniformed young women whose noses and mouths are invariably concealed by a surgical mask, the integrity of their countenances and bodies disturbingly compromised by the sloppiness of drippy paint that appears to be washing the figures away before our eyes. Also under assault in Prince's ribald

160 **Jenny Holzer**, *Projections (Paris)*, 2009. Light projection onto Louvre, Paris

161 **Richard Prince**, *Mission Nurse*, 2002. Ink jet and acrylic on canvas

THEHAR
DERYOU
LOOK
THEHAR
DERYOU
LOOK

162 **Christopher Wool**, *Untitled*, 2000. Enamel on aluminium

163 **Christopher Wool**, *Untitled*, 2005. Enamel on linen

rendering of the books' cover designs are the titles themselves, whose legibility is so hampered that the paintings are less a tribute to a written narrative than to the humid memory of the pubescent passions those stories excited.

The near obliteration of discernible language from the surface of Prince's work, which appears to rescind the invocation of words almost as quickly as their syllables are summoned, is emblematic of the verbal vision of several notable imaginations operating in the age. For the painter Christopher Wool, the sense of language's utter eradication has been obtained more conspicuously across different works rather than within the space of a single canvas. Throughout the 1990s, Wool, originally from Boston, attracted attention to two competing artistic predilections: one relying on an almost overbearing prominence of letters and words and the other suggesting their violent erasure. A word-painting such as one created in 2000 and featuring the enigmatic saying 'The Harder You Look The Harder You Look', whose letters are syntactically enjambed by the removal of spaces between words and the awkward breaking of spelling across lines, seems aesthetically at odds with any number of untitled works from the same moment. By stark contrast, works such as *Untitled* (2005) feature a scrawl of cursive lines, gesturally suggestive of written words, that have been obscured by blank smears. These works have the appearance of a hastily graffitied wall whose private undeciphered exclamations have been blotted out.

American artist Glenn Ligon's paintings from the beginning of the 1990s are likewise characteristic of the self-cancelling ambivalence that at once includes and excludes language from a visual plane. In *Untitled (Black Like Me #2)* (1992) [164], the Bronx-born black artist incorporates a phrase from a 1961 memoir of the same title that records the journey of a white journalist, John Howard Griffin, who, after altering the colour of his skin, travelled across the racially-divided American south. In Ligon's work, Griffin's anguished assertion 'All traces of the Griffin I had been were wiped from existence' is repeated over and over again such that an easy legibility of the phrase at the top of the work gradually descends into a dense and unreadable blackout of language at the bottom. Here, the slow erosion of language mirrors the writer's disappearance into the darkness of regional bigotry as powerfully as any purely pictorial portrayal of a lynching or a congregation of Klansmen

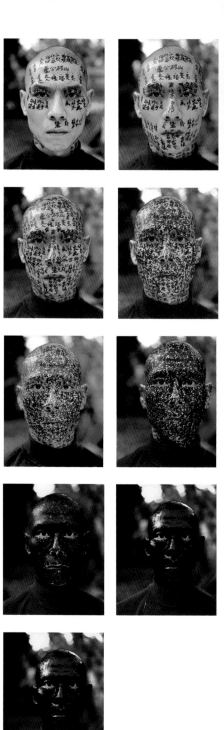

164 **Glenn Ligon**, *Untitled
(Black Like Me #2)*, 1992.
Oil and gesso on canvas

165 **Zhang Huan**,
Family Tree, 2000. Nine
chromogenic prints

could convey. In 2009, the painting was among a clutch of works selected by US President Barack Obama for display in his private quarters at the White House.

The eventual illegibility of repetition is also at the heart of Chinese artist Zhang Huan's series of photographic self-portraits, *Family Tree* (2000), a work that likewise suggests the slow dissolution of self in a culture of relentless iteration. The nine images that comprise *Family Tree* feature the artist's own countenance gradually being consumed by a mask of cursive words that a group of three calligraphers were commissioned to inscribe in black ink directly onto Zhang Huan's skin. The traditional folkloric texts that the calligraphers transcribed onto the artist's face were rendered unreadable by the density of inscription, which soon devoured the entirety of the artist's visage in unnerving darkness.

The words in Ligon's and Huan's works, uttered again and again until they can no longer recognize themselves, participate too in a significant trend of the age in which repetition and the physical reflex of writing become as important as the presence of the words themselves. For his work *2.2.1861* [166], begun in 2009 and still ongoing, Vietnamese-born Danish artist Danh Vo relies on the involvement of his father, Phung Vo, to transcribe continually and for each collector who buys a version of the work, the last letter that the condemned French Catholic Saint Théophane Vénard wrote to his father before he was decapitated in Vietnam in 1861. A record of each re-expression of Vénard's final communication is preserved in a ledger and retained by the artist before being posted to the individual or institution that has commissioned the new work: a performative component of the work's production considered crucial to its meaning. In Vo's imagination, the entire ritual of language's inscription, conveyance and eventual receipt by the intended communicant is as important as the aesthetic qualities of the calligraphic composition itself that visitors to a gallery are invited to see.

The ritual of transcription is likewise central to Indian photographic artist Dayanita Singh. For her series of works collectively entitled *Sent a Letter* (2008) [167], Singh compiled an intimate collage of images and words whose secret connotations are known only to herself and to the close friend or family member with whom she has undertaken a journey and shared the experiences necessary to comprehend the document. Before relinquishing each volume, which is always produced

20 janvier 1861.

J. M. J

Très cher, très honoré et bien-aimé Père,

Puisque ma sentence se fait encore attendre, je veux vous adresser un nouvel adieu, qui sera probablement le dernier. Les jours de ma prison s'écoulent paisiblement. Tous ceux qui m'entourent m'honorent, un bon nombre m'aiment. Depuis le grand mandarin jusqu'au dernier soldat, tous regrettent que la loi du royaume me condamne à la mort. Je n'ai point eu à endurer de tortures, comme beaucoup de mes frères. Un léger coup de sabre séperera ma tête, comme une fleur printanière que le Maître du jardin cueille pour son plaisir. Nous sommes tous des fleurs plantées sur cette terre que Dieu cueille en son temps, un peu plus tôt, un peu plus tard. Autre est la rose empourprée, autre le lys virginal, autre l'humble violette. Tâchons tous de plaire, selon le parfum ou l'éclat qui nous sont donnés, au souverain Seigneur et Maître.

Je vous souhaite, cher Père, une longue, paisible et vertueuse vieillesse. Portez doucement la croix de cette vie, à la suite de Jésus, jusqu'au calvaire d'un heureux trépas. Père et fils se reverront au paradis. Moi, petit éphémère, je m'en vais le premier. Adieu.

Votre très dévoué et respectueux fils.

J. Théophane Vénard

m. s.

166 **Danh Vo**, 2.2.1861, 2009.
Ink on A4 paper, writing by
Phung Vo

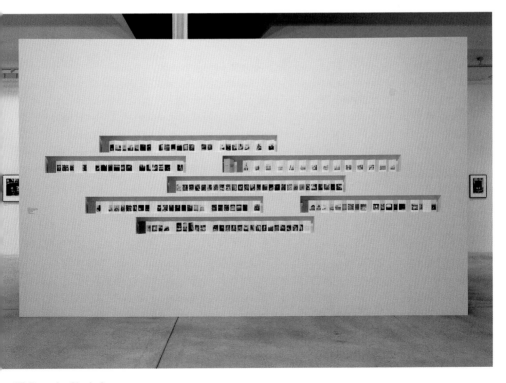

167 **Dayanita Singh**, *Sent a Letter*, 2008. Accordion-folded books, seven volumes

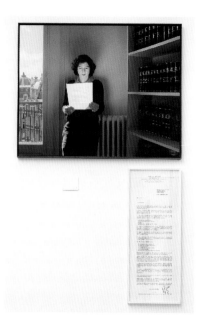

as an accordion of folded pages so that her former travelling companion can stretch the entire 'letter' out to create a private exhibition, Singh makes an identical copy of the object for herself, which she lodges in an archive that she calls her 'kitchen museum'.

For French writer and conceptual artist Sophie Calle's 2007 installation *Take Care of Yourself*, the repetition of words was less an intimate exercise reinforcing the profound connection that binds people than it was an elaborate display of how language can expose an unconquerable divide between individuals. The work consisted of 107 interpretations of an email that the artist had received from her lover ending their relationship. The painful message concluded with the disorientating and eponymous phrase 'take care of yourself'. Suddenly bewildered by the common expression, Calle invited women from a wide array of occupations to analyse the message from their unique professional perspectives. Among those asked to elucidate the upsetting correspondence were a clown, a tarot reader, an opera singer, an animator, a forensic psychiatrist, a puppeteer, a marksman, an expert on social manners, a chess champion, a copy-editor and a sexologist, each of whom managed to wring from the same set of words distinctly different inflections and meanings.

Distinct from common words, names occupy a unique linguistic position in everyday discourse, at once official and

168 (above left) **Sophie Calle**, *Take Care of Yourself. Lawyer, Caroline Mecary*, 2007. Portrait: fine-art print dry mounted on aluminium, wooden frame; text: lambda print dry mounted on aluminium, wooden frame

169 (above centre) **Douglas Gordon**, *List of Names*, 1990–ongoing. Vinyl text on wall. Installation view, Aargauer Kunsthaus, Aarau, 2010

170 (opposite) **Tracey Emin**, *Everyone I Have Ever Slept With 1963–95*, 1995. Appliquéd tent, mattress and light (destroyed 2004)

intimate, public and private. The commemorative exercise of inscribing or embedding this particular species of language into works of art has proved especially invigorating to the imaginations of contemporary artists. Six years before he won the Turner Prize in 1996, Scottish artist Douglas Gordon embarked upon a work entitled *List of Names* that is still ongoing to this day. Gordon's ever-growing roster is an organic repository of the identities of every person the artist can recall having met over the course of his life. In a sense, the artist's work is more a kinetic piece in which memory and gesture are coordinated, than it is an inert archive of the formal and informal appellations of each individual whose life has intersected with that of the artist.

For her controversial 1995 installation, *Everyone I Have Ever Slept With 1963–95*, British artist Tracey Emin adorned the interior of a nylon and polyester tent with fabric patches displaying the names of each individual with whom Emin has ever shared a bed. Unknowable to visitors who peered inside her work, however, was the true nature of the relationship that the names denoted or the intensity of intimacy that every stitch conveyed. For Emin, the private syllables of these sewn-on identities paradoxically inscribed a very public space when the tent was installed in a gallery: an indiscreet stunt that sensationally highlights the unique position occupied by every work of exhibited art, whose meanings are poised between what is secret and what is shared.

The concept of names embroidered on the sides of a fabric tent defined the coordinates of another notable work of art from the era: Palestinian artist Emily Jacir's *Memorial to 418 Palestinian Villages which were Destroyed, Depopulated and Occupied by Israel in 1948*. Comprised initially of a spotless white refugee tent that the artist displayed in a New York gallery in 2001, the work was quickly recognized by visitors for what it really was – a blank canvas on which those whose lives had been affected by the events of half a century earlier were invited to record either their own names or those of loved ones by sewing them onto the tent. Soon the walls and roof of the haunting cloth structure bore the accents of Palestinian survivors and Jewish immigrants to New York alike, as each contributor was eager to see some semblance of themselves woven into the fabric of a peaceful all-embracing shelter, threaded harmoniously onto the same plane of existence.

The works of Gordon, Emin and Jacir rely for their effect on acceptance of the static identities that individuals have been given by others: on the fixed names that the vast majority of us unquestioningly accept as signifying who we are. In assembling her most famous work, *Signs that say what you want them to say and not Signs that say what someone else wants you to say* (1992–93), British artist Gillian Wearing set out to discover what words we might assign to ourselves to indicate who we are at a given moment in our lives. The artist supplied willing participants whom she approached on the streets of London with a black felt-tip pen and a blank white card on which they were invited to record whatever self-applied caption or slogan they wished to be photographed holding. For one volunteer, the occasion provoked a confession of existential despair, as he marked out the words 'I'm desperate'. For another, Wearing's work was an opportunity to wax philosophical, stating 'Everything in life is connected, the point is to know it and understand it.'

For a number of artists, the instinct to merge the visual with the verbal is bound up with the urge to collapse the past into the present. Where the story of word and image throughout the twentieth century, from Cubism through to the disciples of Pop Art, had been the blurring of media that traditionally make a claim on endurance (painting and sculpture) with those shapes of culture that are necessarily disposable (newspapers, consumer advertisements and retail packaging), artists of the

171 **Gillian Wearing**, *I'M DESPERATE*, from the series *Signs that say what you want them to say and not Signs that say what someone else wants you to say*, 1992–93. C-type print mounted on aluminium

past quarter of a century have sought to inscribe a new chapter in which contemporary art facilitates instead the recovery of more cultivated enunciations, excavated from classical, scriptural and elite literary sources. A key leader for such an approach is the American expatriate painter Cy Twombly, who resided for more than half a century in Italy before his death in 2010. An intimate of Robert Rauschenberg's at a formative stage in his development, Twombly shared with the celebrated collagist a fascination with the power of cultural allusion to invest an otherwise static work with the kind of narrative movement that only words can conjure. Where Rauschenberg was inclined to appropriate iconic images drawn from contemporary sources, Twombly experimented instead with quasi quotation from a wider range of literary contexts, borrowing alike from classical myths and nineteenth-century European poetry. Scribbled chaotically across an untidy surface and obscured by childlike scrawls and pencil crossings-out, words and parts of words intended to connect a given painting to a literary antecedent in Twombly's paintings and drawings before the 1990s, gave way in the last years of the artist's life to more legible extracts of verse from Modernist texts such as Rainer Maria Rilke's *Les Roses* (1949).

172 **Cy Twombly**, *Rose (IV)*, 2008. Acrylic on wood panel

An unlikely disciple of Twombly's proclivity for epic verse, doodled disorderedly across the painted surface, is Japanese-born German performance artist Jonathan Meese. Cluttered set designs and associated visual props for Meese's idiosyncratic arrangement of Richard Wagner's opera *Parsifal* (based on a thirteenth-century poem by German poet Wolfram von Eschenbach) irreverently deconstruct names and language significant to the celebrated Arthurian cycle. As a child, Meese demonstrated a keen obsession with the manipulation of words, devising at a young age his own secret language comprised economically of the thirteen invented terms with which he believed anything could be expressed: a playfulness that continues to characterize his adult vision. The curious collision of scrappily executed illustration with literary excerpts has enlivened too the art of Raymond Pettibon, best known for his black-and-white India-ink cartoons, entangled with quotations taken from William Faulkner, Henry James and James Joyce. On occasion, we see an artist taking to the furthest extreme imaginable the merging of word and image by allowing the latter to overtake entirely not only the easy legibility of the former, but also any discernible trace of its utterance. British artist

173 **Christopher Le Brun**,
Walton, 2013. Oil on canvas

174 **Xu Bing**, *Book from the Ground*, 2003–ongoing. Works on paper

Christopher Le Brun's majestic painting *Walton* (2013) [173], for instance, conceals behind a mute blare of humid notes the names of the composer and opera that inspired his canvas in the first place (English composer William Walton's 1954 *Troilus and Cressida*), thus sublimating the syllables with which Le Brun had begun his work into faint accents that the eye must squint to hear.

The impulse to integrate into works of contemporary art enunciations from the literature of earlier eras implies a confidence in a language's ability to be revitalized when respired through fresh lips. By contrast, underlying much of the work of Chinese-born artist Xu Bing is the suspicion that language, over time, fundamentally erodes and requires a radical rejuvenation that mere recontextualization cannot achieve. Xu experimented early in his career with elaborate caricatures of Chinese symbols for his work *Book from the Sky* (1987–91), which comprised huge scrolls that drooped from a gallery's ceiling. Ornate and atmospheric, the work silently lampooned the satirized characters' meaninglessness, particularly when exhibited in English-speaking communities where the inanity of their senseless syntax and convoluted construction were unlikely to be spotted. *Book from the Sky* is a necessary antecedent for appreciating the ingenuity and power of a later work, the artist's ambitious *Book from the Ground* (2003–ongoing) [174]. An epic narrative expressed entirely in universal pictograms of the variety we encounter everyday in public facilities, on road signs and in the emoticon libraries of our mobile telephones, the work is at once universally accessible and insurmountably ambiguous. *Book from the Ground* constitutes, in many respects, the ultimate example of the age's determination to unite into a single emotive system the expressive powers of word and image.

CHAPTER 10 Timeline: The Key Detail

The preceding nine chapters have explored the themes,
techniques and cultural catalysts that have preoccupied artists
living and working in the tumultuous years since the late 1980s.
The aim of this final chapter is to reveal something of the forward
thrust of imagination in an age of turmoil by focusing attention
on a single key work from each year. By constructing such a
chronology, I hope to highlight more vividly the evolution of
creative consciousness in a period of unparalleled change.

1989

Keith Haring, *Ignorance = Fear*. Offset-lithograph on glazed poster paper

'Life is so fragile', American artist Keith Haring confided to his journal in July 1986, 'it is a very fine line between life and death. I realize I am walking this line.' His politically charged poster *Ignorance=Fear*, a comment on society's reaction to the AIDS crisis in the late 1980s, was created a year before he died of complications from the disease in February 1990. The work represents a heightened awareness on the part of Haring in the last phase of his life to maintain the same level of cultural critique that brought him to public prominence as a subway artist a decade earlier. Haring's ability to blur the lines between intimacy and activism, integrity and popular appeal would have an influence on the imaginations of many artists of the age.

Rebecca Horn, *Concert of Anarchy*. Piano, hydraulic rams and compressor

Dangling from the gallery's ceiling like a discordant chandelier, Rebecca Horn's upended piano alternates, every few minutes, between a composed silence (during which the lid is shut and the keys retracted) and an almost insufferable cacophony, when the instrument spills out of itself and an inharmonious music blares. Created a year after the fall of the Berlin wall in the artist's native Germany, *Concert of Anarchy* provides a fitting soundtrack to the ambience of upheaval that overwhelmed Europe. The dislocation of the object from its conventional setting, a music hall, is in harmony with other key works of the era including Tracey Emin's *My Bed*, also first exhibited in 1990, and Damien Hirst's *The Physical Impossibility of Death in the Mind of Someone Living*, unveiled the following year.

1990

1991

Christian Boltanski, *Monument Odessa*. Installation: lights, wire, photographs

Riffing off Marcel Duchamp's subversive notion of the 'readymade', Pop Artists like Andy Warhol recast everyday retail merchandise such as soup cans, Coca-Cola bottles and Brillo boxes as high art and dared us to articulate the difference. But what if the prefab 'found object' is death itself and the commodity being repackaged is the loss of innocence? These are the questions asked by French conceptual artist Christian Boltanski's chilling *Monument Odessa*, named after the Ukrainian town from which his grandfather hailed. Comprised of manipulated photographs of strangers (schoolchildren celebrating Purim, the Hebrew holiday of deliverance from destruction, on the eve of the Holocaust in 1939), Boltanski's work has the feel of a makeshift altar, haloed affectingly by a tangle of bare bulbs. Drawn instinctively to the work's eerie allure, observers are left to wonder for what, exactly, they have been called to pray.

Dorothy Cross, *Bull's Eye*. Dartboard, cow's teat, 26 darts

When we look at art, what is really in the firing line of our vision? The process of selecting works, whether for a museum or a home (or indeed a survey of contemporary art), involves a zeroing in on the efforts and imaginations of a few individuals in society at the exclusion of others. All too frequently, the work of women artists and those who live and labour far from the dominant geographic capitals of culture has fallen outside the line of critical sight. Irish artist Dorothy Cross invites us to consider the silent violence of looking by placing the vulnerable tissue of a protruding cow's teat at the centre of an actual target (a symbol of modern art since Jasper Johns began incorporating targets into his work in 1955). By making a crass caricature of female sexuality the object of the 'male gaze' (a feminist phrase perhaps punned upon by the work's title), Cross places in the cross hairs of her work the complex politics of seeing itself.

1992

1993

Jeff Wall, *A Sudden Gust of Wind (after Hokusai)*. Transparency in lightbox

A significant artistic impulse of the age has been to merge seemingly exclusive aesthetic genres. Canadian photographer Jeff Wall's large cibachrome transparency, which appears to capture the instant a powerful gale strikes pedestrians in a rural landscape, is representative of the instinct. In truth, there is nothing serendipitous about Wall's capturing of the moment, which he choreographed on separate occasions over the course of a year outside his native Vancouver. A painstaking fusion of some fifty individual scenes featuring actors, *Sudden Gust of Wind* is a meticulous composite based on a famous woodcut by the Japanese printmaker Katsushika Hokusai (1760–1849), *Travellers Caught in a Sudden Breeze at Ejiri* (c. 1832). By merging the techniques and patience of modern-day filmmaking with the drama of nineteenth-century Japanese illustration in order to create an illusion of spontaneous photography, Wall's work is in accord with the amalgamating imaginations of the era.

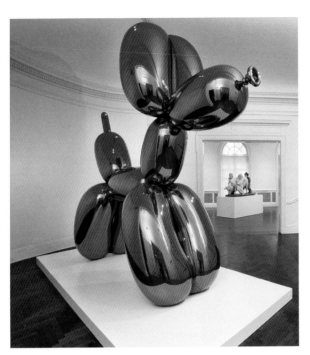

Jeff Koons, *Balloon Dog (Orange)*. Mirror-polished stainless steel with transparent colour coating

How far can art take the appeal of kitsch before observers begin losing faith in its sincerity and start suspecting the artist is full of hot air? With his equally lauded and lampooned *Balloon Dog (Orange)*, American artist Jeff Koons has taken the allure of Pop Art to popping point by daring audiences to deny the enduring value of an object of pure pleasure. 'I never want anybody', Koons has said, 'to look at a sculpture, and to lose trust in it somewhere.' For some, the thousands of hours spent designing and polishing the sixty welded steel sections that comprise the monumental mirrored mongrel have succeeded in conjuring the very essence of childhood wonder, while affectingly reflecting back on adult viewers a lost sense of innocent desire. For others, Koons's sculpture symbolizes the airheaded vacuity of an over-inflated art market whose bulging bubble of swollen sale prices deserves to be burst.

1994

1995

Mike Kelley, *Educational Complex*. Synthetic polymer, latex, foam core, fibreglass and wood

If you could map your mind, what would the atlas look like? For *Educational Complex*, American artist Mike Kelley constructed entirely from memory a 4.88 by 2.44 metre (16 by 8 foot) model displaying every school he had ever attended, from his childhood home and kindergarten to the California Institute of the Arts, where he attended graduate school. The rooms, corridors and basement passageways that are missing from the elaborate display, which sprawls more like an architectural projection for an unbuilt institution than a fossil from one's consciousness, correspond to gaps in the artist's recollection and are represented merely as solid blocks. Kelley interpreted these impenetrable 'holes' in his memory as sites of repressed sexual abuse. The impulse to compress into a single psychological space ghostly vestiges of the physical world that one has inhabited is a characteristic urge of the age and in harmony, in particular, with South Korean artists Do Ho Suh's *Home Within Home* (2009–11) and Haegue Yang's 2006 site-specific work *Sadong 30*.

Paul McCarthy, *Yaa Hoo Town, Saloon*. Steel, mechanical parts, fibreglass, polyester resins, clothing, wigs and other miscellaneous materials

It is a cliché to assert that art bears an obligation to push the boundaries of acceptable expression and that it inhabits a hazy borderland between what society sanctions and what it considers taboo. If one doubts that art continues to assume any such responsibility to test cultural limits, consider the imagination of American artist Paul McCarthy. Comprised of mechanical dummies dressed in kinky cowboy kitsch, like sex tourists at a debauched ranch, McCarthy's controversial *Yaa Hoo Town* is an oversized diorama of outrageous orgiastic robotics that observers alternately find amusing and deeply disturbing. The work lampoons the symbols and swagger of an America that it portrays as dangerously depraved. Zoom out from the particularities of the carnal carnival of pelvic gnashing it depicts, and the work also shines a light on the voyeuristic complicity of the audience that cannot pull itself away from the galloping grotesquerie. After all, only you know how long you have lingered on this page.

1996

1997

Steve McQueen, *Deadpan*. Video still

It is said that new artists must create the territory in which they work by clearing a space for their imagination within the cramped canon of all the artists who came before. The notion is as mystifying as it is mystical. Yet it is one that British filmmaker Steve McQueen illustrates powerfully in a work that rewrites a famous cinematic scene from the 1928 silent film, *Steamboat Bill, Jr*, in which Buster Keaton narrowly misses being crushed to death when the front of a house falls on top of him, by the luck of a perfectly-positioned window. In McQueen's reinvention of the hair-raising stunt, which is repeated from different perspectives for four and half minutes, the cultural context of the near calamity has been shifted from the slapstick of Hollywood comedy to a forgotten tract of segregation-era America. By transferring the audience's focus from gimmickry and guffaws to the perilousness of life on the margins of society, McQueen demonstrates the risks and exhilaration of taking an artistic stand.

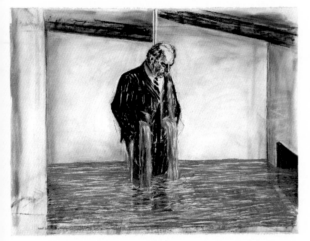

William Kentridge, drawing for the film
Stereoscope. Charcoal and pastel on paper

How does an artist know a work is finished? When we encounter a completed drawing, painting or sculpture in a gallery, it is easy to forget that the stasis we perceive conceals a dynamic story of dramatic unfolding: an energetic ordeal that the work in question has undergone from the first stroke of the brush or jut of the chisel. Every work is a compression of transitory works that might have been its final state had the artist stopped at an earlier stage. Such are the anxieties that inform South African artist William Kentridge's animated films, which capture the slow evolution of drawings by photographing every phase of their creation into soulfully surreal narratives that only fleeting sketches can capture: a typewriter that moments before was a cat, morphing into a bomb; a forlorn man staring into nothingness, while an existential fluid of everything he has ever been flows from his body and fills the space around him.

1998

1999

Louise Bourgeois, *Maman*. Bronze, stainless steel and marble

Throughout her life, French artist Louise Bourgeois symbolically equated the spider and its mysterious gift for silken spinning with her mother, a talented weaver who died when the young artist was studying at university. When London's Tate Modern opened its Turbine Hall in 2000 as a pre-eminent venue for the showcasing of large-scale contemporary artworks, Bourgeois was invited to design the inaugural installation. A key component of her display was the erection of an enormous steel spider entitled *Maman* (or 'mother') that stood over 10 metres (33 feet) high on eight spindly legs around which visitors were invited to wander. At once intimately private in its meaning and ensnaringly public in its aesthetic embrace, Bourgeois's work is a fitting emblem for the gigantism of scale towards which the art of the age has increasingly been creeping.

Thomas Hirschhorn, *The Bridge*. Intervention commissioned by the Whitechapel Art Gallery for the exhibition 'Protest and Survive'

How sturdy is the link today between social activism and artistic consciousness? That is the question that undergirds Swiss artist Thomas Hirschhorn's *The Bridge*: an ersatz passageway constructed over a narrow lane that connected the group exhibition 'Protest and Survive' at the Whitechapel Gallery in London in 2000 with a nearby anarchist bookshop. Every step that visitors took attempting to cross the conduit (which appeared to have been built haphazardly from makeshift materials such as packing tape, rubbish bags and cardboard) constituted a leap of faith that the structure would hold. The result was a work that invites audiences to reflect on how social conscience feeds into the materiality of art. *The Bridge* asks what is lost when an artwork moves from inception to presentation in a gallery space and whether that rickety conveyance from notion to exhibition strips the object of its rawness.

2000

2001

Tracey Rose, *The Kiss*. Lambda print

Is it possible to perceive a work of art separate from its position in the history of art, or from the prejudices and politics of the society from which it emerged? Such are some of the dilemmas that invigorate South African artist Tracey Rose's photographic recasting of Auguste Rodin's once controversial marble sculpture *The Kiss* (1882). Where Rodin's original work freezes forever the fateful embrace of adulterous lovers in Dante's *Inferno*, moments before the couple are discovered and killed, Rose's work features instead the near union of herself and her New York art dealer. The black-and-white medium accentuates the divergence of tones of African skin that distinguish the clinching figures, a contrast that is only amplified by the memory of the pale stone that characterized the French artist's original sculpture. The result is a document of acute cultural entanglements that reminds us of the inseparability of a work's meaning from the breadth of its audience's discrimination.

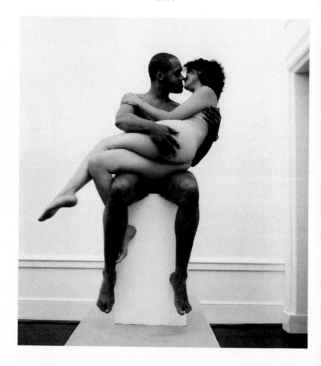

Yayoi Kusama, *Fireflies on the Water.*
Mixed media

Although artists and critics frequently use enthralling language such as 'immersing' and 'absorbing' to describe the intensity of art, is it really possible to lose oneself entirely in the fabric of a work? A belief in art's potential fully to engross one's body and psyche motivates the installation *Fireflies on the Water* by Japanese artist Yayoi Kusama, who has experimented with the hypnotic effect of polka dots since the 1960s. Comprised of a small dark room and pond-like floor, illuminated only by hanging fairy lights reflecting off mirrored panels to create an illusion of infinitely regressing space, *Fireflies on the Water* offers visitors an enchanting paradox of claustrophobic openness. To step inside the installation is to feel pulled between the microscopic whir of subatomic particles and the dazzle of distant galaxies. Lauded by admirers as a visionary while dismissed by others as a diversionary by-product of Pop Art, the profundity of Kusama's work is likely to depend on the temperament of the observer and what he or she perceives in a handful of dust.

2002

2003

Paula Rego, *War*. Pastel on paper on aluminium

Can a work of art respond intimately to the issues of the day while remaining relevant to future generations? For Portuguese painter Paula Rego, the convertibility of meaning from one age to the next is linked to the integrity of the myths that artists manage to forge in their work. Fascinated by the timelessness of fairy tales and folklore, Rego frequently devotes the surfaces of her paintings to the invention of fresh legends, providing audiences with the raw ingredients of a rich but inchoate story whose narrative and meaning are left teasingly unresolved. In her brutally bewitching *War*, conceived shortly after the allied invasion of Iraq in 2003, Rego introduces a beguiling cast of rabbit-headed figures, groping storks and oversized insects, who appear to be fleeing a scene of undefined conflict. Although the work's ambiguous composition was inspired by a journalistic photograph of imperilled children running from a bomb's blast, the portrayal of the figures as soft toys rather than real people nudges the drama in the direction of a waking nightmare, untethered to any worldly time or place.

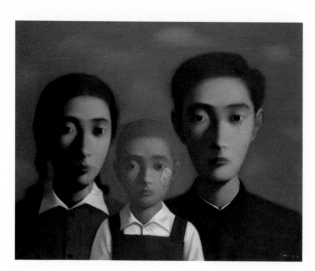

Zhang Xiaogang, *Bloodline: Big Family No. 1*.
Oil on canvas

Can a portrait represent a people rather than a person? Leaders of the Chinese Cultural Revolution from the mid-1960s to the mid-1970s thought so and sought strenuously to erase evidence of individual personality in favour of a collective identity. That ideological aim laminates itself across the mask-like countenances of the countless state-sanctioned photographs that survive from the era. Relics from the childhood of Chinese painter Zhang Xiaogang, these impassive black-and-white images form the basis of a celebrated series, *Bloodlines*, in which Zhang challenges such soulless self-annihilation. At first glance, Zhang's portraits may seem to endorse the emotionless veneer of the documents that inspired them. But look again, and the fragile varnish of self-erasure begins to weaken as an irrepressible spirit vibrates to the surface.

2004

2005

Luisa Lambri, *Untitled (Barragan House, #01)*.
Laserchrome print

'There is one spectacle grander than the sky', Victor Hugo wrote, 'that is the interior of the soul'. Since the golden age of seventeenth-century Dutch painting, a frequent urge among artists has been the quaint equation of interior spaces with the wide undimmable dimensions of one's inner existence. For the Italian photographer Luisa Lambri, this perennial impulse has drawn the focus of her lens to intimate details of celebrated domestic structures around the world, such as the Modernist architect Luis Barragan's home in Mexico City. Here, the unhinged matrices of shadow and light, captured through the cracks of shutters in different arrangements of openness and closure, at various points in the day, create an unchoreographed drama of darkness and illumination.

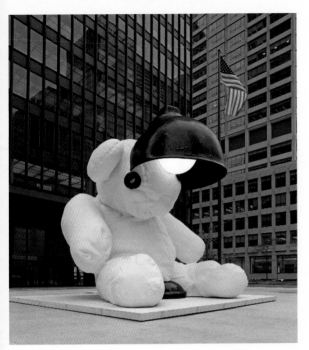

Urs Fischer, *Untitled (Lamp/Bear)*. Cast bronze, epoxy primer, urethane paint, acrylic polyurethane topcoat, acrylic glass, gas discharge lamp, stainless-steel framework

'I don't think my parents liked me', Woody Allen once said, 'they put a live teddy bear in my crib'. Good things can, of course, be taken to terrifying extremes and even the gift of a teddy bear can cross a line. Is the same true of art? It is a question that German artist Urs Fischer (whose first name is nearly *ursus*, the Latin for bear) appeared to ask with the public installation of his enormous 17-tonne *Lamp/ Bear*, which seeks to shed new light on the notion of lost-and-found art objects. Traditionally a symbol of comfort and reassurance, the teddy in Fischer's sculpture seems instead to be a swollen relic of neglect: a vestige of gigantic abandonment. The slumped physique of the oversized sculpture, whose head has merged surreally with the metal shade of an enormous anglepoise bedside light, dares observers to come to terms with what they themselves may have left behind in the dark corners of their childhoods.

2006

2007

Fiona Tan, still from *A Lapse of Memory*. HDcam, 1:1, 77 widescreen anamorphic

If art helps us make sense of the world, how can it succeed when the world refuses to make sense? The search for coherence in the face of profound incoherence is at the heart of Indonesian-born photographer and installation artist Fiona Tan's twenty-four-minute film, *A Lapse of Memory*. Set in the opulently confused interior of the Royal Pavilion in Brighton (a wilful mash-up of neo-classical and Indo-Islamic ornamentation and styles), the work chronicles a day in the life of a disoriented old man called 'Henry'. Like his surroundings, Henry's muddled mannerisms are a curious mix of Eastern and Western conventions that make discerning a plausible backstory for him impossible. The resulting visual narrative is a poignant meditation on our own daily routines and habits, which are rarely of our own devising and are invariably played out against a chaotic background of strangers' designs.

David Hockney, *More Felled Trees on Woldgate*.
Oil on canvas, two panels

British artist David Hockney's *More Felled Trees on Woldgate* is a vibrant masterclass in subliminal allusion. On its surface, the two-panel painting seems merely to capture in captivating quasi-Fauvist light the foreshortened piles of felled limbs along a lane in the countryside where the artist grew up and worked as a farmhand in his youth. But the path the eye takes towards the horizon is one that it has been down before, in the Symbolist dusk of Edvard Munch's *The Scream* (1893), which ghosts Hockney's composition. 'One evening I was walking along a path', Munch recalled of the earlier work's inception, and 'sensed a scream passing through nature.' The hacked and gnarled figure of Hockney's standing stump, shunted to the side, howls silently, subsuming the anguish of Munch's internal terror, while the railings in the earlier work have been transformed into the stripped limbs of the later scene, pointing in the same direction. The figures in the distance have been slimmed to vertical trunks that will too, in time, be chopped down.

2008

2009

Aleksandra Mir, *Astronaut*. Paper collage on board in gold leaf frame

However contentious their relationship throughout history, science, religion and art share a responsibility to awe. For her collage *Astronaut*, Polish-born Swedish-American artist Aleksandra Mir collapses into a single portrait seemingly antithetical Catholic and space-exploratory iconography, thereby asserting art as the undiscovered frontier in which such historically rivalrous visions are reconcilable. The work comes a mere seventeen years after the Catholic Church finally acknowledged in 1992 the centricity of the sun in the solar system (a claim it previously punished as heresy) and a decade after Mir propelled herself to prominence by staging a phony lunar landing on a beach in Holland in a facetious feminist stunt to stake a claim to being the first woman to land on the moon.

Wolfgang Tillmans, *Freischwimmer 15.*
Inkjet print

Can you take a photograph of nothing? German artist Wolfgang Tillmans can. The images that comprise his celebrated *Freischwimmer* series are the result of darkroom chemicals interacting unpredictably with each other, divested entirely from the usual process or rationale of developing photographs of the observable world that have been shot with a conventional camera's lens. What emerges are abstract snaps of strange acidic volatility, like antediluvian juices surging in a primordial sea. Now cresting like a great galactic surf, now misting delicately into a gauzy curtain drawn across uncharted corridors of the psyche, *Freischwimmer* relies for its power on the material ambiguity of what it depicts: everything and nothing at all.

2010

2011

Nathalie Djurberg with music by Hans Berg,
The Parade. Clay animation, digital video

We expect art to surprise us with flashes of unexpected beauty, but is there merit too in choreographing utter depravity? Swedish artist Nathalie Djurberg dares us to think so. *The Parade* consists of five claymation films running in loops on screens that overlook eighty freestanding sculptures of menacing avian concoctions. If wandering among the grotesque descendants of prehistoric raptors creates an implicitly unnerving environment, the explicit violence that unfolds on-screen, executed in the deceptively innocent medium of Plasticine animation, places beyond doubt the sinister nature of the artist's vision. The result is a work that brutally reminds visitors that, however refined their gallery-going sensibilities may seem, human inclinations are incorrigibly primal and owe their origin to the basest and nastiest of animal instincts.

Laure Prouvost, *Wantee*. Video with mixed-media installation

The past is anything we say it is. Such is the inescapable conclusion of French artist Laure Prouvost's enveloping installation *Wantee*, which explores the supposed disappearance of her grandfather: a conceptual artist who, we are told, suddenly vanished one day through a hole in the floor of his cabin. Prouvost's display centres on a shaky-lens documentary that lavishly reconstructs the eccentric space that swallowed him. Visitors to the installation where the film is shown find themselves seated at a tea table cluttered with the same unsettling debris with which the hut on-screen is strewn. The result is unintended collusion on the part of observers in the forging of the artist's fiction and a claustrophobic sense that Prouvost's preposterous tale is slowly devouring them as well.

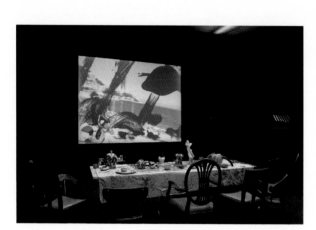

2012

2013

Sarah Sze, *Triple Point (Planetarium)*. Wood, steel, plastic, stone, string, fans, overhead projectors, photograph of rock printed on Tyvek, mixed media

In an age of relentless digitization, the compression of information onto the flat screens of smartphones, laptops and HD TVs would seem to have rendered obsolete the whirring gears and bygone gadgetry of antiquated clockworks and orreries with which we once strove to calibrate our relationship to time and space. But to judge from the outrageous horology of her complex contraption *Triple Point (Planetarium)*, constructed for the installation with which she represented the USA at the 55th International Venice Biennale in 2013, the imagination of American artist Sarah Sze is anything but impeded by the demands of faddish technology. A curious contrivance that summons into the obsolete orbit of its spinning spheres a galactic gallimaufry of disconnected bric-a-brac (dandelions and disco balls, hoops and twigs), Sze's dizzying device resists the practical gravity of utility in favour of something uselessly beautiful.

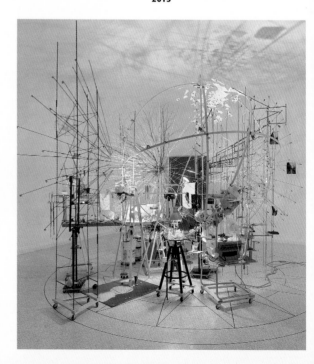

Monika Sosnowska, *Tower*. Steel, paint

In her 2014 novel *The Goldfinch*, Donna Tartt poses the question, 'What if the heart, for its own unfathomable reasons, leads one willfully and in a cloud of unspeakable radiance… straight towards a beautiful flare of ruin?' Enter, on cue, Polish artist Monika Sosnowska and her sprawling ruinous sculpture *Tower*: a crumpled and twisted industrial steel framework that helixes 32 metres (105 feet) across the ground like the discarded scaffold God used to construct the universe's DNA. Sosnowska's mangled monumental work comes to terms with the dominance of the International Style of architecture that symbolized the Modernist city in the twentieth century by dragging its distressed skeleton to the ground. Unveiled in New York in the autumn of 2014, thirteen years after the attacks of 11 September 2001, *Tower* asks the world if it is ready to perceive destruction itself as 'readymade' art.

2014

2015

Hans Haacke, *Gift Horse*. Cast bronze, LED electronic ticker tape

To what extent do money and power shape the art we install into our cultural institutions and, ultimately, into our consciousnesses? This is the question at the heart of German artist Hans Haacke's winning bid to erect a sculpture atop the fourth plinth of London's Trafalgar Square (a pedestal that was originally intended to feature an equestrian statue of William IV). *Gift Horse* is a large bronze riderless skeleton whose front left leg, lifted in full trot, features a real-time electronic display of the London Stock Exchange's trading ticker looped into a bow. Haacke's subversive work, which seeks to lay bare the power structures of society, is based on drawings by the English painter George Stubbs (author of *The Anatomy of the Horse*, 1766), several of whose canvases feature in the National Gallery, just opposite the statue. The relentless scroll of fluctuating commodity prices across a static armature of death invites observers to contemplate who determines the value of the art they cherish.

SOURCES AND FURTHER READING

GENERAL SOURCES

Birnbaum, D., *Defining Contemporary Art*, London, 2011

Bonham-Carter, C., and D. Hodge, *The Contemporary Art Book*, London, 2011

Chadwick, W., *Women, Art, and Society*, London, 2012

Cotton, C., *The Photograph as Contemporary Art*, London, 2009

Grovier, K., *100 Works of Art That Will Define Our Age*, London, 2013

Heartney, E., et al, *The Reckoning: Women Artists of the New Millennium*, London, 2013

Holzwarth, H. W., *100 Contemporary Artists*, Berlin, 2009

Hung, W., *Contemporary Chinese Art*, London, 2014

Manco, T., *Big Art/Small Art*, London, 2014

Moszynska, A., *Sculpture Now*, London 2013

O'Reilly, S., *The Body in Contemporary Art*, London, 2009

Smith, T., *Contemporary Art: World Currents*, London, 2011

Trigg, D., et al, *The Twenty First Century Art Book*, London, 2014

Wilson, S., *Art + Science Now*, London, 2010

INTRODUCTION

Archer, M., *Art Since 1960*, London, 1997

Stallabrass, J., *Contemporary Art: A Very Short Introduction*, Oxford, 2006

CHAPTER 1

Beckwith, N., et al, *Lynette Yiadom-Boakye*, London, 2014

Biesenbach, K., *Marina Abramović: The Artist is Present*, New York, 2010

Blessing, J., and Sandra S. Phillips, *Rineke Dijkstra: A Retrospective*, New York, 2012

Bonetti, M. F., and G. Schlinkert, *Samuel Fosso*, Milan, 1999

Celant, G., and R. Calcagno, *Marc Quinn: Memory Box*, Italy, 2014

Cooke, L., et al, *Roni Horn*, London, 2000

Danto, A. C., *Shirin Neshat*, New York, 2010

Finch, C., *Chuck Close: Work*, London, 2014

Fuchs, R., *Glenn Brown*, New York, 2015

Goldin, N., *Nan Goldin: The Other Side*, Zürich, 2000

Respini, E., and J. Burton, *Cindy Sherman*, New York, 2012

Rosenthal, N., *Neo Rauch: At the Well*, New York, 2015

Self, W., et al, *George Condo: Mental States*, London, 2011

Tsai, E., *Kehinde Wiley: A New Republic*, London, 2015

Vinas, V., and A. Born, *Jindřich Ulrich: Miniaturní svět*, Prague, 2010

CHAPTER 2

Alberro, A., et al, *Monica Bonvicini*, London, 2014

Alberts, H. R., 'The Perfect Home, Between New York and Seoul', *Wall Street Journal*, 24 April 2012

Betsky, A., et al, *Doug Aitken: 100 YRS*, New York, 2014

Blazwick, I., *Cornelia Parker*, London, 2013

Borchardt-Hume, A., *Doris Salcedo: Shibboleth*, London, 2007

Christo and Jeanne-Claude, *Wrapped Reichstag Berlin: 1971–1995*, Berlin, 1995

Dunser, H., *Erwin Wurm: Narrow House*, Berlin, 2011

Lind, M., et al, *Rirkrit Tiravanija: A Retrospective (Tomorrow is another fine day)*, Zürich, 2007

Mullins, C., *Rachel Whiteread*, London, 2004

Pacquement, A., *Richard Serra*, Berlin, 2015

Perry, G., *Playing at Home: The House in Contemporary Art*, London, 2014

Sainsbury, H., *The Unilever Series: Mirosław Bałka*, London, 2009

Schneider, E., et al, *Antony Gormley: Horizon Field*, Berlin, 2010

Tóibín, C., and A. O'Hagan, *Gregor Schneider: Die Familie Schneider*, Berlin, 2006

CHAPTER 3

Albrecht, K. *Gottfried Helnwein*, Berlin, 2013

Basualdo, C., *Philippe Parreno: Anywhere, Anywhere Out of the World*, Berlin, 2014

Bernier, R., *The Unspeakable Art of Bill Viola*, Eugene, 2014

Brett, G., *Cildo Meireles*, London, 2009

Gallagher, A., *Damien Hirst*, London, 2012

Gallagher, A., *Susan Hiller*, London, 2011

Haste, A., *Craigie Aitchison*, London, 2014

Hunt, T., and A. Haden-Guest, *Polly Morgan: Psychopomps*, London, 2011

Michaud, P.-A., *Adel Abdessemed: Je Suis Innocent*, Berlin, 2012

Obrist, H. U., *Adrián Villar Rojas: Today We Reboot the Planet*, 2013

Roth, P., et al, *Maurizio Cattelan*, London, 2003

Storr, R., et al, *Ron Mueck*, Paris, 2013

van den Boogerd, D., *Marlene Dumas*, London, 2009

CHAPTER 4

Alÿs, F., *Francis Alÿs*, London, 2007

Berger, D., *Inventory: The Work of Christine Hill and Volksboutique*, Berlin, 2003

Dery, L., et al, *Artur Żmijewski: Scenarios of Dissidence*, Montreal, 2011

Dietch, J., *Cai Guo-Qiang: Ladder to the Sky*, Berlin, 2012

Erdemci, F, *Elmgreen & Dragset: A Space Called Public*, Berlin, 2013

Fibicher, B., et al, *Ai Weiwei*, London, 2009

Foster, H., *Cyprien Gaillard: The Recovery of Discovery*, Berlin, 2012

García-Antón, K., *Santiago Sierra: Works 2002–1990*, Birmingham, 1999

Gupta, S., *Ghandi's Three Monkeys*, New York, 2008

Nakas, K., et al, *The Atlas Group: A Project By Walid Raad*, Berlin, 2007

O'Reilly, S., *Mark Wallinger*, London, 2014

Shaw, G. D., *Seeing the Unspeakable: The Art of Kara Walker*, Durham, 2004

Smith, T., *Sheela Gowda*, Berlin, 2007

CHAPTER 5

Ardalan, Z., *Bharti Kher*, London, 2012

Cappellazzo, A., *Janine Antoni*, Berlin, 2000

Collings, M., *Sarah Lucas*, London, 2002

Conkelton, S., and C. S. Eliel *Annette Messager*, New York, 1995

Curiger, B., et al, *Rebecca Warren: Every Aspect of Bitch Magic*, London, 2012

Czarnecki, G., et al, *Humancraft: Contaminating Science With Art*, Liverpool, 2012

Eccher, D., *Cecily Brown*, New York, Milan, 2014

Obrist, H. U., *Matthew Barney/Hans Ulrich Obrist (Conversation Series)*, Berlin, 2013

Phillipson, H., *Instant-flex 718*, London, 2013

Ravenal, J., *Outer and Inner Space: Pipilotti Rist, Shirin Neshat, Jane and Louise Wilson and the History of Video Art*, Seattle, 2009

Rosenthal, S., *Pipilotti Rist: Augapfelmassage*, Berlin, 2012

Schoonmaker, T., *Wangechi Mutu: A Fantastic Journey*, Durham, 2013

CHAPTER 6

Basualdo, C., et al, *Philippe Parreno: Anywhere, Anywhere Out of the World*, Berlin, 2014

Brand, S., *The Clock of the Long Now*, New York, 1999

Bull, M., et al, *Mark Alexander: The Bigger Victory*, London, 2005

Criqui, J.-P. (ed.), *ON&BY: Christian Marclay*, London, 2014

Davey, R., and S. Schama, *Anselm Kiefer*, London, 2014

Dean, T., and H. U. Obrist, *Tacita Dean / Hans Ulrich Obrist*, Berlin, 2013

Engelbach., B., and L. McKenzie, *Lucy McKenzie: Chene De Weekend*, Cologne, 2009

Grynsztejn, M., and H. Molesworth, *Luc Tuymans*, New York, 2009

Harris, J., *Inside the Death Drive: Excess and Apocalypse in the World of the Chapman Brothers*, Liverpool, 2009

Herbert, M., and H. Walker, *Darren Almond*, London, 2001

Kelly, J., and J. Wood, *The Sculpture of Bill Woodrow*, London, 2013

Klein, J., *Grayson Perry*, London, 2013

Shiff, R., and C. Lampert, *Peter Doig*, New York, 2011

Snoddy, S., et al, *Ged Quinn: From the World Ash to the Goethe Oak*, London, 2013

Weiss, J., and A. Wheeler, *On Kawara Silence*, New York, 2015

Wright, R., et al, *Richard Wright*, New York, 2010

CHAPTER 7

Bertola, C., *Mona Hatoum: Interior Landscape*, Italy, 2009

Corrin, L., and D. Molon, *Mariko Mori*, London, 1998

Goetz, I., *Mona Hatoum*, Berlin, 2011

Kac, E., *Telepresence and Bio Art*, Michigan, 2004

Kent, R., *Yinka Shonibare*, London, 2013

Marsh, J., et al, *Alexis Rockman: A Fable for Tomorrow*, London, 2010

May, S. (ed.), *Olafur Eliasson – The Weather Project (Unilever Series)*, London, 2003

Miller, A. I., *Colliding Worlds: How Cutting-Edge Science is Redefining Contemporary Art*, New York, 2014

Moeller, C., *A Time and Place: Christian Moeller Media Architecture*, Zürich, 2002

Morgan, J., *Carsten Höller: Test Site (Unilever Series)*, London, 2006

Tezuka, M., et al, *Rebirth: Recent Work by Mariko Mori*, Yale, 2013

Wilson, S., *Art + Science Now*, London, 2010

CHAPTER 8

Anfam, D., et al, *Anish Kapoor*, London, 2009

Badura, E., et al, *Franz West: Where is My Eight?*, Berlin, 2013

Baume, N., *Anish Kapoor: Past, Present, Future*, Boston, 2008

Bell, T., *Sean Scully*, 2010

Benezra, N., et al, *Franz West (Contemporary Artists Series)*, London, 1999

Beyeler, F. (ed.), *Beatriz Milhazes*, Berlin, 2012

Costello, E., *Brice Marden*, London, 2013

Criqui, J.-P., et al, *Gabriel Orozco: Natural Motion*, Berlin, 2013

Elger, D., *Gerhard Richter: A Life in Painting*, Chicago, 2010

Ferguson, R., *Liz Larner*, Los Angeles, 2001

Grovier, K., *Sean Scully: Different Places*, Provence, 2015

Fritz, N., *Gert & Uwe Tobias*, Berlin, 2013

Gorner, V., et al, *Karla Black*, Berlin, 2014

Grosenick, U. (ed.), *The Art of Anselm Reyle*, Berlin, 2009

Grunenberg, C., *Ellsworth Kelly*, London, 2007

Jacobson, H., *Mark Grotjahn*, Aspen, 2012

Kruger, S., et al, *André Butzer*, Berlin, 2012

Lawrence, C., and A. Perez, *Julie Mehretu: Black City*, Berlin, 2006

Moorhouse, P., and R. Shiff, *Bridget Riley: The Stripe Paintings, 1961–2014*, New York, 2014

Morgan, J., *Gabriel Orozco (Modern Artists Series)*, London, 2011

Nixon, A., et al, *Charline Von Heyl: Now or Else*, Berlin, 2012

Pelzer, B., and G. Tosatto, *Gerhard Richter: 100 Pictures*, Berlin, 2003

Peyton-Jones, J., and H. U. Obrist, *Anish Kapoor: Turning the World Upside Down*, Berlin, 2010

Riemschneider, B., *Albert Oehlen*, Berlin, 1995

Serota, N., and M. Godfrey, *Gerhard Richter: Panorama*, London, 2011

Temkin, A., and J. N. Wood, *Ellsworth Kelly: Chatham Series*, New York, 2013

Vogel, S. M., *El Anatsui: Art and Life*, Munich, 2012

Watkins, J., et al, *Arturo Herrera*, Birmingham, 2007

CHAPTER 9

Banks, E., et al, *Christopher Wool*, Taschen, 2012

Brinson, K., and S. Hudson, *Christopher Wool*, New York, 2013

Brooks, R., et al, *Richard Prince (Contemporary Artists Series)*, London, 2003

Brown, K. M., *Douglas Gordon (Modern Artists Series)*, London, 2004

Brown, N., *Tracey Emin (Modern Artists Series)*, London, 2006

Dyer, G., et al, *Dayanita Singh*, London, 2013

Dziewior, Y., et al, *Zhang, Huan (Contemporary Artists Series)*, London, 2009

Dziewior, Y., *Richard Prince: It's a Free Concert*, Berlin, 2014

Ferguson, F., et al, *Gillian Wearing*, London, 1999

Gorner, V., et al, *Barbara Kruger: Desire Exists Where Pleasure is Absent*, Berlin, 2006

Herrmann, D. F., et al, *Gillian Wearing*, London, 2012

Joselit, D., et al, *Jenny Holzer*, London, 2001

Pavlouskova, N., *Cy Twombly: Late Paintings 2003–2011*, London, 2015

del Roscio, N., and S. Schama, *The Essential Cy Twombly*, London, 2014

Rothkopf, S., *Glenn Ligon: America*, Yale, 2011

Scherf, A., and F. Hergott, *Danh Vo: We the People*, Paris, 2013

Townsend, C., et al, *The Art of Tracey Emin*, London, 2002

Tsao, H., and Ames, R. T., *Xu Bing and Contemporary Chinese Art: Cultural and Philosophical Reflections*, New York, 2011

Vainker, S., and X. Bing, *Landscape Landscript: Nature as Language in the Art of Xu Bing*, Oxford, 2013

CHAPTER 10

Banz, S., *Jeff Wall: With the Eye of the Mind*, Nuremberg, 2014

Barringer, T., and E. Devaney, *David Hockney: A Bigger Picture*, London, 2012

Bizzarri, T., and T. Hirschhorn, (eds), *Thomas Hirschhorn: Establishing a Critical Corpus*, New York, 2010

Bradley, F., *Paula Rego (Modern Artists Series)*, London, 2002

Burnett, C., *Jeff Wall (Modern Artists Series)*, London, 2005

Burton, J., *Wolfgang Tillmans*, London, 2014

Celant, G., *Nathalie Djurberg – Turn Into Me*, Madrid, 2008

Chevrier, J.-F., et al, *Jeff Wall (Contemporary Artists Series)*, London, 2009

Coxon, A., *Louise Bourgeois (Modern Artists Series)*, London, 2008

Fineberg, J., et al, *Zhang Xiaogang: Disquieting Memories*, London, 2015

Foster, E. O. (ed.), *Luisa Lambri. Interiors*, Madrid, 2011

Galassi, P., *Andreas Gursky*, New York, 2001

Gumpert, L., *Christian Boltanski*, Paris, 1994

Haenlein, C., *Rebecca Horn: The Glance of Infinity*, Zürich, 1998

Hoptman, L., et al, *Yayoi Kusama (Contemporary Artists Series)*, London, 2000

Lydenberg, R., *Gone: Site-Specific Work by Dorothy Cross*, Chicago, 2005

Museet, M., and I. Muller-Westermann, (eds), *Louise Bourgeois: I Have Been to Hell and Back*, Berlin, 2015

Morris, F., *Yayoi Kusama*, London, 2012

Norden, L., and A. C. Danto, *Sarah Sze*, New York, 2007

Norman, J., et al, *Urs Fischer*, New York, 2013

Rondeau, J., and S. Comer, *Steve McQueen*, Heidelberg, 2012

Rosenthal, T. G., *Paula Rego: The Complete Graphic Work*, London, 2012

Turowski, A., *Monika Sosnowska Tower*, Berlin, 2015

PICTURE CREDITS

Sizes are given in centimetres, followed by inches, height before width before depth, unless otherwise stated

pp. 2–3 Ai Weiwei, *Dropping a Han Dynasty Urn*, 1995. Three black-and-white prints, each 148 × 121 (58 ¼ × 47 ⅝). Photo Ai Weiwei

1 Janine Antoni, *Loving Care*, 1992. Performance with Loving Care hair dye Natural Black, dimensions variable. Courtesy the artist and Luhring Augustine, New York. Photo Prudence Cuming Associates Ltd at Anthony d'Offay Gallery, London, 1993. © Janine Antoni

2 Damien Hirst, *For the Love of God*, 2007. Platinum, diamonds and human teeth, 17.1 × 12.7 × 19.1 (6 ¾ × 5 × 7 ½). Photo Prudence Cuming Associates Ltd via Getty Images. © Damien Hirst and Science Ltd. All rights reserved, DACS 2015

3 Felix Gonzalez-Torres, *"Untitled"*, 1992. Candies individually wrapped in variously coloured cellophane, endless supply, overall dimensions vary with installation, original size 5.1 × 121.9 × 121.9 (2 × 48 × 48). Installation view of 'A Day Without Art'. St Louis Art Museum, St Louis, MO. 29 Nov. – 3 Dec. 2002. Courtesy Andrea Rosen Gallery, New York. © The Felix Gonzalez-Torres Foundation

4 Robert Gober, *Melted Rifle*, 2006. Plaster, paint, cast plastic, beeswax, walnut and lead, 69 × 58 × 40 (27 ⅛ × 23 × 15 ¾). Courtesy Matthew Marks Gallery. © Robert Gober

5 Pierre Huyghe, *De-extinction*, 2014. Film still, colour, stereo sound, 12 minutes 35 seconds. Courtesy the artist, Marian Goodman Gallery, Hauser & Wirth, London and Anna Lena Films, Paris

6 Wim Delvoye, *Sylvie*, 2006. Taxidermied tattooed pig, 64 × 124 × 40 (25 ¼ × 48 ⅞ × 15 ¾). © Studio Wim Delvoye, Belgium/Courtesy Galerie Perrotin, Paris/New York

7 Dale Chihuly, *V&A Chandelier*, 2001. 68.6 × 31.8 (27 × 12 ½). Victoria and Albert Museum, London. © 2015 Chihuly Studio. All rights reserved

8 Pablo Picasso, *Guernica*, 1937. Oil on canvas. Museo Nacional Centro de Arte Reina Sofía, Madrid. © Succession Picasso/DACS, London 2015

9 Marcel Duchamp, *The Fountain*, 1917. Replica (original lost). Porcelain urinal, 36 × 48 × 61 (14 ⅛ × 18 ⅞ × 24). Philadelphia Museum of Art, The Louise and Walter Arensberg Collection. © Succession Marcel Duchamp/ADAGP, Paris and DACS, London 2015

10 Andreas Gursky, *Los Angeles*, 1999. Cibachrome print, 178 × 300 × 6.2 (70 ⅛ × 118 ⅛ × 2 ½). © Courtesy Sprüth Magers Berlin London/DACS 2015

11 Leonardo da Vinci, *Mona Lisa*, c. 1503–6. Oil on wood (poplar), 77 × 53 (30 ⅜ × 20 ⅞). Musée du Louvre, Paris

12 Edvard Munch, *The Scream*, 1893. Tempera and crayon on cardboard, 91 × 73.5 (35 ⅞ × 28 ⅞). The National Museum of Art, Oslo

13 Glenn Brown, *America*, 2004. Oil on panel, 140 × 93 (55 × 36 ½). © Glenn Brown. Courtesy Gagosian Gallery. Photo Robert McKeever

14 George Condo, *The Laughing Cavalier*, 2013. Acrylic, charcoal and pastel on linen, 152.4 × 127 (60 × 50). Courtesy the artist and Simon Lee Gallery. © George Condo 2015

15 Jindřich Ulrich, *The Collector*, 1996. Oil on wood, 11 × 16.5 (4 ⅜ × 6 ½). Courtesy the artist

16 Neo Rauch, *Armdrücken*, 2008. Oil on canvas, 50 × 40 (19 ⅝ × 15 ¾). Private collection. Photo Uwe Walter, Berlin. © Neo Rauch courtesy Galerie EIGEN+ART Leipzig/Berlin/DACS, 2015

17 Kehinde Wiley, *Napoleon Leading the Army over the Alps*, 2005. Oil on canvas, 274.3 × 274.3 (108 × 108). Brooklyn Museum, Collection of Suzi and Andrew B. Cohen. Courtesy Roberts & Tilton, Culver City, California; Sean Kelly, New York; Galerie Daniel Templon, Paris; and Stephen Friedman Gallery, London. © Kehinde Wiley

18 Lynette Yiadom-Boakye, *Greenfinch*, 2012. Oil on canvas, 140 × 100 (55 ⅛ × 39 ⅜). Courtesy the artist, Jack Shainman Gallery, New York and Corvi-Mora, London. © Lynette Yiadom-Boakye

19 Chuck Close, *Self-Portrait*, 2004–5. Oil on canvas, 259.1 × 214.6 (102 × 84 ½). Courtesy Pace Gallery. Photo Kerry Ryan McFate. © Chuck Close

20 Marc Quinn, *Self*, 2011. Blood (artist's), liquid silicone, stainless steel, perspex and refrigeration equipment, 208 × 63 × 63 (81 ⅞ × 24 ¹³⁄₁₆ × 24 ¹³⁄₁₆). Courtesy White Cube. Photo Prudence Cuming Associates Ltd. © Marc Quinn

21 Tim Noble & Sue Webster, *The Individual*, 2012. One wooden stepladder, discarded wood, light projector, 299 × 69 × 193 (117 ¾ × 27 ¼ × 76). Solent News/REX. © Tim Noble and Sue Webster. All Rights Reserved, DACS 2015

22 Gavin Turk, *Pop*, 1993. Waxwork in vitrine, 279 × 115 × 115 (109 ⅞ × 45 ½ × 45 ½). Courtesy Gavin Turk/Live Stock Market. Photo Hugo Glendinning

23 Marcus Harvey, *Myra*, 1995. Acrylic on canvas, 396 × 320 (155 ⅞ × 126). © Marcus Harvey. All Rights Reserved, DACS 2015

24 Nan Goldin, *Jimmy Paulette and Tabboo! undressing, NYC*, 1991. Cibachrome photograph, 101.6 × 76.2 (40 × 30). Courtesy Matthew Marks Gallery. © Nan Goldin

25 Rineke Dijkstra, *Kolobrzeg, Poland, July 26, 1992*. C-print, 62 × 52 (24 ½ × 20 ½). © Rineke Dijkstra

26 Dash Snow, *Untitled*, 2000–9. #DSI30. © Dash Snow Estate. Used by permission

27 Cindy Sherman, *Untitled #225*, 1990. Chromogenic colour print, 121.9 × 83.8 (48 × 33). Edition of 6. Courtesy the artist and Metro Pictures, New York

28 Samuel Fosso, *Autoportrait*, from series *African Spirits*, 2008. Courtesy Jean Marc Patras/Galerie, Paris. © Samuel Fosso 2008

29 Roni Horn, *You are the Weather*, 1994–96. Courtesy the artist and Hauser & Wirth. Photo Stefan Altenburger Photography, Zürich. © Roni Horn

30 Marina Abramović performs during the 'Marina Abramović: The Artist is Present' exhibition opening night party at The Museum of Modern Art on 9 March, 2010 in New York City. Photo Bennett Raglin/WireImage/Getty Images. © Marina Abramović. Courtesy of Marina Abramović and Sean Kelly Gallery, New York. DACS 2015

31 Shirin Neshat, *Rebellious Silence*, 1994. Black-and-white RC print & ink. Courtesy Gladstone Gallery, New York and Brussels. Photo Cynthia Preston. Copyright Shirin Neshat

32 Rirkrit Tiravanija, *untitled (pad thai)*, 1990. Mixed media, dimensions variable. Courtesy the artist and Gavin Brown's enterprise. Copyright the artist

33 Rachel Whiteread, *House*, 1993. Mixed media. Photo Sue Omerod. © Rachel Whiteread

34 Gregor Schneider, *Totes Haus u r*, Rheydt 1985–Venice 2001. Copyright the artist, courtesy Sadie Coles HQ, London. © DACS 2015

35 Do Ho Suh, *Fallen Star*, 2012. Stuart Collection, University of California, San Diego. Photo Philipp Scholz Rittermann. © Do Ho Suh

36 Haegue Yang, *Sadong 30*, 2006. Light bulbs, strobes, chains of lights, mirror, origami objects, drying rack, fabric, fan, viewing terrace, cooler, bottles of mineral water, chrysanthemums, garden balsams, wooden bench, wall clock, fluorescent paint, wood piles, spray paint, IV stand. Installation view of Sadong 30, Incheon, South Korea, 2006. Courtesy the artist. Photo Daenam Kim

37 Erwin Wurm, *Narrow House*, 2010. Mixed media, 700 × 130 × 1600 (275⅝ × 51¼ × 629⅞). Installation view at the 54th Biennale di Venezia, Glasstress. Courtesy Gallery Thaddaeus Ropac. Photo Studio Erwin Wurm

38 Cornelia Parker, *Cold Dark Matter: An Exploded View*, 1991. A garden shed and contents blown up for the artist by the British Army, the fragments suspended around a light bulb, dimensions variable.

Courtesy the artist and Frith Street Gallery, London

39 Doris Salcedo, *Shibboleth*, Tate Modern Turbine Hall, 9 October 2007–24 March 2008. Courtesy White Cube. Photo Stephen White. © the artist

40 Monika Sosnowska, *The Corridor*, 2003. Installation view, Venice Biennale, Italy, 2003. Courtesy the artist, Foksal Gallery Foundation, The Modern Institute, Galerie Gisela Capitain, Kurimanzutto, Hauser & Wirth. © Monika Sosnowska

41 Mirosław Bałka, *How It Is*, 2009. Steel, 1300 × 3000 (511¾ × 1181⅛). Photo Peter Macdiarmid/Getty Images. Mirosław Bałka, Tate Modern, The Unilever Series

42 Monica Bonvicini, *Stairway to Hell*, 2003. Steel stairs, steel chains, broken safety glass, aluminium plates, spray paint, 'S' hooks, clamps, 850 × 360 × 400 (334⅝ × 141¾ × 157½). Installation view at 8th Istanbul Biennale, Poetic Justice, 2003. Donation by Monica Bonvicini to Istanbul Modern, Istanbul/TR. Photo Mehdi Chouakri. © DACS 2015

43 Mike Nelson, *Quiver of Arrows*, 2010. Installation view, The Power Plant, Toronto, 2014. Image courtesy the artist and 303 Gallery, New York; Galleria Franco Noero, Turin; Matt's Gallery, London; and Nugerriemschneider, Berlin. Photo Toni Hafkenscheid

44 Richard Serra, *Torqued Torus Inversion*, 2006. Weatherproof steel, two identical torqued toruses inverted relative to each other, each 390 × 1120 × 890 (153½ × 441 × 350⅜), plates: 5 (2) thick. Private collection. Photo Lorenz Kienzle. © ARS, NY and DACS, London 2015

45 Richard Serra, *Open Ended*, 2007–8. Weatherproof steel, three torus sections and three spherical sections, 400 × 182 × 74 (157½ × 71⅝ × 29⅛), plates 5 (2) thick. Caldic Collectie BV, Wassenaar, The Netherlands. Photo Lorenz Kienzle. © ARS, NY and DACS, London 2015

46 Antony Gormley, *Horizon Field*, August 2010–April 2012. 100 cast-iron elements, each 189 × 53 × 29 (74⅜ × 20⅞ × 11⅜), spread over an area of 150 square kilometres (detail). Installation view, the High Alps, Vorarlberg, Austria. Presented by Kunsthaus Bregenz. Photograph by Makus Tretter. © Antony Gormley and Kunsthaus Bregenz

47 Klara Lidén, *Pretty Vacant*, 2012. Installation image. Plywood, paint, discarded Christmas trees, grow lights and couch. Courtesy the artist and Reena Spaulings Fine Art, NY

48 Christo and Jeanne-Claude, *Wrapped Reichstag*, 1971–95. 100,000 square metres (1,076,000 square feet) of polypropylene fabric and 15,600 metres (51,181 feet) of rope. Photo Wolfgang Volz. Copyright Christo 1995

49 Doug Aitken, *Mirror*, 2013. Custom software editor displaying responsive video on site-specific architectural-media façade, Seattle Art Museum, Seattle. Environmentally triggered continuous video recombination, colour, no sound, screen: 3072 × 1620 pixels. Courtesy the Artist, Seattle Art Museum and 303 Gallery, New York. Photography © Ben Benschneider/OTTO. © Doug Aitken

50 Marlene Dumas, *Dead Marilyn*, 2008. Oil on canvas, 40 × 50 (15¾ × 19⅝). Courtesy Zeno X Gallery, Antwerp. Photo Peter Cox

51 Christoph Schlingensief, *Diana II – What happened to Allan Kaprow?*, London, 2006. Photo © Aino Laberenz, Estate Christoph Schlingensief

52 Philippe Parreno, *Marilyn*, 2012. Runtime 19 minutes 49 seconds, Colour, Sound Mix 5.1, Aspect Ratio 2.39. Courtesy Pilar Corrias Gallery

53 Ron Mueck, *Mask II*, 2002. Mixed media, 77 × 118 × 85 (30⅜ × 46½ × 33½). Courtesy the artist, Anthony D'Offay London and Hauser & Wirth. Photo Patrick Gries. © Ron Mueck

54 Damien Hirst, *The Physical Impossibility of Death in the Mind of Someone Living*, 1991 (side view). Glass, painted steel, silicone, monofilament, shark and formaldehyde solution, 217 × 542 × 180 (85⅜ × 213⅜ × 70⅞). Photo Prudence Cuming Associates Ltd. © Damien Hirst and Science Ltd. All rights reserved, DACS 2015

55 Polly Morgan, *Carrion Call*, 2009. Taxidermy and wood. Courtesy Polly Morgan 37 × 61 × 186 (14⅝ × 24 × 73¼).

56 Adrián Villar Rojas, *Mi familia muerta (My Dead Family)*, 2009. Wood, rocks and clay. Ushuaia's End of The World Biennale 2nd Edition, Ushuaia. Courtesy the artist and Ruth Benzacar

Art Gallery, Buenos Aires. Photograph © Kayne Di Pilato, Argentina

57 Cildo Meireles, *Babel*, 2001. Radios, metal, 5 × 3 metres diameter (197 × 118 inches diameter). Installation view at Hangar Bicocca, Milan, 2014. Courtesy Galerie Lelong, New York. © Cildo Meireles

58 Susan Hiller, *Channels*, 2013. Installation featuring 120–150 televisions, DVD players, splitters. Dimensions variable. Unique artwork + IAP. Courtesy Timothy Taylor Gallery and Matt's Gallery, London. Installation photograph Peter White. © the artist

59 Maurizio Cattelan, *La Nona Ora*, 1999. Polyester resin, painted wax, human hair, fabric, clothing, accessories, stone and carpet, dimensions variable. Courtesy, Maurizio Cattelan's Archive. Photo Attilio Maranzano

60 Gottfried Helnwein, *Epiphany I (Adoration of the Magi)*, 1996. Mixed media (oil and acrylic on canvas), 210 × 333 (82⅝ × 131⅛). Denver Art Museum

61 Gottfried Helnwein, *Epiphany II (Adoration of the Shepherds)*, 1998. Mixed media (oil and acrylic on canvas), 210 × 310 (82⅝ × 122). de Young Museum, San Francisco

62 Gottfried Helnwein, *Epiphany III (Presentation at the Temple)*, 1998. Mixed media (oil and acrylic on canvas), 209.6 × 309.9 (82½ × 122). Private collection, New York

63 Craigie Aitchison RA, *Crucifixion August*, 2008. Oil on canvas, 29.7 × 25.5 (12 × 10). Courtesy private collection & Timothy Taylor Gallery, London. © The Estate of Craigie Aitchison

64 Tomás Sánchez, *Al sur del Calvario*, 1994. Acrylic on canvas, 91.5 × 122 (36 × 48). Courtesy Marlborough Gallery, New York. © Tomás Sánchez

65 Adel Abdessemed, *Décor*, 2011–12. Razor wire, four elements each approx. 210 × 174 × 41 (82⅝ × 68½ × 16⅛). François Pinault Foundation. © Adel Abdessemed, ADAGP Paris

66 Bill Viola, *Emergence*, 2002. Colour high-definition video rear projection on screen mounted on wall in dark room, projected image size 200 × 200 (78¾ × 78¾), room dimensions variable,

11:40 minutes. Performers Weba Garretson, John Hay, Sarah Steben. Photo Kira Perov. Courtesy Bill Viola Studio

67 Teresa Margolles, *En el aire*, 2003. Installation with bubble machines producing bubbles with water that has been used to wash dead bodies after autopsy, dimensions variable. 10 litres water and certificate included. Machines are not included! Courtesy the artist, Galerie Peter Kilchmann, Zürich

68 Anonymous, *One-kyat Note*, 1990. Monetary note from Myanmar, Burmese; 21st century. Photo © Victoria and Albert Museum, London

69 Ai Weiwei, *Dust to Dust*, 1998. Thirty glass jars with powder from ground Neolithic pottery (5000–3000 BC), wooden shelving, 200 × 240 × 36 (78¾ × 94½ × 14⅛). Photo Ai Weiwei

70 Zeng Fanzhi, *Tian'anmen*, 2004. Oil on canvas, 215 × 330 (81⅝ × 129⅞). © 2015 Zeng Fanzhi Studio

71 Cai Guo-Qiang, *Desire for Zero Gravity*, 2012. Gunpowder on canvas, 340.4 × 1066.8 (134⅛ × 420). Courtesy The Museum of Contemporary Art, Los Angeles. Photo Joshua White/JWPictures.com

72 Subodh Gupta, *Gandhi's Three Monkeys*, 2007–8. Bronze, old utensils, steel. Gas mask head 184 × 140 × 256 (72½ × 55⅛ × 100¾), balaclava head 200 × 131 × 155 (78¾ × 51⅝ × 61), helmet head 175 × 125 × 150 (68⅞ × 49¼ × 59). Courtesy the artist and Hauser & Wirth. Photo Stefan Altenburger Photography Zürich. © Subodh Gupta

73 Sheela Gowda, *And…*, 2007. Thread, needles, pigment and glue, three cords: two cords each 11250 × 1.8, one cord 5250 × 1.8. Installation view from *Open Eye Policy*, Lunds konsthall 15 June–24 August 2013, dimensions variable. Photo Lunds konsthall/Terje Östling

74 Francis Alÿs, *Paradox of Praxis I (Sometimes Making Something Leads to Nothing)*, 1997. Documentation of an action, Mexico City, video 5 mins, colour, sound. Courtesy the Artist, Galerie Peter Kilchmann, Zürich. Photo Enrique Huerta

75 Santiago Sierra, *Person remunerated for a period of 360 consecutive hours*, 2000. Installation view, P.S.1 Contemporary Art Center, New York. Courtesy the artist and Lisson Gallery. © DACS 2015

76 Kara Walker, *They Waz Nice White Folks While They Lasted (Says One Gal to Another)*, 2001. Cut paper and projection on wall installation, dimensions variable; approximately 426.7 × 426.7 × 609.6 (168 × 168 × 240). Installation view American Primitive Brent Sikkema Gallery/ Sikkema Jenkins & Co., New York, 2001. Photo Erma Estwick

77 Banksy: 'Better Out Than in' NY Exhibition, October 2013, New York – 'What We Do In Life Echoes In Eternity', an artwork created by British graffiti artist Banksy in Queens, New York. © Dan Herrick/ZUMA Press/Corbis. Banksy, New York, 2013

78 Walid Raad/The Atlas Group, *Let's be honest, the weather helped_Iraq*, 1998. Archival colour inket print, one of a series of 17 prints 46.4 × 71.8 (18¼ × 28¼); *I might die before I get a rifle (1989)*, 2008. Archival inkjet prints, set of 12 prints. Each print each print 160 × 213.4 (63 × 84); *Notebook volume 38: Already been in a lake of fire_Plates 59 and 60*, 1991/2003. Archival inkjet print mounted on aluminium anodized. Courtesy Anthony Reynolds Gallery, London. Copyright the artist

79 Khaled Jarrar, *State of Palestine stamps*, 2011. Courtesy the artist, Ayyam Gallery & Galerie Polaris

80 Yael Bartana, *The First International Congress of the Renaissance Movement in Poland*, 2012, Berlin. Photo Ilya Rabinovich

81 Artur Żmijewski, *Democracies*, 2009. Single-channel video, projection (or to be shown on 20 flatscreens), 2 hours 26 mins, sound, colour, with English subtitles. Courtesy the Artist; Galerie Peter Kilchmann, Zürich; Foksal Gallery Foundation, Warsaw

82 Cyprien Gaillard, *Desniansky Raion*, 2007. DVD, 30 mins, soundtrack by Koudlam. © Cyprien Gaillard, Courtesy Sprueth Magers

83 Franz Ackermann, *African Diamond*, 2006. Mixed media on wood, 122.5 × 178.5 × 85.5 (48¼ × 70¼ × 33¹¹⁄₁₆). Collection MoCA, Los Angeles. Photo courtesy the artist and neugerriemschneider, Berlin. © Franz Ackermann

84 View of the performance by Elmgreen & Dragset *"But I'm on the Guest List, Too!"* during the Liverpool Biennial in 2012, UK. Courtesy the artists and Victoria Miro Gallery

85 Christine Hill, *Volksboutique*, 1996–97. Organizational venture and second-hand shop in Berlin, Germany. Courtesy Ronald Feldman Fine Arts, New York. Photo Uwe Walter, Berlin

86 Mark Wallinger, *State Britain*, 2007. Mixed-media installation, approx. 570 × 4300 × 190 (224 ³⁄₈ × 1692 ⁷⁄₈ × 74 ³⁄₄). Courtesy the artist and Hauser & Wirth. Photo Dave Morgan. © Mark Wallinger

87 Wafaa Bilal, detail from *and Counting…*, 2010. Performance. Courtesy Driscoll Babcock Galleries and Lawrie Shabibi Gallery. Photo Brad Farwell

88 David Černý, *Pink Tank*, 1991. Copyright the artist

89 Cecily Brown, *Untitled (The Beautiful and Damned)*, 2013. Oil on linen, 276.9 × 434.3 (109 × 171). © Cecily Brown. Courtesy Gagosian Gallery. Photo Robert McKeever

90 Gillian Carnegie, *rsXX-/8-7*, 2007. Oil on board, 23 × 33 (9 × 13). Courtesy Galerie Gisela Capitain, Cologne. © the artist

91 Rebecca Warren, *The Mechanic*, 2000. Clay on painted MDF plinth with turntable, 48 × 36 × 48 (18 ⁷⁄₈ × 14 ¹⁄₈ × 18 ⁷⁄₈). Courtesy Maureen Paley, London, © the artist

92 Wangechi Mutu, *Madam Repeateat*, 2010. Mixed media ink, spray paint, collage on Mylar, 134.6 × 136.5 (53 × 53 ³⁄₄). Courtesy the artist and Victoria Miro, London. Copyright Wangechi Mutu

93 John Currin, *Big Hands*, 2010. Oil on canvas, 101.6 × 71.1 (40 × 28). © John Currin. Courtesy Gagosian Gallery. Photo Robert McKeever

94 Annette Messager, *The Pikes*, 1992–93. Steel, fabric, coloured pencils, paper, cardboard, glass and dolls, 300 × 800 × 112 (118 ¹⁄₈ × 315 × 44 ¹⁄₈). Photo Tate, London 2014. © ADAGP, Paris and DACS, London 2015

95 Janine Antoni, *Saddle*, 2000. Full rawhide, edition of five, 68.6 × 81.3 × 200.7 (27 × 32 × 79). Courtesy the artist and Luhring Augustine, New York. © Janine Antoni

96 Kevin Francis Gray, *Ballerina*, 2011. White Statuario marble, 19 × 45 × 52 (7 ¹⁄₂ × 17 ³⁄₄ × 20 ¹⁄₂). Photo Tara Moore

97 Pipilotti Rist, *Pour Your Body Out (7354 Cubic Meters)*, 2008. Multichannel audio video installation. Installation view at Museum of Modern Art, New York. Courtesy the artist, Hauser & Wirth and Luhring Augustine. Photo © Frederick Charles, fcharles.com

98 Gina Czarnecki, *I*, 2013. Gina Czarnecki in collaboration with Professor John Girkin, University of Durham Biophysical Sciences Institute. Produced by Forma Art and Media. Commissioned by Artichoke. Supported by The Wellcome Trust

99 Heather Phillipson, *immediately and for a short time balloons weapons too-tight clothing worries of all kinds*, 2013. Installation view, Bunker259, New York, 2014. Courtesy the artist and Bunker259

100 Matthew Barney, *Cremaster 4*, 1994. Production still. Courtesy Gladstone Gallery, New York and Brussels. Photo Michael James O'Brien. Copyright Matthew Barney

101 Ernesto Neto, *anthropodino*, 2009. Mixed-media installation, installation dimensions variable. Commissioned by Park Avenue Armory for Wade Thompson Drill Hall. Photo Jean Vong. Courtesy the artist and Tanya Bonakdar Gallery, New York

102 Sarah Lucas, *Pauline Bunny*, 1997. Tan tights, black stockings, chair, clamp, kapok, wire, 103 × 79 × 89 (in.). Courtesy Sadie Coles HQ, London. Copyright the artist

103 Janaina Tschäpe, *Juju 1*, from *The Sea and The Mountain*, 2004. Cibachrome, 101.6 × 127 (40 × 50). Courtesy the artist. © Janaina Tschäpe

104 Bharti Kher, *The Messenger*, 2011. Fibreglass, wooden rake, saree, resin, 188 × 136 × 84 (74 × 53 ¹⁄₂ × 33 ¹⁄₈). Courtesy the artist and Hauser & Wirth. Photo Genevieve Hanson. © Bharti Kher

105 The Long Now Foundation, *Prototype 1 of the 10,000 Year Clock*, 1999 (the full-scale 10,000 Year Clock is still under construction in West Texas). Science Museum, London. Courtesy The Long Now Foundation (longnow.org). Photo Rolfe Horn

106 On Kawara, *28 SEP. 68*, 1968. from 'Today' series, 1966-2013. Acrylic on canvas, 20.3 × 25.4 (8 × 10). Courtesy David Zwirner, New York/London

107 Christian Marclay, still from *The Clock*, 2010. Single-channel video with stereo sound, 24 hours, looped. Courtesy Paula Cooper Gallery, New York. © Christian Marclay

108 Darren Almond, *Tide*, 2008. Digital wall clocks, perspex, electro-mechanics, steel, vinyl, computerized electronic control system and components, each clock: 31.2 × 18.2 × 14.2 (12 ⁵⁄₁₆ × 7 ³⁄₁₆ × 5 ⁵⁄₁₆). Courtesy Art Tower Mito. Photo Keizo Kioku. © Darren Almond

109 Lucy McKenzie, *Olga Korbut*, 1998. Oil on canvas, 240 × 106 (94.5 × 41.7). Courtesy the artist and Cabinet, London

110 Ged Quinn, *The Fall*, 2006. Oil on linen, 188 × 250 (74 × 98 ¹⁄₂). Courtesy the artist and Stephen Friedman Gallery, London. Copyright the artist

111 Mark Alexander, *American Bog (The Freakes)*, 2013. Oil on canvas, 85.5 × 65 (33 ⁵⁄₈ × 25 ⁵⁄₈). Courtesy Wilkinson Gallery, London. Photo Peter White. Copyright the artist

112 Jake and Dinos Chapman, *If Hitler Had Been a Hippy How Happy Would We Be*, 2008. One of thirteen reclaimed Adolf Hitler watercolours on paper, dimensions variable. Image courtesy White Cube. © Jake and Dinos Chapman. All Rights Reserved, DACS 2015

113 Robert Smithson, *Spiral Jetty*, 1970. Mud, precipitated salt crystals, rocks, water coil 4.6 × 457.2 metres (1500 × 15 feet). Rozel Point, Great Salt Lake, Utah. Photo © George Steinmetz/ Corbis. © Estate of Robert Smithson/ DACS, London/VAGA, New York 2015

114 Tacita Dean, *Directions to Robert Smithson's Spiral Jetty*, faxed to the artist by the Utah Arts Council, 1997. Courtesy the artist and Frith Street Gallery, London

115 Anselm Kiefer, *Shevirath Ha Kelim*, 2009. Terracotta, acrylic, oil and shellac on canvas, 330 × 760 × 1300 (129 ¹⁵⁄₁₆ × 299 ³⁄₁₆ × 511 ¹³⁄₁₆). Courtesy White Cube. © Anselm Kiefer

116 Grayson Perry, *The Rosetta Vase*, 2011. Glazed ceramic, 78.5 × 40.7 (30 ⁷⁄₈ × 16 ¹⁄₄). Collection British Museum. Courtesy the Artist and Victoria Miro, London. Copyright Grayson Perry

117 Bill Woodrow, *Regardless of History*, 2000. Bronze, approx. 560 × 540 × 245 (220 ¹⁄₂ × 212 ⁵⁄₈ × 96 ¹⁄₂). Photo Jerry Young,

London. © Bill Woodrow. All Rights Reserved, DACS

118 Luc Tuymans, *Big Brother*, 2008. Oil on canvas, 146 × 224 (57 ½ × 88 ¼). Photo Jurgen Doom. Courtesy Zeno X Gallery, Antwerp and David Zwirner, New York/London

119 Peter Doig, *100 Years Ago (Carrera)*, 2001. Oil on linen, 229 × 359 (90 ¼ × 141 ½). Photo Jochen Littkemann. © Peter Doig. All Rights Reserved, DACS 2015

120 Richard Wright, *Untitled (06.01.08)*, 2008. Gold leaf on paper, 102.7 × 129 × 6.4 (40 ⁷⁄₁₆ × 50 ¹³⁄₁₆ × 2 ½). © Richard Wright. Courtesy Gagosian Gallery

121 Mona Hatoum, *Corps étranger*, 1994. Video installation with cylindrical wooden structure, video projector, video player, amplifier and four speakers, 350 × 300 × 300 (137 ¹³⁄₁₆ × 118 ⅛ × 118 ⅛). Courtesy Centre Pompidou, Paris. Photo Philippe Migeat. © Mona Hatoum

122 Justine Cooper, *RAPT II* (1998). Incorporates 76 slices/MRI scans to create Cooper's 10-metre-long databody. Shown at the exhibition 'Probe: Explorations into Australian Computational Space', at the Australian Embassy, Beijing, China. Courtesy the artist

123 Mariko Mori, *Wave UFO*, 1999–2003. Brainwave interface, vision dome, projector, computer system, fibreglass, Technogel®, acrylic, carbon fibre, aluminium, magnesium, 493 × 1134 × 528 (194.09 × 446.46 × 207.87). Edition of 2 + 1 AP. Courtesy Shiraishi Contemporary Art, Inc., Tokyo, Deitch Projects, New York. Photo courtesy of Mariko Mori / Art Resource, NY. Photograph © Richard Learoyd. Artwork © Mariko Mori, member Artists Rights Society (ARS), New York/DACS 2015

124 Brian Eno, *77 Million Paintings*, 2006. Painting, digital coding and architectural mapping projection. Nick Robertson, Lumen London

125 Scott Draves, *Generation 244 of the Electric Sheep* showing at Emoção Art.ficial Biennial 2012. Courtesy the artist

126 Eduardo Kac, *GFP Bunny*, 2000. Transgenic artwork, Alba, the fluorescent rabbit. Courtesy the artist

127 Alexis Rockman, *Study for Romantic Attachments (Bust of Homo Georgicus)*, 2007.

Ink and gouache on paper, 40.6 × 30.5 (16 × 12). Courtesy Alexis Rockman and Sperone Westwater Gallery

128 Darrell Viner, *'Is Tall Better Than Small'*, 2000. Electrics, electronics, computers, pneumatics, steel, LEDs, aluminium, laser ranger. Permanent commission for the Wellcome Wing at the Science Museum. Courtesy Darrell Viner Estate

129 Adam Brown in collaboration with Andrew Fagg, *Bion*, 2006. 1,000+ injection-moulded plastic synthetic life-forms. Courtesy Adam Brown

130 Olafur Eliasson, *The Weather Project*, 2003–4. Installation, monofrequency lights, projection foil, haze machines, mirror foil, aluminium and scaffolding, 26.7 × 22.3 × 155.4 metres (87 feet 7 ³⁄₁₆ inches × 73 feet 2 inches × 509 feet 10 ⅛ inches). Installation view, Turbine Hall, Tate Modern, London, 2003–4. Photo © Eva-Lotta Jansson/Corbis

131 Daro Montag, *This Earth 1* (detail), *This Earth 6* (detail) and *This Earth 9* (detail), 2006. Digital print made from film decomposed by soil microorganisms. Daro Montag

132 Ken Goldberg, Sanjay Krishnan, Fernanda Viegas, and Martin Wattenberg, *Bloom*, 2013. Collection of the Nevada Museum of Art. Special thanks to JoAnne Northrup, Richard Allen, Doug Neuhouser, and Peggy Hellweg of the UC Berkeley Seismological Laboratory for the live data feed, and to David Nachum, Vijay Vasudevan, Woj Matusek for work on earlier versions

133 James Auger, Jimmy Loizeau, Stefan Agamanolis, *Iso-phone*, 2004. Fibreglass, aluminium and electronic media. Courtesy Auger-Loizeau

134 Carsten Höller, *Umkehrbrille (Upside Down Goggles)*, 1994/2009. Acrylic glass prisms, aluminium, polyethylene, polypropylene, foam, leather, nylon. Installation view Il Tempo del Postino, Manchester International Festival, 2007. Courtesy the artist. Photo © Howard Barlow and Joel Fildes. Carsten Höller © DACS 2015

135 Christian Moeller, *Do Not Touch*, 2004. Courtesy Christian Moeller

136 Ellsworth Kelly, *Curves on White (Four Panels)*, 2011. Oil on canvas, four panels, 178 × 833 (70 × 328). Courtesy

Matthew Marks Gallery, New York. Photo Ronald Amstutz. © Ellsworth Kelly

137 Gerhard Richter, *16. Nov. 06.*, 2006 (Catalogue Raisonné 898-13). Oil on paper, 131.5 × 99 (51 ¾ × 39). © Gerhard Richter, 2016

138 Bridget Riley, *June*, 1992/2002. Colour screenprint, image 80 × 114.3 (31 ½ × 45), sheet 92.7 × 132.1 (36 ½ × 52), edition of 75 plus 10 artist's proofs. Courtesy Karsten Schubert, London. © Bridget Riley 2015. All rights reserved

139 Sean Scully, *Lear*, 2013–14. Oil on aluminium, 215.9 × 190.5 (85 × 75) (× 6). © Sean Scully

140 Mark Grotjahn, *Untitled (White Butterfly)*, 2002. Oil on linen, 121.9 × 86.4 (48 × 34). Courtesy the artist and Blum & Poe. Copyright Mark Grotjahn

141 Tomma Abts, *Fewe*, 2005. Oil and acrylic on canvas, 48 × 38 (18 ⅞ × 14 ½). Collection of the SF MoMA, San Francisco, CA. Courtesy greengrassi, London. Photo Marcus Leith

142 Brice Marden, *Weaver Letter*, 2010–11. Oil on linen, 183 × 244 (72 × 96). Courtesy Matthew Marks Gallery. © ARS, NY and DACS, London 2015

143 Liz Larner, *2 As 3 And Some Too*, 1997–98. Paper, steel, watercolour, 2 elements, 152.4 × 152.4 (60 × 60) each. Courtesy Regen Projects, Los Angeles. © Liz Larner

144 Arturo Herrera, *Say Seven*, 2000. Wool felt, 165.1 × 228.6 (65 × 90). Courtesy Sikkema Jenkins & Co., New York. © Arturo Herrera

145 André Butzer, *Untitled*, 2008. Oil on canvas, 180 × 290 (70 ⅞ × 114 ⅛). Courtesy the artist; Giò Marconi, Milan

146 Albert Oehlen, *Untitled*, 2012. Oil, paper on canvas, 230 × 180 (90 ⁹⁄₁₆ × 70 ⅞). Courtesy Gagosian Gallery. Photography by Lothar Schnepf

147 Charline von Heyl, *Momentito*, 2009. Acrylic, pastels and charcoal on linen, 208.3 × 198.1 (82 × 78). Courtesy the artist and Petzel, New York

148 Franz West, *The Ego and the Id*, 2008. Installed in Central Park, New York.

Courtesy the legal ancestors of Franz West. Photo Chris Ilsley

149 Karla Black, *Pleaser*, 2009. Cellophane, paint, Sellotape, thread, 250 × 200 (98 3/8 × 78 3/4). Courtesy Galerie Gisela Capitain, Cologne. Photo © Fred Dott

150 Tauba Auerbach, *Untitled (Fold)*, 2012. Acrylic paint on canvas on wooden stretcher, 182.9 × 137.2 (72 × 54). Courtesy Paula Cooper Gallery, New York. Photo Steven Probert. © Tauba Auerbach

151 Anselm Reyle, *Untitled*, 2005. Mixed media on canvas, acrylic glass, 143 × 121 × 15.5 (56 1/4 × 47 5/8 × 6 1/8). © Anselm Reyle. Courtesy Gagosian Gallery. Photography by Matthias Kolb

152 Liliane Tomasko, *Vestige*, 2012. Oil on linen, 106.7 × 121 (42 × 48). Courtesy private collection & Timothy Taylor Gallery, London. © the artist

153 Beatriz Milhazes, *As Irmas*, 2004. Print on paper, 132.1 × 152.4 (52 × 60). Edition of 35. Courtesy James Cohan Gallery, New York and Shanghai. Photo Durham Press, Inc. © the artist

154 Julie Mehretu, *Stadia I*, 2004. Ink and acrylic on canvas, 274.3 × 365.8 (108 × 144). Collection San Francisco Museum of Modern Art. Courtesy Marian Goodman Gallery and White Cube. Photo © Richard Stoner. © Julie Mehretu

155 El Anatsui, *Dusasa II*, 2007. Found aluminium and copper wire, 546.1 × 655.32 (215 × 258). Courtesy the artist and Jack Shainman Gallery, New York. © El Anatsui

156 Gert and Uwe Tobias, *Ohne Titel/ Untitled*, 2007. Coloured woodcut on paper, 210 × 188 (82 5/8 × 74). Copyright Alistair Overbruck/Gert & Uwe Tobias/ VG Bildkunst, Bonn

157 Gabriel Orozco, *Prototype*, 2004. Synthetic polymer paint on canvas, 50 × 50 (19 5/8 × 19 5/8). Courtesy the artist and Marian Goodman Gallery

158 Guggi, *Calix Meus Inebrians*, 2009. Painted bronze, 310 × 452 × 452 (122 × 178 × 178). © Guggi 2014

159 Barbara Kruger, *Belief+Doubt*, 2012. Vinyl. Courtesy Hirshhorn Museum and Sculpture Garden, Smithsonian Institution and Mary Boone Gallery, New York. Photo Cathy Carver. Copyright Barbara Kruger

160 Jenny Holzer, *Xenon for Paris*, 2009. Light projection Louvre Pyramid, Napoleon Courtyard, Paris. Text: Lustmord, 1993–95; Truisms, 1977–79; Laments, 1989. National Contemporary Art Fund, Paris. Photo Lili Holzer-Glier. © Jenny Holzer, ARS, NY and DACS, London 2015

161 Richard Prince, *Mission Nurse*, 2002. Ink jet and acrylic on canvas, 177.8 × 121.9 (70 × 48) (Inv# RPS3198). © Richard Prince. Courtesy the artist and Gagosian Gallery. Photo Larry Lamay

162 Christopher Wool, *Untitled*, 2000. Enamel on aluminium, 274.3 × 182.9 (108 × 72). © Christopher Wool

163 Christopher Wool, *Untitled*, 2005. Enamel on linen, 264.2 × 198.1 (104 × 78). © Christopher Wool

164 Glenn Ligon, *Untitled (Black Like Me #2)*, 1992. Oil and gesso on canvas, 203.2 × 76.2 (80 × 30). Collection Hirshhorn Museum and Sculpture Garden. Courtesy the artist, Luhring Augustine, New York, and Regen Projects, Los Angeles. © Glenn Ligon

165 Zhang Huan, *Family Tree*, 2000. Courtesy Zhang Huan Studio

166 Danh Vo, *2.2.1861*, 2009. Ink on A4 paper, writing by Phung Vo, 29.6 × 21 (11 5/8 × 8 1/4). Courtesy the artist and Marian Goodman Gallery

167 Dayanita Singh, *Sent a Letter*, 2008. Installation Fotomuseum Winterthur. Courtesy the artist and Frith Street Gallery, London

168 Sophie Calle, *Take Care of Yourself. Lawyer, Caroline Mecary*, 2007. Portrait: fine art print dry mounted on aluminium, wooden frame, text: lambda print dry mounted on aluminium, wooden frame, glass portrait: 113 × 140 (44 1/2 × 55 1/4), text: 113 × 45 (44 1/2 × 17 3/4), overall: 234 × 140.3 (92 1/8 × 55 1/4). Courtesy Sophie Calle and Paula Cooper Gallery, New York. © ADAGP, Paris and DACS, London 2015

169 Douglas Gordon, *List of Names*, 2010. Vinyl text on wall, installation view, Aargauer Kunsthaus, Aarau. Photo René Rötheli, Baden. © Studio lost but found/ DACS 2015

170 Tracey Emin, *Everyone I Have Ever Slept With 1963–95*, 1995, appliquéd tent, mattress and light (destroyed 2004),

122 × 245 × 215 (48 × 96 1/2 × 84 1/2). akg-images/MPortfolio/Electa. © Tracey Emin. All rights reserved, DACS 2015

171 Gillian Wearing, *Signs that say what you want them to say and not Signs that say what someone else wants you to say, I'M DESPERATE*, 1992–93. C-type print mounted on aluminium. © the artist, courtesy Maureen Paley, London

172 Cy Twombly, *Rose (IV)*, 2008. Acrylic on wood panel, 252 × 740 (99 3/16 × 291 5/16). Courtesy Gagosian Gallery. © Cy Twombly Foundation. Photo Mike Bruce

173 Christopher Le Brun, *Walton*, 2013. Oil on canvas, 240 × 170 (94 1/2 × 66 7/8). Courtesy the artist

174 Xu Bing, *Book from the Ground*, 2003–ongoing. Works on paper. Courtesy Xu Bing Studio

p.198 Keith Haring, *Ignorance = Fear*, 1989. Offset-lithograph on glazed poster paper, 9 1/2 × 16 7/8 (24 × 43). For Act Up, the AIDS Coalition to unleash power, New York. © The Keith Haring Foundation

p.199a Rebecca Horn, *Concert of Anarchy*, 1990. Piano, hydraulic rams and compressor, 150 × 106 × 155 (59 × 41 3/4 × 61). Tate, London. Photo Attilio Maranzano. Copyright Rebecca Horn. DACS 2015

p.199b Christian Boltanski, *Monument Odessa*, 1991. Installation: lights, wire, photos, 218.4 × 104.8 (86 × 41 1/4). Spencer Museum of Art, Helen Foresman Spencer Art Acquisition Fund, 1994.0059. © ADAGP, Paris and DACS, London 2015

p.200a Dorothy Cross, *Bull's Eye*, 1992. Dartboard, cow's teat, 26 darts, 46 × 8.5 (18.1 × 3.3). Courtesy the artist, Frith Street Gallery, London and Kerlin Gallery, Dublin

p.200b Jeff Wall, *A Sudden Gust of Wind (after Hokusai)*, 1993. Transparency in lightbox, 229 × 377 (90 1/8 × 148 3/8). Courtesy the artist

p.201a Jeff Koons, *Balloon Dog (Orange)*, 1994–2000. Mirror-polished stainless steel with transparent colour coating, 307.3 × 363.2 × 114.3 (121 × 143 × 45). Photo Tom Powel Imaging. © Jeff Koons

p.201b Mike Kelley, *Educational Complex* (detail), 1995. Synthetic polymer, latex, foam core, fibreglass and wood, 146.7 × 488.2 × 244.2 (57 3/4 × 192 3/16 × 96 1/8).

Whitney Museum of American Art, New York, Purchase, with funds from the Contemporary Painting and Sculpture Committee 96.50. Photo David Allison. © The Estate of Mike Kelley, LLC/VAGA, NY/DACS, London 2015

p.202a Paul McCarthy, *Yaa Hoo Town, Saloon*, 1996. Steel, mechanical parts, fibreglass, polyester resins, enamel, latex, urethane and lacquer paint, programmable logic controls, pneumatic cylinders and components, silent air-compressors, sound generated from pre-programmed CD player, wood, clothing, wigs and accessories, 353.1 × 485.1 × 279.4 (139 × 191 × 110). Courtesy the artist and Hauser & Wirth. Photo Genevieve Hanson

p.202b Steve McQueen, *Deadpan*, 1997. Video still. Courtesy the artist and Thomas Dane Gallery, London

p.203a William Kentridge, drawing for the film *Stereoscope*, 1998–99. Charcoal and pastel on paper, 12 × 16 (4¾ × 6¼). Courtesy the artist

p.203b Louise Bourgeois, *Maman*, 1999 at the National Gallery of Canada, in the City of Ottawa, Ontario, Canada c. August 2008. © Gunter Marx/Gunter Marx Photography/Corbis. Bourgeois © The Easton Foundation/VAGA, New York/DACS, London 2015

p.204a Thomas Hirschhorn, *The Bridge*, 2000, exhibited at 'Protest and Survive', Whitechapel Art Gallery, London, 2000. Courtesy the artist and Whitechapel Art Gallery, London

p.204b Tracey Rose, *The Kiss*, 2001. Lambda print, 124.5 × 127 (49 × 50). Courtesy Dan Gunn, Berlin, Goodman Gallery and Christian Haye. Copyright the artist

p.205a Yayoi Kusama, *Infinity Mirrored Room (Fireflies on the Water)*, 2000. Mixed media, 450 × 450 × 320 (177⅛ × 177⅛ × 126). Installation, Yayoi Kusama, Maison de la culture du Japon, Paris, 2001. Courtesy KUSAMA Enterprise, Ota Fine Arts, Tokyo/ Singapore and Victoria Miro, London. Copyright Yayoi Kusama

p.205b Paula Rego, *War*, 2003. Pastel on paper on aluminium, 160 × 120 (63 × 47¼). Tate, London. Courtesy the artist and Marlborough Fine Art

p.206a Zhang Xiaogang, *Bloodline: Big Family No.1*, 2004. Oil on canvas,

120 × 150.2 (47¼ × 59⅛). Copyright Zhang Xiaogang

p.206b Luisa Lambri, *Untitled (Barragan House, #01)*, 2005. Laserchrome print from an edition of 5 and 1 artist's proof, 86 × 96 (33¹³⁄₁₆ × 37¾). Photo © Luisa Lambri; Courtesy the artist and Luhring Augustine, New York. © Barragan Foundation, Switzerland, owner of the copyright on the work of Luis Barragan Morfin

p.207a Urs Fischer, *Untitled (Lamp/Bear)*, Seagram Plaza, New York, 2011. Courtesy the artist and Galerie Eva Presenhuber, Zürich. Photo Christie's Images Ltd, 2012. © Urs Fischer

p.207b Fiona Tan, *A Lapse of Memory*, 2007. HDcam, 1:1, 77 wide screen anamorphic, surround/dolby, colour, 24 minutes 35 seconds. Edition of 4 + AP. Courtesy the artist and Frith Street Gallery, London

p.208a David Hockney, *More Felled Trees on Woldgate*, 2008. Oil on 2 canvases, 152.4 × 121.9 (60 × 48 each), 152.4 × 243.8 (60 × 96) overall. Photo Richard Schmidt. © David Hockney

p.208b Aleksandra Mir, *Astronaut*, 2009. Paper collage on board in gold leaf frame, 31 × 24 (12¼ × 9½). Courtesy the artist

p.209a Wolfgang Tillmans, *Freischwimmer 15*, 2010. Inkjet print, 382 × 506.3 (150⅜ × 199⅜). (MP-TILLW-00821). © the artist, courtesy Maureen Paley, London

p.209b Nathalie Djurberg & Hans Berg, *The Parade*, 2012. Courtesy Lisson Gallery, London. © Nathalie Djurberg

p.210a Laure Prouvost, *Wantee*, 2013. Video with mixed-media installation. Installation view Tate Britain, London. Courtesy the artist and MOT International London and Brussels. Photo Tim Bowditch. Copyright Laure Prouvost

p.210b Sarah Sze, *Triple Point (Planetarium)*, 2013. Wood, steel, plastic, stone, string, fans, overhead projectors, photograph of rock printed on Tyvek, mixed media, 632.5 × 548.6 × 502.9 (249 × 216 × 198). Courtesy the artist, Victoria Miro, London and Tanya Bonakdar Gallery, New York. Photo Tom Powel Imaging. Copyright Sarah Sze

p.211a Monika Sosnowska, *Tower*, 2014. Steel, paint, 332.7 × 3223.3 × 668 (131 × 1269 × 263) Installation view,

Hauser & Wirth, 18th Street, New York. Courtesy the artist, Foksal Gallery Foundation, The Modern Institute, Galerie Gisela Capitain, Kurimanzutto, Hauser & Wirth. Photo Genevieve Hanson. © Monika Sosnowska

p.211b Hans Haacke, *Gift Horse*, 2015. Cast bronze, LED electronic ticker tape, 424.2 × 449.6 × 142.2 (167 × 177 × 56). Courtesy the artist and Paula Cooper Gallery, New York. Photo Gautier Deblonde. © DACS, London

INDEX

Page numbers in *italics* refer
to illustration captions.

222